Aberystwyth
– AND THE –
GREAT WAR

William Troughton

AMBERLEY

ACKNOWLEDGEMENTS

Many thanks to Nigel Davies, Peter Henley, Pete Walkingshaw, Gil Jones, Huw Spencer-Lloyd, Steven Edwards and Lord Ashcroft for their assistance and to Lorena, Eluned and Ioan for their patience.

Dedicated to the memory of Samuel George Pipe (1885–1917) and William John Jones (1898–1918), two young men from very different backgrounds, who had they lived would have been my great-uncles.

First published 2015

Amberley Publishing
The Hill, Stroud
Gloucestershire, GL5 4EP

www.amberley-books.com

Copyright © William Troughton, 2015

The right of William Troughton to be identified as the Author of this work has been asserted in accordance with the Copyrights, Designs and Patents Act 1988.

British Library Cataloguing in Publication Data.
A catalogue record for this book is available from the British Library.

ISBN 978 1 4456 4290 1 (print)
ISBN 978 1 4456 4303 8 (ebook)

Typesetting and Origination by Amberley Publishing.
Printed in Great Britain.

CONTENTS

INTRODUCTION

The experiences of townspeople during the First World War can be divided into two camps. There were those who served in the forces who saw the horrors and endured hardships first-hand. Over a thousand men from Aberystwyth served in the Armed Forces and Merchant Navy. Many women served as nurses and auxiliaries, often in theatres of war. Those remaining in the town may have been hundreds of miles from the Western Front but still witnessed much at first hand. There was the arrival of 6,000 troops in November 1914. Later, Aberystwyth Red Cross Hospital played host to numerous convalescing soldiers. All the while reminders of those in the services were published in the *Cambrian News* and *Welsh Gazette*. If all this wasn't enough, there was a stream of flotsam and jetsam being washed up on local beaches, a macabre testament to the presence of enemy submarines in the Irish Sea.

A note of caution needs to be exercised when reading contemporary newspapers and accounts from the front. All mail was subject to censorship, in turn inducing an element of self-censorship in the writer. For men serving in the forces, there was an intense patriotism and awareness, through receipt of the newspapers from the Comforts Fund, of the effects of their writing back home. Nobody wanted to let the side down by talking graphically about pain or mutilation and neither did the public want to read about it. The horror and terror of what many witnessed is not recorded. Death tends only to be mentioned when the casualty dies swiftly and painlessly. Successes and local heroes was the diet fed to the public.

In order to understand the events of 1914–18 in their local context, it has been necessary to approach it from the viewpoint of the era. Consequently, the book attempts to retain a flavour of those years in the way the information is presented.

Those who wish to know more about Aberystwyth's fallen heroes can do no better than refer to Steve John's excellent West Wales War Memorials Project website (www.wwwmp.co.uk).

CHAPTER 1

SUMMER OF 1914

In the Spring of 1914, there was every reason for the townspeople to feel optimistic about the forthcoming summer. Visitor numbers were expected to be high. Aberystwyth was then a popular resort, able to attract the famous names of the day.

As summer approached, the town was looking forward to the arrival of several thousand territorial soldiers for their annual tented encampment. These camps had become a regular feature and in previous years had been at Bow Street, Lovesgrove and Llanfarian. This year the encampment was to be near Capel Bangor, and 6,000 soldiers from the Welsh Territorial Division were expected. A smaller camp for the Army Service Corps was to be in Plascrug. In addition, 900 delegates arrived for the Annual Movable Conference of the Oddfellows, their first visit since 1885.

The flurry and activity in preparation for the summer months would have made the rumblings and blustering of continental Europe seem far away and irrelevant. Not many people would really have understood the ramifications of the assassination of Archduke

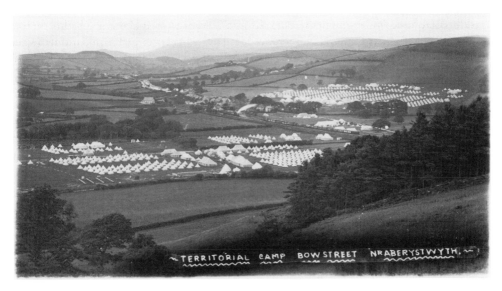

Territorial Army Camp at Bow Street, 1910.

Franz Ferdinand on Sunday 28 June. Meanwhile, local newspapers continued to carry the usual selection of local news:

Fourteen-year-old Thornton Oxley who was holidaying with his parents at No. 62, Marine Terrace paid more attention to his kite than to his footing, fell six feet and fractured his ankle when flying a kite on Constitution Hill; John Daniel, boatman, was fined two shillings and sixpence with costs for touting for business on the prom; in Trefor Road, Mr Davies of Glwydfa picked peas from his garden on 1 June, unusually early for the district; Mr James Vearey, who specialised in tomatoes, succeeded in growing a bunch of tomatoes weighing a total of seven pounds and fourteen ounces. These were proudly placed on view in his shop at 17, Northgate Street.

Of more lasting importance was the official opening of Aberystwyth Golf Club. George Duncan, the 1913 French Champion, and reigning Open Champion Harry Vardon were to officially open the Golf Course on Wednesday 20 May. Vardon was responsible for the design of the course. Both arrived on the preceding evening, but Vardon received news of the death of his father shortly after arriving. Consequently, Vardon had to leave Aberystwyth. New arrangements were devised, and 500 spectators witnessed the French champion Duncan beaten in a three-ball game against the Aberystwyth and Harlech professionals, Lewis and Walker, respectively. In the afternoon, Duncan and Walker played Lewis and Charles Gadd, the professional at Aberdyfi. Duncan redeemed himself, and he and Walker were victorious.

In a ritual familiar to all the participants, Jack Levenson, Tobacconist, Terrace Road, was fined under the Sunday Observance Act of 1677 for 'unlawfully following his calling on the Lord's Day.' On having been confronted by PC Evans on the Sunday in question, Levenson had merely replied, 'I will not dispute the facts and will not defend the case or attend the Court, but will send the fine.' Evidently opening on the Lord's Day was lucrative, as Jack Levenson and a few other traders were serial offenders in the matter of Sunday trading. By late September, he had been fined eleven times for opening on a Sunday.

Alexander Finlay, professor of chemistry at the university announced his engagement to Alice Mary de Rougemont. The Earl of Lisburne went one better and on 16 July married Mademoiselle Regina de Bittencourt. Unfortunately, their celebrations planned for August back in Trawscoed had to be curtailed. In Trinity Place, Master Sidney Roberts had reason to be proud for beating pupils two years older than himself in a national competition organised by the 'Daily Sketch'. Willie Owen of Cambrian Street was nursing a sore head

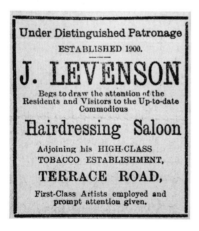

Advertisement for Levenson's Tobacconist and Hairdresser. (*Cambrian News* 1914.)

following an encounter with the handle of a crane on the building site of the National Library of Wales but was expected to make a full recovery.

Aberystwyth was a popular Edwardian resort and able to attract many of the celebrities of the time. This year a new troupe, Ellison's Entertainers, along with their portable pavilion were to entertain visitors. They performed three times daily, rain or shine, and emphasised that their shows were free of vulgarity.

One of the most eccentric celebrities to arrive was Giuseppe Sacco-Homann, one of a genre known as Hunger Artists, who was to give an exhibition of fasting at 8, Pier Street (admission 3*d*, children 1*d*). At the time, he held the world fasting record of sixty-three days. He would perform his fasts all over the world, bulking up between fasts. Three weeks later, it was stated that he had now been fasting for eighteen days and lost about 20 pounds in weight, was rather irritable and sometimes depressed but determined to go on. He was reported to be sleeping well and his nerves to be fairly steady. By his fourth week of a proposed sixty-day fast, he had lost 28 pounds. By early August, he was taken to court for non-payment of rates and either wasted away completely or hastily departed from Aberystwyth. Although describing himself as Hungarian, following his death in 1929, his real name was revealed as Richard Hans Jones, born in Holland of British parents.

Another celebrity of the period was the aviator Henri Salmet. In 1912, he had been sponsored by the *Daily Mail* to visit 121 towns and cities in Britain to raise interest in aviation. Aberystwyth missed out, but in 1914, Salmet visited Aberystwyth, landing his Bleriot monoplane on the Vicarage Fields on 5 June. The plane was a two-seater allowing him to carry a fare-paying passenger. This is the first recorded occasion of an aeroplane visiting Aberystwyth. In the evening, when the wind had moderated, Salmet made flights with Mr O. R. Howell, a college student, and Mr Guy Harries,[1] son of Dr T. D. Harries. The aeroplane reportedly circled over an incoming train and flew up the Rheidol Valley. On Sunday afternoon, crowds of visitors paid a fee for admission to the Vicarage Field

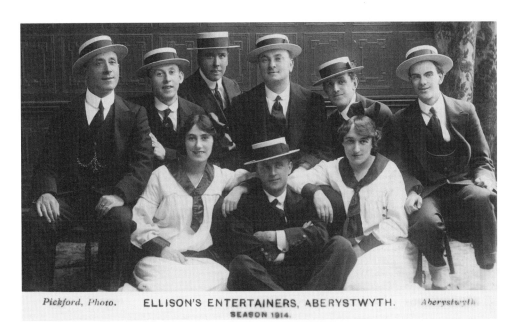

Pickford, *Photo.* ELLISON'S ENTERTAINERS, ABERYSTWYTH. *Aberystwyth* SEASON 1914.

Ellison's Entertainers, 1914.

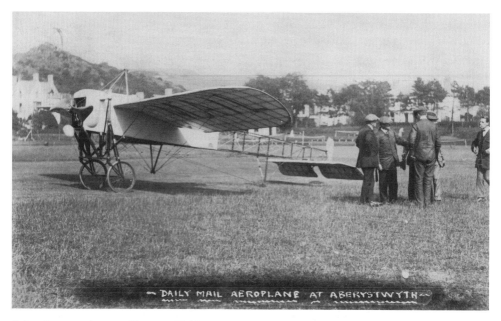

— DAILY MAIL AEROPLANE AT ABERYSTWYTH —

Salmet's monoplane on Vicarage Fields, 1914.

and inspected the aeroplane, the proceeds being donated to charities. On Monday, when the town was full of excursionists and country people, a strong wind made flights in the morning and afternoon impracticable. In the evening, the wind moderated and the weather improved. A large crowd assembled in Plascrug, and more flights were made.

In July, more visitors intent on conquering the skies visited Aberystwyth, this time in hot-air balloons. Their visit was courtesy of the annual competition for 'Le grand prix de L'Aero Club de France.' Setting off from Paris on the evening of Sunday 19 July, their intention was to cross St George's Channel and land in Ireland. Three of the balloons had reached Cardiganshire by Monday morning. Having mistaken Cardiganshire for Cornwall, the balloonists saw the coast looming and believed they were to be blown out into the Atlantic. Consequently, they effected landings as well as they could. One balloon landed near Pencarreg Farm, Llanrhystud, a second near Llanilar and the third near Chancery. This balloon had been seen earlier in the day near Ysbyty Ystwyth when attempts had been made to land using a grappling hook, gouging the road and breaking a telegraph wire. Their attempts near Chancery were successful when the grappling hook caught on the telegraph wires, plunging the two occupants to the ground. Monsieur Dubois was unhurt, but his companion, Monsieur Spire, had to be taken to the infirmary with a broken ankle and a bruised eye. He was still there two weeks later. Mademoiselle Marie Marvingt,[2] one of the occupants of the balloon that landed near Llanrhystud, sustained a black eye.

Black eyes were not purely the reserve of balloonists in Aberystwyth. Boxing was held at the Coliseum where top of the bill was Londoner Alf Inglis against the Swiss boxer Jack Georgie [sic] who lived and worked locally. Inglis was the eventual winner. In another bout, the African American Andrew Green beat Londoner Ted Moore. Battling Robinson also boxed in Aberystwyth, and two years previously Fred Welsh, soon to be world lightweight champion, had boxed here.

The expected territorials arrived by train on 25 July and were met by heavy rain for their five-mile march to their camp. The territorials comprised men from the Royal Welsh Fusiliers (RWF), Shropshires, Welsh Field Ambulance, Cheshire Engineers, and Welsh Engineers & Welsh Signalling Corps, in all 5,642 men. There was also a detachment of nurses belonging to the South Wales St John's Ambulance Brigade. Most of the territorials regarded these camps as their annual holidays, far away from the factories, mills, mines and warehouses where most worked. In addition, each man was promised a £1 bounty to stay the full fifteen days.

After experiencing the novelty of a wet weekend under canvas, the sun appeared the following Monday allowing the men to dry out blankets and clothing. Activities planned included company training and elementary musketry in the surrounding hills, followed by rifle inspection. Later in the week, the battalions were to march to their manoeuvring area for night operations and a mock fight. A revised timetable was provided on the Vale of Rheidol Railway to bring the men to Aberystwyth in the evenings.

However, as the international scene deteriorated, the planned activities were abandoned. No sooner had the men had a chance to dry out their equipment, it was time to pack it all away. All left by train to return to their respective headquarters for deployment.

Britain declared war on Germany on 4 August.

An indication perhaps of the paranoia that prevailed at the time is exemplified by two holidaymakers at Aberaeron a few days before. Being suntanned and somewhat weather beaten, they aroused suspicion as being German spies, affirmed in some eyes as indisputable because one of them was wearing spectacles. Subsequent enquiries revealed them to be a Bristol doctor and a clergyman from Southwark Cathedral. Having escaped the clutches of the constabulary at Aberaeron, they walked to Aberystwyth only to find they could not change their five-pound notes in Aberystwyth. The August bank holiday had been

Territorial soldiers in camp near Aberystwyth, *c.* 1914.

extended for three days to allow for the passing of the Currency & Banknote Act. In addition, the Treasury fearing a run on gold prevented banks from issuing gold sovereigns or half-sovereigns. This time the constabulary came to the aid of the stranded travellers and the chief constable acted as the Good Samaritan ensuring the men could catch a train home.

Leonard Douglas Ponting from Macclesfield and Londoner Alfred Silverstone worked as canvassers for an Ammanford photographer. In early August, they did some canvassing on their own account. After some research, the pair descended on Llanilar. Dressed in civilian clothes they called on houses in the district. Each house had one thing in common – sons of military age. Many of the householders were monoglot Welsh or spoke little English. Ponting presented himself as Sergeant Grip, who would take their sons to war unless they paid fifteen shillings (75p) for another man to go in their place. In most instances, the pair was happy to settle for a far smaller sum, justifying this by saying that they were allowing some to pay less, so long as it was kept quiet. Ponting did the talking, and Silverstone kept silent. The activities of the pair aroused suspicion, and their actions were reported to the police. The pair were arrested on South Marine Terrace and committed to the next quarter sessions. At the quarter sessions, they were charged with obtaining money by false pretences, and a number of inhabitants of Llanilar gave evidence. The jury had no hesitation in convicting Ponting, who had a long list of convictions dating back over ten years including burglary and housebreaking. Despite handing in a long written statement about his wife and unborn child, how he had been in prison since his committal, nor was he in want of money, followed by what was described as a 'whining appeal' he was sentenced to two years' hard labour. Silverstone, who had been present at each of the incidents but said little or nothing during the attempts to defraud, was discharged.

CHAPTER 2

THEY ARE LOUSY AND STINK OF GERMAN SAUSAGE!

The outbreak of war led to scenes of unashamed patriotism. Many local men had been called away to serve in the army or the navy. The arrival back in Aberystwyth of German-born Dr Hermann Ethe, seemingly to a warm welcome, inflamed the passions of many inhabitants who embarked on a witch hunt for Germans in their midst.

Dr Carl Hermann Ethe was a distinguished scholar who joined the staff of the university in 1875 as a professor of oriental languages where he taught Hebrew and other oriental languages as well as German. He had left Germany in 1874, aged 30, for political reasons. His first post was at the Bodleian Library in Oxford working on a catalogue of oriental manuscripts as well as manuscripts in the London India Office. He continued working on both projects in his spare time after being appointed at Aberystwyth. Despite living in Britain for forty years, he did not become a naturalised British citizen and maintained a pride in his nationality. During the 1880s, he applied for a number of professorships in Britain and in Germany but was

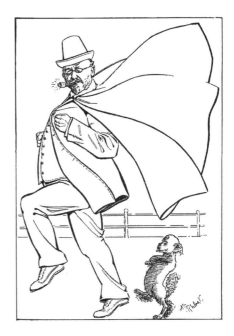

Dr Herman Ethe, from a sketch by Howard Lloyd Roberts.

unsuccessful and settled into a comfortable life in Aberystwyth. At the time war was declared, he and his English wife were in Munich and unable to leave Germany for some months.

With Home Office approval, he and his wife returned to Aberystwyth on Tuesday 13 October 1914, arriving by the early evening train from London. They had landed in Folkestone and been provided with the necessary Foreign Office passport, but as an alien Dr Ethe had to register in London. At the station in Aberystwyth, he was met by Principal Roberts, Mr J. H. Davies, registrar of the university, Mr J. Ballinger, and a student representative. Mr D. C. Roberts, the mayor, had gone to the station to buy a newspaper and, though on the platform, did not participate in the welcome. The police were also present. There was no hostile demonstration, but it was evident that considerable feeling was entertained by people of the town who had gathered at the station to welcome a party of Belgian refugees travelling on the same train. What had probably swayed the authorities in allowing Dr Ethe's return is that he has been on the college staff for forty years.

The following morning, typewritten slips of paper were being handed out in the town:

> As a protest against the return of Dr. Ethe from Germany to teach in our Welsh national institution we intend to form a procession of workmen and others at one o'clock near Shiloh Chapel.

It is not known who instigated the demonstration, but by one o'clock, North Parade was filled with excited people, reportedly a 2,000-strong mass of men and women. Presently, as people left their work for the dinner hour and the shops closed for the Wednesday half-day closing, the crowd rapidly increased, but still with no idea what to do. Shortly afterward, Councillor T. J. Samuel, who had been mayor in 1910, was hoisted up under one of the trees and in response to a demand for a speech said he understood the feeling of the working

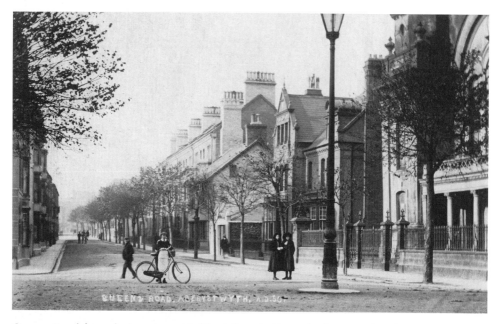

Queens Road from the junction with North Parade. It was in this area that the mob assembled before marching to Dr Ethe's house.

men of the town about the return to Aberystwyth of certain gentlemen who were German was one of resentment and that they wanted to express that feeling by a demonstration. He had lived amongst them many years and had not thought fit to become a naturalised British citizen, and that spoke volumes. In this demonstration, he hoped the people of Aberystwyth would act as Britons and do nothing out of place to injure anybody. Dr Harries of Belgrave House was also pressed to speak. Agreeing, he asked the crowd if they wanted any Germans in Aberystwyth? Cries of 'No' and 'Shoot them' rang out. What then were they going to do? Do not let them act like Germans who tore women and children to pieces, but give them twenty-four-hour notice to clear out, and if they were not out of the town by that time, he would lead in turning them out.

Mr Enoch Davies, a commercial traveller from Trefor Road, then invited the crowd to form in procession and proceed to Schlern Haus in Caradoc Road, the home of Dr Ethe. The mob filled the road and many stood on the lawn in front of the house and went to the ground-floor window and threw it open. Mrs Ethe appeared at the window and bravely confronted the excited crowd. Mr Enoch Davies acted as spokesman and demanded an interview with Dr Ethe. His wife said he was not in the house and asked the crowd to accept her word as an Englishwoman. She added that her brother was in the war fighting for Britain and that her husband had been granted a passport by the British authorities. The reply was that her husband was a German and that the people of Aberystwyth would not tolerate a German amongst them after German barbarities in Belgium. A woman pushed forward and exclaimed that the husband was in the house, but it was just like the Germans to shelter behind women and children. Mrs Ethe then consented to convey a message that Dr Ethe was to clear out of town in twenty-four hours. If not, added someone in the crowd, we will 'come and pull the house down'.

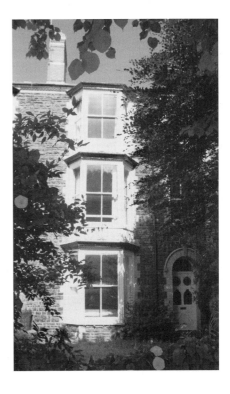

Dr Ethe's house in Caradoc Road.

Just then, a commotion arose near the front door as Professor Marshall, officer in command of the local Officer Training Corps (OTCs) and Professor O. T. Jones (Geology), attempted to mediate on Mrs Ethe's behalf. Marshall, for his trouble, was bonneted (i.e. had his hat pushed right down onto his head), at which point the police at last intervened. After a few minutes, the crowd proceeded to the house of Professor Schott (applied mathematics). In Laura Place, he had recently married a German lady, and he and Mrs Schott were in Germany attending a wedding when war was declared. They left for Aberystwyth immediately but had to abandon their luggage. Dr Schott appeared at his window and, greatly annoyed, declared he was a Yorkshireman. The crowd then accused him of playing the German national anthem, which he denied. They then asked him also to leave the town in twenty-four hours. He replied that that was a matter for college authorities to deal with ending the interview by closing the window. Next, the excited mob rushed to the Belle Vue Hotel and demanded the sacking of any German employees. Next was the Queen's Hotel where the doors were closed and appeared to be locked, waitresses appearing at the windows watching the spectacle. Mr Enoch Davies mounted the steps and asked to enter, and on the door being opened to admit him, the flag pole was thrust in the opening and there was a crash of breaking glass and the mob forced open the door, rushing into the hotel, again demanding that any Germans should be dismissed. The staff member attracting the attention of the mob at the Queen's Hotel was a waiter who had lived in the town for many years, was married and was the father of six children. Outside on the road, a student observed that he would rather be a German than behave in this way. He was immediately set upon by women and children and ran for shelter to his digs. He was subsequently seen in North Parade and again set upon and pummelled but eventually escaped, apparently without serious injury.

Leaving the Queen's Hotel, the mob proceeded to Terrace Road and filled Mr Jack Levenson's tobacconist shop where they demanded the dismissal of any German working in his hairdressing salon. Mr Levenson, recognising that discretion was the better part of valour, coolly replied 'Alright,' and the mob departed. As it was early closing day and his assistants were not on the premises, the crowd went to No. 8, Greenfield Street where they were informed that the person they wanted was not at home. This was probably Theodore Engman, a hairdresser of German nationality who was boarding there. Later, some of the crowd met Principal Roberts and discussed matters, suggesting that action should be postponed for a week to enable the college authorities to consider the matter and that Dr Ethe might leave the town. To this, the crowd agreed. Dr and Mrs Ethe were reported to have left Aberystwyth on Wednesday evening by the mail train. Richard Hinchisman, a Bavarian, who has been employed by Jack Levenson for the past seven years, also left the town. A pawnbroker in South Road was also visited but on verification that he was not German was left alone as was Mr Adler who operated a business in Pier Street and assured his interrogators he was Polish.

On Thursday morning, excited groups of people gathered, and another demonstration was arranged for the dinner hour. Councillor Samuel had received the following telegram from Liverpool:

Bravo Aberystwyth. I cannot help expressing my admiration for you and your townspeople in setting an example to the British nation in hunting the German out of the country. May success follow your exertion.

The mob may have been further encouraged by attention in the national press. On Thursday morning, the Town Crier announced that a further gathering would be held during the

dinner hour to see if promises of the previous day that the Germans should leave had been fulfilled. However, it was rumoured that all German citizens had gone on Wednesday, and the shops not being closed, the crowd was not so large nor as threatening. Students kept away, even as spectators. At one o'clock, boys carrying the Red Ensign and Union Jack came into North Parade from Terrace Road, followed by a man carrying a banner reading 'Patronise the Belgian concert tonight and out with the Germans'. Five policemen were on duty, and at each destination, the crowd found police officers strategically placed.

Mounting the low wall in front of Seilo, Councillor Samuel, who was accompanied by Dr Harries, said the demonstration of the previous day against the Germans had answered its purpose very well. The object of the present demonstration was to enable the people to go and see whether the Germans who had promised to quit had fulfilled their promise. He thought it would be found that one whose house they had visited had gone far away and that the others were going or had gone. (Cheers.) Mr Samuel concluded by urging the crowd not to damage property or injure persons and saying he was glad to find what Aberystwyth had done had been recorded in the English papers and telegrams had been received saying 'Bravo Aberystwyth'. (Applause.) Dr Harries thanked the assembly for the noble way it had behaved. They were Britishers and not Germans. If they acted like Germans, not one German in the town would be alive today. The crowd had acted as well as possible under the provocation the nation had received from German brutes, for whom a day of retribution would surely come. (Cheers.) As Dr Schott had proved himself to be an Englishman, he suggested that crowd should give him three cheers. The men they wanted to deal with were Germans, and he thought their notice on the previous day had been effective. (Cheers.) Like Mr Samuel, he also had received telegrams, one 'from a member of a big house in London'. It said, 'Bravo Aberystwyth; but was there no street lamp and hempen rope available for the murderers?' A telegram from Southend said, 'Bravo Doctor and bravo Aberystwyth. Clear the hellish fiends out.' Yes, added Dr Harries, 'clear them out, but do not touch them for they are lousy and stink of German sausage.'

The crowd then formed in procession and went to Dr Schott's house. Dr Schott appeared at the window with Professor Atkin, and there were cries for a speech. Dr Schott pointed out that he was a British subject and a voice from the mob replied, 'we have come to give you a cheer.' Dr Schott added he was born and bred in England – at which point one wit shouted 'Made in Germany' – and had the same feeling respecting the war as the crowd. Cheers were given for Dr Schott, the British National Anthem and *Rule Britannia* were sang, and the crowd moved to the Belle Vue and Queen's Hotels, where, unsurprisingly, there were now no Germans. Next, the crowd went along Terrace Road, cheering Mr Jack Levenson in passing, into Cambrian Street, to Miss Felix the greengrocer's shop at No. 43 where they asked for the production of a German thought to be in the house, a chef at the Belle Vue. A young man stepped forward and said, 'Ladies and gentlemen—the German has gone to the police station. Go there and get him out.' Not wanting to miss a sales opportunity he added, 'If you want any cabbages you can have them here.' The crowd were not interested in cabbages and moved off, but a portion rushed round the back, saying the German was getting out at the rear of the house. Someone subsequently told the crowd that the man, Gruft, was at the police station. The crowd then dispersed, in part distracted by the fainting of a territorial soldier who was taken into nearby Leamington House and shortly afterward recovered.

Reports in the local papers seem to reveal two driving forces behind the action of the mob. The national newspapers of the day fed the inhabitants of the town with a daily diet of atrocities being committed by German troops in Belgium. As intended, the papers provoked a sense of outrage that may have led to a feeling of collective impotence on the

part of townspeople too remote from the war to be able to intervene positively. This led to them venting their frustration on a few German citizens, many of whom had lived here for years.

Interestingly, the newspaper reports seem to reveal antagonism between the townspeople and the university. For many, the demonstration may also have represented a chance to have a dig at the university. The fact that typewritten notes appealing to workmen were distributed, that there were rumours of a counter demonstration by students, a student condemning their actions being assaulted for his condemnatory remark and also the absence of students from the Thursday meeting all suggest a tension between the town and gown, which may have further inflamed the mob.

The *Welsh Gazette* was unequivocal in laying the blame for the disturbance at the feet of the college authorities:

> As far as we can find, it was the circumstances attending his return and not so much anything against Dr Ethe personally that was the immediate cause of the outburst of feeling against Germans in the town. It is generally felt that Dr Ethe's return, whosoever was responsible for it, was inopportune.

The mob held another meeting the following Wednesday in front of the Town Hall to protest against the College Council continuing to employ Dr Ethe and called for his dismissal. Speeches were delivered from a cart by Dr Harries, Enoch Davies and others. Councillor T. J. Samuel put before the meeting a resolution: 'That this meeting of the inhabitants of Aberystwyth protest most strongly against having a German subject on the staff of the Welsh University College while Germany is at war with our country; and that the resolution be sent to the College Council and Governors for their reply'. Mr Enoch Davies addressed the crowd, saying that he was at the station when Dr Ethe arrived and was thunderstruck to notice the welcome accorded to the alien enemy by the principal and registrar. He could not help remonstrating with them as he considered every German an enemy. (Cheers.) Dr Harries said that Aberystwyth was establishing a home defence league (more cheers). Their doings had spread throughout the country, and their example was emulated in other places. (Even more cheers). The resolution was put to the meeting and carried unanimously with, yes, more cheering.

The Court of Governors acknowledged the resolution and explained that on hearing Dr and Mrs Ethe were returning, the principal understood there was anti-German feeling in town and chose to meet and warn them. It was not until the principal saw the paragraph in the newspapers the following morning that he understood his actions had been misinterpreted.

Dr Ethe and his wife had in fact driven to Llandrindod where they spent one night before driving down to stay with his wife's younger brother in Reading. His correspondence with J. H. Davies reveals that they met with a hearty welcome there. In subsequent letters, Ethe explained that he was moderately well off financially but that his money was tied up in German and Hungarian government stock. As a precaution, he requested that all correspondence to him at Reading be addressed to Mr J. W. Phillips.

Although this was the end of the uglier side of the proceedings, it was not the end of the affair. The college authorities were pressed to dismiss Dr Ethe, which they refused to do. He was unable to continue his teaching career and resigned in 1916 on condition of receiving his pension of £150 a year. Even though he had paid into the university's pension scheme since inception, there were many who then opposed his being given a pension.

The matter rumbled on and was even the subject of discussion in the House of Commons in November 1916. At the time, the pension of £150 may also have seemed inordinately generous to many. To put it into perspective, a new infantry recruit would earn just over £18 a year.

In the immediate aftermath of the protests, the local newspapers, sensing the mood of the town, did not condemn the actions of the mob. Subsequently, the harassment of an innocent seventy-year-old mildly eccentric academic who had spent more than half his life in the town was re-evaluated. Later, the following letter by Jack Edwards, a stationer and exponent of Esperanto, was published.

Cambrian News on 14 April 1916:

Sir,—When Dr. Ethe was driven from his home by an irresponsible crowd, without any interference on the part of our civil authorities, those who disapproved of such proceedings for obvious reasons had to remain silent. The silence has evidently been misconstrued by the promoters of mob law, who now pose as the true representatives of the town. Is it not time that the better element should make itself heard? I believe that there is still in our midst a large number who will refuse to adopt Hunism as their standard of morality and conduct. If what is best in the British character is to be thrown away in exchange for what is worst in that of the German, our stupendous sacrifice of blood and treasure will have been worse than thrown away... – I am, etc., JACK EDWARDS.

After being forced out of Aberystwyth, Dr Ethe subsequently went to live in Reading and later Bristol. The matter was finally resolved once and for all when he passed away on 7 June 1917 in Bristol, leaving an estate of £1,530.

CHAPTER 3

BILLETING SOLDIERS

The outbreak of war put a stop to what had promised to be another bumper summer for Aberystwyth. In order to offset the poor summer for guest house owners and the town in general the Town Council and Corporation negotiated with the War Office to have troops billeted in the town over the winter of 1914–15.

On 7 November 1914, a public meeting was arranged in the Town Hall 'for the purpose of considering the proposed billeting of many thousands of troops in the Town at an early date and of appointing a Committee of Householders to confer with the Town Council should occasion arise.'

Mayor D. C. Roberts reported on a meeting that he and the town clerk had attended in Chester. There they learned it was almost certain one of the Welsh Territorial Divisions would be billeted at Aberystwyth. No date was fixed, but the town would need to be ready to provide billets at two- or three-day notice. The chief constable was proceeding with a

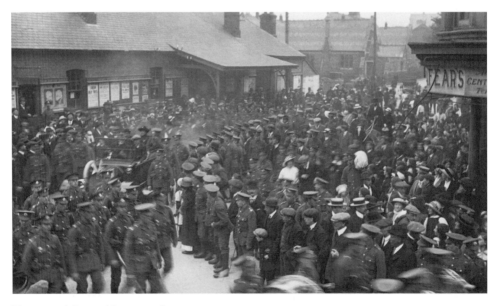

Troops arriving at Aberystwyth.

census of the accommodation available in the borough. It was expected that in the first instance about 5,000 troops would be sent to the town.

The War Office had formulated allowances for billeting, including lodgings and food, as follows: up to 5,000 troops three shillings and four and a halfpence (17p) per head per day. If the number in the town exceeded 10,000 troops, this dropped to three shillings per day (15p). Should the number exceed 15,000, then economies of scale dictated only two shillings and three pence (11p). Food had to be good, sufficient and wholesome, as laid down in the second schedule of the Army Act and provided for three meals a day as follows:

Breakfast: six ounces of bread, one pint of tea with milk and sugar and four ounces of bacon.

Hot dinner: One pound of meat previous to being dressed, eight ounces of bread, eight ounces of potatoes or other vegetables and one pint of beer or mineral water of equal value (the decision to offer beer or mineral water was at the discretion of the householder, not the soldier).

Supper: six ounces of bread, one pint of tea with milk and sugar and two ounces of cheese.

In addition to their board and lodging, the troops were to receive a shilling (5p) per day pocket money.[1] As regards accommodation, each soldier was to have a separate bed and provided 600 cubic feet were provided per man more than one bed could be put in a room. Where possible, officers were to be housed in the same section as their battalions.

The idea was greeted with mixed feelings. Unexpected obstacles were placed in the way of the authorities by a number of householders who, in the words of the *Cambrian News*,

> though it was a matter of life and death to the town and though the billeting of troops was intended for the general benefit of the ratepayers, showed disinclination to take the slightest trouble to fall in with the arrangements.

Initially, there was much reticence on the part of lodging-house keepers at the thought of *troops* lodging with them. Many women who took in visitors in summer would only take one or two 'if forced', and at one time, it seemed as if arrangements for billeting at Aberystwyth would fall through. It was apparently only the persistence of the Colonel concerned, the chief constable and the Town Council, where necessary threatening use of compulsory powers, that overcame the difficulties. Once it became fact that troops were coming, the shops had a busy time and large quantities of groceries were bought. Owing to the war, there had already been an increase in food prices, leading to complaints that the poorer parts of town such as Trefechan and Penparcau were being unfairly penalised, as they too had to pay the higher prices for necessities but did not benefit from having soldiers billeted with them.

On Wednesday 9 December, the first 500 troops arrived by train at 2.30 p.m. All from the Cheshire Brigade, they marched in their khaki uniforms to billets in South Road, Eastgate, Portland Street, Great Darkgate Street and South Marine Terrace. More trains arrived at twenty-minute intervals until five o'clock, bringing a further 1,500 men. It was reported that the troops quickly made themselves comfortable, and after a wash and brush-up paraded the streets of the town making new friends. The promenade, beach and the streets were described as lively as in the height of the season. The next day, to the disappointment of the tradesmen of Newtown, it was the turn of the Reserve Battalion of the 7th Royal Welsh Fusiliers, complete with goat. This battalion comprised men from the counties of Merionethshire and Montgomeryshire and had previously been in Newtown Barracks. Their billets were on

Troops and their landlady, Marine Terrace. The chalk on the right of the door shows how many men are to be accommodated in the property.

Marine Terrace. On the Friday, it was the turn of the Welsh Border Brigade. This comprised the 1st Battalion Hereford Regiment, with the 1st and 3rd Monmouth battalions totalling 1,850 men. Their billet districts were Marine Terrace and the Queens Road area, respectively. Saturday witnessed the arrival of smaller units of Glamorgan Fortress Engineers, Royal Army Medical Corps (RAMC) and Army Service Corps. In total, the number of troops, including these units, totalled 179 officers and 7,055 men. This number was expected to rise as more men were drafted in, though some would leave after their training was complete. The RAMC totalled about 250 men, who were billeted in the Brynymor area.

The committee of the Liberal Club allowed the troops to use the club's premises in St James's Square. Apart from the Liberal Club, the troops were given the run of the skating rink at the junction of Portland Road and Queen's Square, while the local cinemas were always happy to relieve them of part of their pocket money. Numerous reading rooms were set up for them in vestries and halls. Just in case the soldiers enjoyed themselves too much, all public houses were ordered to stop serving between the hours of 9 p.m. and 9 a.m. One pub was later placed out of bounds for disobeying this rule.

Following Sunday service, the troops were free to explore. Naturally, Constitution Hill proved a popular walk. Just to prove that there is always one, a soldier from the Cheshires attempted to climb the cliff, lost his footing, fell and ended up in the infirmary for treatment. Just to prove that the health and safety culture is not a new phenomenon, one councillor had observed some of the troops being taken on boat trips and said as they knew nothing of the sea, they might capsize the boats by suddenly going on one side. He therefore proposed that a boating inspector should be at once appointed. No further action was taken. There were no reports of troops drowning. At the same meeting, another councillor felt it only fair to warn townspeople that there were sentries about the town with fixed bayonets at night and that it was best to answer any challenge from the sentries. There were no reports of townspeople being bayoneted.

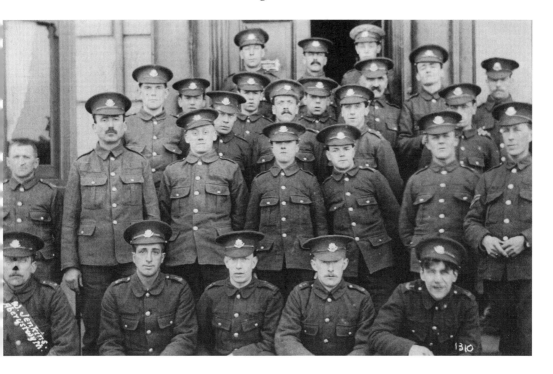

Above: Cheshire Territorials outside their billet.

Right: Lambs to the slaughter. Two Herefordshire Territorials.

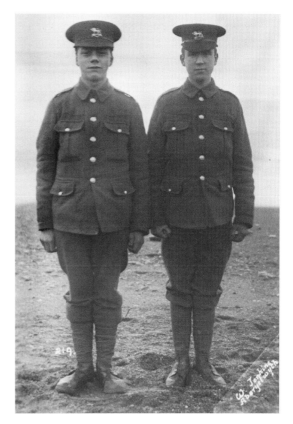

Usually, the men did not parade before nine o'clock, when each company paraded in its own billeting district and afterwards marched to the promenade where the length of the Terrace was used for drill. At twelve o'clock, the men were dismissed for dinner, falling in again at 2.30. In the first weeks, the work of the day was over between four and five o'clock. Full training did not commence for some time, owing to a shortage of equipment.

All did not always go swimmingly. Townspeople complained of the troops' habit of spitting, not always confined to outdoors. In addition, many of the soldiers complained that most of the young ladies in the town refused to talk to them. One soldier complained about the behaviour of many of the townspeople towards them, pointing out that many soldiers were married men and most others were too fond of their families to disgrace themselves. He pointed the finger of blame at ministers who he felt were making them out to be undesirables and warning their congregations to give them a wide berth.

The focus for entertainment was the skating Rink in Portland Street in which a Young Men's Christian Association (YMCA) was established. It also doubled as a concert hall. Between the university, the Theological College, the town and the troops themselves, there was a diverse array of talent available to provide both entertainment and education.

At its peak, some three thousand soldiers a day were visiting the rink and two thousand letters a day written in the YMCA rooms where stationery was made available. Entertainment was often arranged by the men themselves. On their first Saturday in Aberystwyth, the Northwich companies of the 5th Cheshire gave a hastily arranged concert. Private V. Robinson of 'C' Company opened the concert with a piano performance. Private G. W. Moore (a renowned Northwich entertainer) sang 'The Railway Porter' and recited 'How I saved the Express'. Sergeant Gledhill (from Chester) sang 'Drake goes West' and 'Up from Somerset'. Sergeants Gledhill and Roberts sang a duet. Privates G. W. Moore and J. Hitchen each sang a comic song. The second half of the programme was opened by Private V. Robinson, again on the piano. Sergeant Gledhill sang 'The Trumpeter'. Sergeant Roberts then sang 'Sweet and

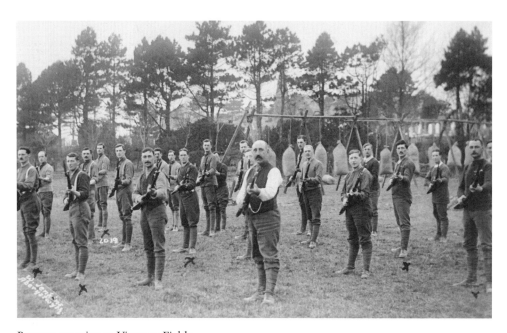

Bayonet practice on Vicarage Fields.

Low'. Private G. W. Moore also sang, and Private J. Hitchen recited. The concert was hailed as a great success.

Christmas 1914 was considerably livelier than usual. Each unit attended religious services in the morning, a logistical nightmare even allowing for all Aberystwyth's churches and chapels. Many troops had Christmas dinner with their host families. Numerous games of soccer were arranged and charabanc trips organised. For the first time ever, boatmen organised boat trips on Christmas Day. In the evening, various concerts were arranged. Boxing Day continued in the same vein.

Shortly after the festivities had been completed, householders received a communication from Western Command stating that from 15 January the daily allowance for troops was to be reduce.A public meeting was held, and despite dissatisfaction being expressed, it was felt that there was no option but to accept as there were still many seaside resorts desperate to have billeted troops placed with them. This reduction was later rescinded, but not until many of the troops had left.

With so many troops in the town, a committee of the Town Council made arrangements to hire the Pier Pavilion at a rental of £8 10 shillings a week until 12 May so long as there were no fewer than 6,000 troops billeted in Aberystwyth. During that period, the pavilion was placed at the disposal of the military authorities for the recreation of the troops, or for military purposes, free of rent, subject to certain conditions such as the military authorities being responsible for any damage done to the premises other than wear and tear. Sacred concerts were held every Sunday evening.

Soldiers were admitted at a charge of two pence each. As the taking over of the pavilion meant a heavy financial undertaking, the council appealed to the townspeople to also give their support. The proceeds of the concerts were used to reduce the rent and the cost of lighting.

Mrs Rowe and members of 'E' Company, 7th Cheshires. The shop behind is now Chives Sandwich Bar.

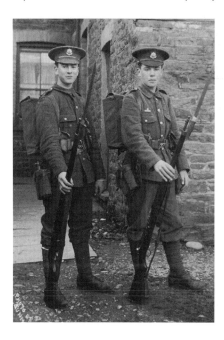

Privates Melling and Howard photographed in the backyard of their billet in South Marine Terrace. Howard (right) is wearing the Imperial Service Badge on his right breast, indicating his willingness to serve overseas.

Throughout January, February and March, there were arrivals and departures of troops. In early January, 300 men from the 4th Cheshire volunteered for active service and left by train to join the 1st Cheshire Battalion. In mid-March, 150 recruits for the RAMC arrived along with eighty for 6th Battalion RWF. In early April, the 6th Cheshire Battalion (formed in Stockport seven months before) received another 160 recruits from their home town. By late January, there were 9,000 troops in the town, slightly more than the pre-war population of Aberystwyth. This enormous increase impacted on prices with milk, meat and bread seeing noticeable inflation. One enterprising landlady found that rather than paying five shillings and sixpence for a hundredweight sack of potatoes locally, she could order them from Cheshire at a price of three shillings and four pence, carriage paid.

In January, the 1st Monmouthshire was kept busy with a route march to Ynyslas via Talybont, apparently the longest route march attempted by a Territorial Battalion. Refreshments were laid on in Talybont and Borth. The troops were given a half-day holiday the following day in order to fully recover. In early February, they marched to Llanon and back, a distance of twenty-two miles. The following week they marched to Aberaeron, and caught the train to Lampeter where they spent two nights before marching back via Tregaron. This was in part a recruiting drive.

The town was saddened to see the 1st and 3rd Monmouthshire battalions leave in February for Cambridge. In particular, their brass band, led by Bandmaster Valentine, had been a popular feature at evening concerts and in heading the daily marching.

The departure of the 3rd Monmouthshire was regarded as very impressive. The men assembled in the early morning darkness outside the Town Hall, the only light being from officer's flashlights as they got their men in order. While waiting for their commanding officer, they sang 'Jesu Lover of My Soul' to the tune of Joseph Parry's 'Aberystwyth'. As they marched to the station carrying kit bags and rifles, the band played 'Men of Harlec'h, while the crowd gave them an enthusiastic and patriotic send-off. Being asked repeatedly by the watching crowd 'Are we downhearted?' (a catchphrase of the time), they answered 'no' enthusiastically. The men left by six special trains scheduled to leave at half-hour intervals.

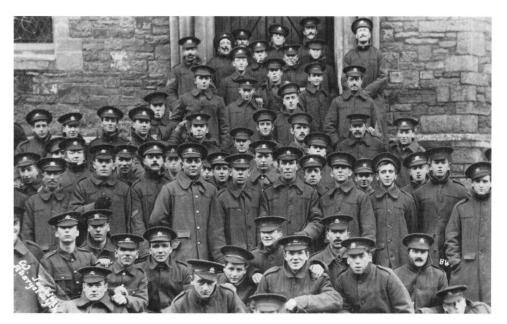

Troops on the steps of the Queen's Road English Wesleyan Methodist Chapel.

On 8 May, three Monmouthshire battalions were in action at Frezenberg Ridge during the second battle of Ypres. Becoming isolated and facing a far-larger attacking force, the three Monmouthshire battalions were almost annihilated. The remaining troops were later amalgamated into just one battalion of 900 men. The 1st and 3rd battalions were able to contribute only 300 able-bodied men between them. Those who left Aberystwyth would go on to form the reconstituted 1st and 3rd battalions.

The departure of so many men led to a reshuffling of accommodation for those remaining. This led to complaints that the seafront properties were being prioritised and that the likes of Cambrian Street, Union Street, Terrace Road, High Street, Bridge Street and Trefechan were merely used as 'storage' for troops until houses on the promenade became available, even though most men preferred to be in a family home rather than in a boarding establishment. Following the departure of so many troops, it was necessary to send an officer to Aberystwyth to investigate claims for damage to furniture, some of which approached £100 in amount. It seems there was rough usage in some of the billets and a great deal of damage done. In others, the authorities declined the claims.

Early March also saw the departure of 300 men of the 5th RWF, but only to go on a recruitment tour of Flintshire. They returned a few weeks later, their ranks swelled to nearly 800 men.

For the 7th Battalion, RWF all the drills and practice obviously paid off when they paraded for inspection at Plascrug Avenue in early March by Lieutenant General Sir Reginald Pole-Carew, KCB, CVO, inspector general of Territorial Forces. Men were praised for their smart appearance, though much of the credit was given to the officers. The bugle band received much praise and was said to be the best he had seen or heard. Route marches were also back on the agenda, this time the 4th, 6th and 7th Cheshires marching through Llanrhystud and Llanilar.

St David's Day was enthusiastically celebrated. The Herefordshire Regiment organised an athletics meeting on the Vicarage Fields while there was what can best be described as

an impromptu eisteddfod in the evening. The concert hall and platform at the skating rink were decorated with leeks and flags. The chief constable (Mr Edward Williams) presided over the large, enthusiastic gathering. Adjudication was by Councillor J. Barclay Jenkins (literary) and Mr D. W. Bundred of the Theological College (music). Prizes were given for best open solo, comic song, an essay on 'Why I enlisted' and 'A letter home' (both these last two were won by Wilfred Hyde of the Army Service Corps), while the prize for a love letter went to Sapper G. Owen: one can only imagine the hoots, catcalls and cheers when entries in this category were read out. The remainder of the items were completed at an adjourned meeting on Wednesday evening. All the prizes were given by Mayor Edwin Morris.

Whereas as many of the troops complained that the local girls ignored them, Private J. E. Colley, a military policeman with the Herefordshire Regiment, had no reason to complain. He and Miss Sarah Oliver from Peckham House, Union Street, were married at Bethel Chapel on 7 April.

Apart from their departure, the last large-scale display of pageantry by the troops occurred in mid-April on the Vicarage fields in front of a large crowd and at the request of the Royal Humane Society. The occasion was the presentation of the Society's awards to Second Lieutenant E. S. Price, of the Cheshire Brigade Army Service Corps (described as a capable swimmer); Lance Corporal Bryn Evans, Welsh Field Ambulance, from Ebbw Vale and billeted at Gwen-y-don, Cliff Terrace; Corporal Mervyn Griffith, of the University OTCs, elder son of Mr and Mrs Griffith, Waterloo Hotel and Driver Jack Westwood, from Bromyard, also in the Army Service Corps. The awards were made in recognition of their gallant attempt to rescue a boy who got into difficulties and was drowned in the sea on Saturday 6 February. He was walking along the pebble beach in front of the Queen's Hotel when he was caught by a heavy wave and carried out to sea. His plight caught the attention of territorials on the promenade at the time, and the men named made brave efforts to rescue him even though the waves were eight to ten feet high and breaking with tremendous force. The combination of a strong backwash, a sloping shore and loose pebbles gave no foothold, and it being so dangerous, their attempts to save the boy's life had to be abandoned. The Royal Humane Society had requested that the awards should be presented in as public a manner as possible. The ceremony was therefore arranged to give

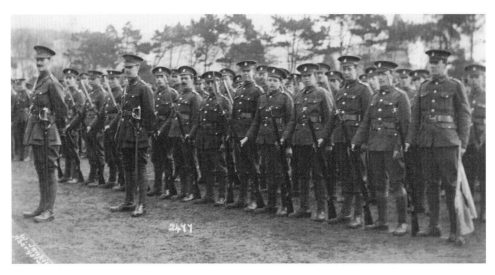

No. 13 platoon standing easy on Parade Ground, 13 April 1915.

the townspeople a last chance of seeing the spectacle of the troops massed together. Headed by their respective bands, they took their places forming up in three sides of a square. The awards were presented by Brigadier General R. B. Mainwaring, CMG, commanding the division, accompanied by numerous other senior officers, the Mayor, Town Clerk and councillors. The Brigadier General, before making the presentation, addressed the troops. His subject was the importance of the good conduct and long service medals. He went on to explain that the Victoria Cross is won in a few minutes when it is either death or the Cross, but the good conduct medal takes twenty years. He then presented the Royal Humane Society medals and Vellum Certificates, explaining the thoroughness with which the Society researched this incident and praised the bravery of the men involved. The Brigadier General then shook hands with each and congratulated them on their gallantry. This concluding the ceremony, the Brigadier General called for three cheers for the King and said they were also cheering every soldier in his Majesty's mighty army, the soldiers of England, Ireland, Scotland, Wales, Canada, India, Australia, New Zealand, South Africa, West Africa, West Indies, Egypt and everywhere the British flag flies for liberty.

Most of the remaining troops left Aberystwyth in late April to be accommodated elsewhere in tents. The Town Council had wanted to arrange entertainment before their departure but as such short notice was given, the soldiers had to settle for a gift of a packet of cigarettes each, in total 50,000 cigarettes. By the 29 April, the only battalion left were the newly arrived third-line 6th Cheshire.

For many householders, it was now the time to prepare for the hoped for arrival of the holiday hordes in newly refurbished rooms, for which householders could claim an allowance of one pound, three shillings and seven pence half-penny (£1.53p) per room from the War Office.

Now the sole unit remaining in Aberystwyth, the 6th Cheshire Regiment was among the last to arrive. In June, they undertook a discipline march. This was not a punishment but an eighteen-mile march at night-time on which no verbal commands were to be issued, all communication being by signals, the intention being to test their map-reading, marching powers and discipline. They arrived back in Aberystwyth at 4.30 a.m., still refraining from using their vocal chords for the sake of their hosts. With rumours of the impending departure of the remaining troops, the now-recovered 6th Cheshire were invited to a social evening by their billet-holders at the Pier Pavilion. As departure loomed, similar smaller events were held in many vestries and halls.

The 6th Cheshire were to stay in Aberystwyth until 20 July when they left for Oswestry.

Souvenir postcard produced for the 3rd–6th Cheshires.

CHAPTER 4

THE ROYAL NAVAL RESERVE

The Royal Naval Reserve was established in 1859 to provide a reserve of professional seamen for the Royal Navy from the fishing fleet and the Merchant Navy in times of war. Reservists were expected to spend a month a year in training.

The register of Naval Reservists in the County of Cardigan (Aberystwyth District) for August 1914 lists forty-four men. Many of these reservists were boatmen on the promenade during the summer months. Such was the demand for their services rowing visitors around the bay that many of them gave up lucrative work on merchant vessels for the summer months to be back in Aberystwyth. One such reservist was Evan James Davies who joined the Royal Naval Reserve (RNR) on 10 November 1910, aged 20. In the years prior to 1914, he had served on a number of merchant vessels including the transatlantic liners *Lusitania* and *Mauretania*. By the time war broke out, he had visited New York, Callao and ports in the Mediterranean. Identifiable by a tattoo of clasped hands and a Union Jack on his right forearm, he was mobilised with other local reservists in August 1914. He was eventually discharged on 4 February 1919.

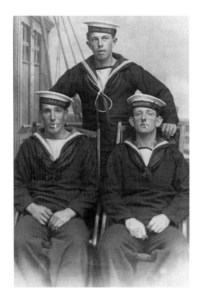

Three RNR reservists who served on HMS *Jupiter*).
From left: Evan James Davies, Thomas Owen Jones and William John Roberts. (Courtesy H Spencer Lloyd.)

Orders for mobilisation of the Aberystwyth RNR came by telegram on Sunday morning, 2 August, two days before the declaration of war. Posters were displayed in prominent locations, and before evening thirty-seven local men, all those available, were ready to leave by train for Devonport. The only exceptions were those men already at sea. The men assembled in front of the government offices at 30, Pier Street for an official send-off by the Town Council. Having been drawn up by Quartermaster Mortimer, Alderman D. C. Roberts (the mayor) made a short address. He was sure that they would conduct themselves like men, remembering that their friends at home in Aberystwyth would think much of them and watch their movements with interest. Quartermaster Mortimer, on behalf of the local detachment, thanked the mayor for his kind remarks and the members of the council for their attendance. With the town band at their head, the thirty-seven marched down the promenade and through Terrace Road to the station. Visitors and townspeople assembled in increasing numbers, and the crowd at the station reportedly numbered several thousands, bursting into '*Rule Britannia*', waving flags and cheering as the train departed. At the time Frank Smith was an observant twelve year old on holiday in Aberystwyth with his parents. As the train departed, the crowd dispersed, and the euphoria ebbed away, he couldn't help but notice some women lingering on the platform, crying.

Jenkin Davies, from Aberystwyth but a member of the Swansea RNR, was probably the first local reservist to taste action. On Sunday 4 October, he was in the naval brigade attempting to assist in lifting the siege of Antwerp. They spent two days and three nights in the trenches until ordered to retreat. During their retreat, German spies dressed as Belgian soldiers attempted to lure them away, but the ruse was discovered and the retreat was completed satisfactorily.

Initially, most of the Aberystwyth reservists were allocated to two vessels but became scattered as the war dragged on. The vessels on which most of the Aberystwyth contingent found themselves were two battleships from the pre-Dreadnought era – HMS *Caesar* and HMS *Jupiter*.

The Epic Voyage of the *Jupiter*

This has been the subject of much research by Huw Spencer Lloyd who has identified the local men who sailed on her in 1915. Fortunately, there also exists a diary kept by an unidentified crew member. This is now in the Royal Naval Museum, Portsmouth, and is the source for much of the information in the following account.

By January 1915, HMS *Jupiter* was serving as a guard ship at North Shields on the mouth of the River Tyne. On 5 February, she was given orders to proceed to the White Sea to replace an icebreaker that had broken down. Her role was to keep open the route to Archangel for the supply of munitions to the Russian Army. The order to depart was given in haste, and such was the urgency of her mission that there was no time to arrange for extra winter clothing for the crew of over 600 men or make additional arrangements for heating the ship. After tremendous efforts to get through the ice, she arrived at Alexandrovsk, now known as Poljarnyj.

The fifteen local reservists who served on *Jupiter* are as follows:
Evan James Davies, Vulcan Street.
Jenkin Davies, Skinner Street.
James T. Edwards, 1 Beehive Terrace.

T. J. Griffiths, originally from Cilgerran.
William D. James, Portland Road.
David Thomas Jenkins, 7 Crynfryn Row.
Richard Arfon Jones, 24 South Road.
Richard Jones, South Road.
Thomas Owen Jones, 8 Glanyrafon Terrace.
James Lewis Pugh, 5 Glanyrafon Terrace.
Jimmy Pugh, Portland Road.
William J. Roberts, Eastgate.
Willie Shewring, Aubury House, Queens Road.
John Warrington, Portland Road.
Benjamin White, Thespian Street.

HMS *Jupiter* was a majestic-class battleship launched in 1897 and assigned to the channel fleet until 1905. *Jupiter* had a speed of 16 knots (around 18 mph) and only four twelve-inch guns. By 1908, she had been rendered obsolete by the emergence of the dreadnought-class battleships. Two years later, the invincible-class battle cruiser, with its maximum speed of 25 knots, had rendered her even more obsolete. Perhaps more relevant to her officers and crew was her inability to compete against the new generation of faster, bigger and better armed vessels of the Imperial German Navy. Although these were still not quite up to the level of the newer British battleships, they were more than a match for the likes of HMS *Jupiter*. She therefore became a reserve with the Home Fleet. By 1913, *Jupiter* was based jointly at Pembroke Dock and Devonport. It was to the latter that Class A of the local RNR had been ordered to report in the summer of 1914.

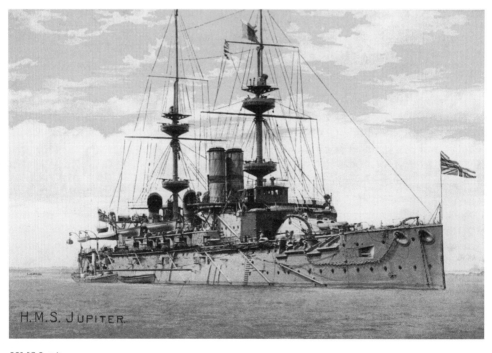

HMS Jupiter.

On Thursday 4 February 1915, HMS *Jupiter* was guarding the mouth of the River Tyne. That afternoon, the crew were given notice that they were to set forth to an unknown destination. The ship sailed at 6 a.m. the next morning. After 'Divisions and Prayers', the crew were informed they were proceeding to Archangel in northern Russia. As this meant passing through enemy lines, the crew were exhorted to be alert and to 'keep their eyes skinned'. As mentioned earlier, HMS *Jupiter* was an old vessel, slow and on this occasion undermanned. Had she encountered an enemy vessel, she would have been at a considerable disadvantage. It was further explained to the crew that due to the urgency of her departure, the ship had not been provisioned or prepared as well as she should. The crew were urged to make the best of it as there was no time for delay, and they were required to proceed at once. Their mission was in the interest of Britain and her allies, especially the Russian Government, and the captain was sure that this would one day be recognised (it was). He went on to assure them that although they were leaving the war zone, they would have plenty of experiences. Again, he was to be proved correct.

The first test of the crew's mettle came that afternoon when the pressure in the ship's barometer started to drop suddenly, a sure portent of a storm. Sure enough, within hours, HMS *Jupiter* was being tossed around like a cork on the ocean. Though in the midst of a severe gale (the ship's log records 8–9 on the Beaufort Scale), a full lookout had to be kept at all times for enemy vessels, all guns were cleared for action stations, and all gun ports kept open. The result was that she took in a lot of water, flooding many compartments. At midday the following day, she was struck by a monster wave that stove in one of her lifeboats and washed another overboard. In addition, one of the gun ports towards the bow of the vessel was carried away, leaving a gaping hole for more water to enter. By 7.30 a.m. the next morning, after a sleepless night, the damage had been rectified and water baled out. No decent breakfast, as seawater had extinguished most of the galley fires, crockery was broken, and their bread was floating about the mess decks. Breakfast was to be ship's biscuits and anything that could be found for a drink. Lunch was little better, with corned beef added to the biscuits. The interval between the two meals was spent baling water out of the flooded compartments. By evening, the weather ameliorated, though the ship was still rolling heavily and accidents were caused by doors of the casemates opening and closing as the ship rolled and lurched. (A casemate is an armoured room in the side of a warship, from which a gun fires.) By Sunday morning, the weather had cleared up, and the crew were able to dry clothing and bedding. Sunday service was held for the crew to give thanks that nothing worse had befallen them. They journeyed north throughout Sunday, and by evening, the air had a distinct chill and flurries of snow started to appear. By midday on Monday, HMS *Jupiter* was thought to be out of danger from enemy ships. This gave the gun crews some respite, though watch still had to be kept for mines and other hazards. The weather grew colder, and in the evening, the Vido Island lighthouse (probably present-day Værøy) was spotted to the south-east. That same evening, the Northern Lights were visible for the first time on the voyage. The next morning, dawn revealed a panorama of snow-clad mountains bathed in a wintry morning sun and a flat calm sea. The next day was noteworthy for the clarity of the seawater that allowed the ram on the bows of the ship, twenty feet below the waterline, to be seen clearly. Lookouts were posted to keep an eye out for floating ice, and that evening, North Cape Rock was sighted. At this point, the ship altered her course and headed south-east. By now, the intensity of the cold was evident and the crew grateful for their warm clothing, much of which they had received from relatives at home mindful that their kin were likely to be patrolling the North Sea. The following day a breeze sprang up, followed by a blizzard. This was the first of many days to come in

which the thermometer did not rise above freezing. Searchlights were used to keep an eye out for ice floes, and their radio repaired. On 12 February, a week after leaving the Tyne, *Jupiter* started encountering ice floes. By late afternoon, she was wedged amongst the ice. The crew were on the verge of using explosives to release her when she managed to break free and was able to proceed slowly. The searchlights were kept on at night, providing the crew with an exquisite light show as the light was refracted through and off the ice. By now, the temperature was a cool –23°C. Slow progress was made as the engines strained to break through three and four feet of ice. The constant ramming and pressure from the ice soon caused some of the plates in the bow to buckle and eventually resemble a concertina. These had to be strengthened on the inside by the carpenter and his crew. Eventually on 14th, *Jupiter* sighted another ship in the distance. This proved to be the Russian icebreaker *Canada*. The two vessels approached, and two Russian officers, including the captain, were transferred to *Jupiter* to act as pilots and guide her into port. It was decided that they should head for the port of Alexandrovsk as the approaches to Archangel had fifteen to twenty feet of ice and were impassable. *Jupiter* followed *Canada*, and shortly after they came across another vessel, the liner *Dvinsk*. *Canada* left to escort *Dvinsk* through the ice and did not rejoin *Jupiter* until late April. Good progress was made over the next few days with the occasional hiccup when *Jupiter* stuck fast in the ice. On one such occasion, the commander and chaplain took advantage and walked out on the ice in order to photograph the vessel. The ice became less dense, and by late afternoon on the 18th, both vessels were clear of the ice. Release from the ice revealed that a number of compartments were leaking and would require attention. By making as swift a passage as possible, they reached Alexandrovsk at 5 p.m. the next day. Despite the ice, the evening was relaxed, with dancing and other entertainment on deck until it was time to turn in. However, with temperatures of –10°C, these activities were designed to keep the participants warm rather than being a source of pleasure.

On, 21st, the entire starboard watch was given two-hour shore leave to explore Alexandrovsk. Thus, at 2 p.m. the jolly jack tars in duffle coats, seaboots and balaclavas

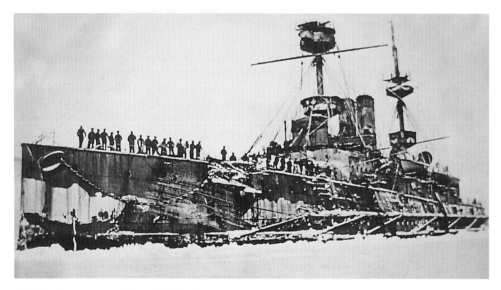

HMS Jupiter icebound in the White Sea.

(and any other garment that helped keep them warm) descended on Alexandrovsk. They found a hundred or so wooden houses, shops, a post office and a stone red-brick church with a green roof and gold domes. The shops had little to offer, being themselves reliant on the outside world for their stock. Plentiful supplies of furs were available, but these were of little interest. However, the sailors occupied themselves with learning to ski and walk in snowshoes. Despite the inherent risks in such winter sports, the sailors were more than happy to try and master these new skills, aided by a metre of snow to cushion their falls. The ship's log does not record any increase in the number of men in the sickbay after these visits suggesting all went well. The port watch had their turn the next day.

One surprise for the sailors was the presence of ten Englishmen, there since commencement of the war. They were there to install wireless telegraphy in the area and overland to Archangel. They specifically requested the attentions of the ships barber, nobody in the locality being deemed capable of cutting their hair.

One Aberystwyth sailor got to see a little too much of Alexandrovsk. Ben White was sent off with another sailor, a signaller and an officer to a land observation post above the town to keep a lookout for any likely enemy attack. Their only shelter in the sub-zero temperatures was a tent.

After a few relatively relaxing days, the crew were joined in harbour by the collier *Muirfield*. Coaling was a necessary but unpleasant chore, the coal usually covering the vessel and crew with a fine dust. It was a task undertaken by both officers and crew and universally detested. Bearing in mind the sub-zero temperatures, the crew probably found the prospect of hard strenuous labour more appealing than usual; at least it would keep them warm. The next day, coaling commenced at 6.15 a.m. and continued for twelve hours. The procedure, involving the handling of 1,481 tons of coal was completed the next morning. The remainder of that day, and the next, was taken up with the cleaning of the ship. On 27 February, *Jupiter* left port heading for Archangel. The next day, she fell in with the *Lintrose*, an icebreaker. The captain told his crew they were to attempt to rescue two ships stuck fast in ice. By now, it was evident the voyage would be far longer than the five or six weeks envisaged. Consequently, the crew were put on base rations, evidently insufficient for such a cold climate. For the next fortnight, *Jupiter* made slow progress through thick ice, the ship's log reading 'proceeded' and 'stopped, ship stuck in ice' alternating throughout each day. Frequently, explosives had to be used to free the ship. During the periods when the ship was stuck fast she was at the mercy of the currents and tides, which, on occasion, would move her back to where she had started from twenty-four hours before. On 8 March, the temperature dropped to -22°C. This was sufficient to freeze all the food supplies on the ship, whether in bottles, tins or any other container. Breath would immediately freeze on beards and moustaches, making smoking almost impossible. On one occasion, the men were allowed on the ice to stretch their legs and run around. On 14 March, they reached the last reported position of the first of the two stricken vessels, only to be told that the vessel had sunk without loss of life as the crew had been saved by icebreakers. By now, coal supplies aboard *Jupiter* were running low, and efforts were made to conserve as much as possible, including sending the crew out to collect snow for an hour each day for freshwater. Finally, at 2.47 p.m. on 15 March, they sighted a vessel stuck fast in the ice. This was *Thracia*, a 2,891-ton Cunard liner carrying military supplies believed to be aeroplanes and motor vehicles for the Russian government. Due to the nature of the cargo, it was important to get *Thracia* to port as soon as possible. She was in a poor state, with her propellers barely functioning and therefore unable to make headway through the ice. It had taken *Jupiter* three days to reach the stricken vessel though she was in sight

the whole time. There were now two choices. *Thracia* could be abandoned, and the cargo transferred to *Jupiter*. Alternatively, *Thracia* could be towed to Archangel. The first choice would have involved a lot of extra work and taken time, assuming space could be found for the cargo. Therefore, it was decided to try and tow the stricken vessel and her cargo to Archangel. Initially, *Jupiter* circled *Thracia* in an attempt to break up the ice around her. The first attempt at a tow lasted less than two hours before a four-and-a-half-inch-thick hawser parted from *Thracia*. This required *Jupiter* and *Thracia* to stop, while the hawser was attached before they could proceed. A number of hawsers were subsequently fitted to the *Thracia*, but the ships log over the next fourteen days records numerous occasions on which one of the hawsers parted or needed adjusting. The log entries below are for 16 March and give an indication of the conditions endured.

4.50 a.m.: Proceeded with *Thracia* in tow.
6.20 a.m.: 6½" wire hawser parted. Stopped.
7.37 a.m.: Proceeded.
9.30 a.m.: Port watch stowing cable.
10.28 a.m.: 6½" wire hawser stranded. Stopped.
11.00 a.m.: Proceeded.
11.25 a.m.: Stopped to equalize strain on hawsers.
11.38 a.m.: Proceeded.
1.36 p.m.: 5½" wire hawser stranded. Stopped.
3.08 p.m.: Proceeded.
4.45 p.m.: Stopped to adjust hawsers.
4.55 p.m.: Proceeded.
5.30 p.m.: 6½" hawser stranded. Stopped.
8.15 p.m.: Proceeded.
8.45 p.m.: Stopped. Ice very heavy.
9.20 p.m.: Lit fires in No. 8 boiler.
10.20 p.m.: Let fire die out in No. 2 boiler.

Add on the numerous stoppages due to the ice, and the journey must have seemed endless and frustrating for the crews of both ships.

The coal situation was remedied on 28 March when the icebreaker *Lintrose* came alongside with 300 tons of coal, all of which had to be loaded using only one derrick. *Lintrose* also brought two luxury items for the crew – potatoes and reindeer meat. Finally, at 2.30 p.m., *Thracia*'s tow was cast off for the final time in Archangel.

5 April found *Jupiter* stuck fast in ice. It was also Easter Monday and a chance for the crew to relax with impromptu sports being played on the ice. These included football, baseball and various races. The next day saw the thermometer briefly rise above freezing for the first time in nearly two months. The following day, *Lintrose* returned with more supplies and 304 tons of coal. The crew worked through the night to stow the provisions and coal the ship in order to proceed back to Alexandrovsk the next day. This was achieved in nine days, with the vessel frequently having to be freed from the ice either by the *Lintrose* or in a more entertaining and spectacular fashion with explosives. There were also opportunities for the 'hands to make and mend clothes' as well as gunnery practice for the gun crews in case of encountering enemy vessels on the return journey. In addition, the torpedo nets had to be unshipped and stowed away out of reach of the ice.

On arrival at Alexandrovsk, they were met by the store carrier *Rievaulx Abbey* with much-needed and very welcome provisions. Also in the hold of the *Rievaulx Abbey* were much longed-for letters from home. These were the first letters or news from home that the crew had received since leaving the mouth of the Tyne in early February. *Rievaulx Abbey* left a few days later, carrying mail from the crew. Before setting sail for home, the vessel needed to be painted, cleaned and refitted. Further training of the gun crews took place. A party of marines were sent ashore to dig trenches for telegraphic cables. Temperatures were only a few degrees above freezing, and the ground was still frozen solid, making this a back-breaking task. Orders were received to head back for England on 30 April. Before this could be contemplated, more coal would be required. This duly arrived aboard the *Muirfield,* so the crew were once more set to work coaling the vessel and cleaning her afterwards. Coaling usually involved manhandling two hundredweight bags of coal from the hoist to the bunkers and emptying them there. Finally on 1 May, with the temperature reaching a heady 8°C, *Jupiter* proceeded at 8.38 a.m., course and speed as requisite for leaving harbour. The crew left behind one reminder of their stay in the form of the ship's name painted on one of the cliffs overlooking the harbour.

The return journey was uneventful though collision drills, 'night defence station' and 'prepare for immediate action' exercises were held, and a close lookout kept for submarines. In addition, she frequently zigzagged to confuse any potential submarine threat. Finally, on 8 May, *Jupiter* entered Birkenhead, escorted by four destroyers. Her eventual destination was to be No. 7 dock of the Cammell Laird shipyard for a much-needed refit. Before the refit could commence, ammunition and stores had to be removed, Lyddite shells unfused, gear stowed, and the ship cleaned. Shore leave until 7 a.m. the following day was granted to the port watch and part of the starboard watch on 12 March. The following day it was the turn of the starboard watch and part of the port watch (again). No doubt alcohol was consumed on these occasions, and it can be surmised that not all the crew were at their optimum the following day. Finally, at 6 a.m. on 19 May, all hands were paid off. The following articles from local newspapers give an indication of the welcome received on their return.

From the Sea – On Wednesday afternoon a welcome was given by the townspeople to local boatmen, who are members of the Royal Naval Reserve, on their return home from active service on furlough for fourteen days. They have been away since they were mobilised at the beginning of August and have had exciting experiences on board the battleship "Jupiter" in the North Sea during the winter, particularly in breaking ice when convoying ships. Nevertheless, they looked healthy, strong, and jolly on their arrival. They were met on the station platform by the Mayor (Alderman Edwin Morris), the Town Clerk (Mr. A. J. Hughes), and members of the Town Council, with a large gathering of relatives and friends. The Mayor and councillors shook hands with the men and congratulated them on their safe return and splendid appearance. They were also cheered on emerging from the Station. It had been intended to arrange a procession, but the Cheshire band was not available as the battalion had gone on a route march. The men numbering fifteen arrived in two batches, a few of them preferring to stop on the way at Borth as they were too modest to undergo the ordeal of a public reception. (*Cambrian News* 21 May 1915)

Naval Reservists Entertained. The Silent Navy. There was an enjoyable gathering at the Waterloo Hotel on Tuesday evening when the mayor (Alderman Edwin Morris JP) entertained the Aberystwyth members of the Royal Naval Reserve who had been in town for the last

fortnight on furlough after ten months active service eon the Jupiter. Thirteen of the men were able to accept the mayor's kind invitation and did full justice to a sumptuous dinner. His worship was supported at the head of the table by Rev T A Penry, English Congregational Church, Captain T Doughton JP (captain of the local lifeboat) Lieutenant Pearce RNR (Officer in charge of the Cardigan Bay Coast) & others. The health of the king was enthusiastically received. His majesty's noble example was worthily emulated in this pleasant function. The refreshments were of a non-intoxicating character. (*Welsh Gazette* 3 June 1915)

As a result of their efforts in the White Sea, the tsar of Russia awarded medals to the officers and crew of HMS *Jupiter*, including the Aberystwyth contingent who each received the silver medal for zeal. By now, the Aberystwyth contingent who had served together on HMS *Jupiter* had been assigned to other vessels including HMS *Ascot, Edgar, Endymion, King Alfred, Mersey, Nepaulin, Sutlej, Valiant* and *Zago*. Their medals were presented to each of the crewmen by the captain of their new vessel in front of the assembled crew. It later emerged that each of the crew had also been promised a pension by the tsar. Unfortunately, the Russian revolution put paid to that.

T. O. Jones served next on HMS *Moldavia*, a P&O liner converted into an armed merchant cruiser, before being drafted to HMS *Nepaulin*, a 314-ton Glasgow paddle steamer pressed into service as a minesweeper in the English Channel. From 1 to 3 January, *Nepaulin* was one of a number of vessels that safely escorted the 5,686-ton steamer *Sussex* into port after she hit a mine off Calais. Later the same month, she was involved in rescuing ninety men from the *Port Nicholson*, which struck a mine fifteen miles west of Dunkerque. Unfortunately, *Nepaulin's* luck ran out on when she too hit a mine near the Dyck light vessel off the Dutch coast on 20 April 1917. Thomas Owen Jones was at the helm at the time of the explosion and was killed along with eighteen other crewmen. The family hairdressing business in North Parade retained the name *Nepaulin* until its recent closure.

HMS *Caesar*

Another contingent of Aberystwyth reservists served together on HMS *Caesar* for most of the war. After some initial excitement, they were stationed at Bermuda and had an uneventful but noisy few years.

HMS *Caesar* was similar to HMS *Jupiter*. Both were majestic-class battleships commissioned into the Royal Navy in the late 1890s. As mentioned earlier, *Jupiter* was older, slower and less well-armed than the newer vessels in both the Royal and Imperial German navies. HMS *Caesar* was no different. Her official log is now available online.

The official log records that 146 ratings joined HMS *Caesar* in various drafts during the afternoon and evening of 4 August. A full complement of crew for HMS *Caesar* was 670, but whether she sailed with a full complement is unclear. All crew and new ratings were put to work immediately, providing ready ammunition, demolishing cabins and all woodwork between decks, between the fore and after bridges as well as chart houses and landing the woodwork on shore. Coaling was undertaken, and 257 pounds of beef and 1,400 pounds of bread brought on board. The boilers were lit and the fires banked, enabling her to sail at four-hour notice. The crew were drilled in fire and collision drills, in night exercises and in darkening the ship.

On 8 August, after taking on yet more provisions, she commenced patrolling in the English Channel. On 27 August, she assisted with the defence of Ostend. Here some of the crew went on shore to assist the Marines of the Royal Naval Division. This was a

HMS Caesar, sister ship to *HMS Jupiter*.

brief exploit and lasted only four days. The next few months were spent patrolling in the Devonport–Plymouth–Falmouth area, probably with the intention of bringing the crew up to scratch as much as defending the coast. On 23 November, they left Devonport for Gibraltar, arriving on the 27th. She then commenced patrolling in the Straits of Gibraltar or the nearby Alboran Sea. *Caesar* was also used as a training vessel with large numbers of ratings from other vessels being brought on board for gunnery training. On 27 March, excitement beyond that exuded by gunnery practice was caused by the need to offer assistance to the *Trostburg*, which ran aground near Cape Spartel, Morocco, while carrying a cargo of coal from Cardiff to Gibraltar.

On 14 April 1915, she set sail on an uneventful voyage from Gibraltar to Malta and back. On 15 May, HMS *Caesar* was summoned from Gibraltar to assist other Royal Navy vessels. They were guarding a stranded British steamer ashore at Cruces Point, Almanta Bay, again in Morocco. This was the *Eburna*, belonging to the Anglo-Saxon Petroleum Company Ltd, sailing in ballast from Cette to New Orleans with a mixed crew of Chinese and European sailors. Two days previously, she had run aground in a fog. This had excited a considerable number of the natives, who were of the belief that the vessel was now theirs to plunder. The morning after running aground, one of the ship's boats, with two officers and two sailors, was captured by armed locals (referred to as Moors in the ship's log) and taken away. Later, more locals used the very same ship's boat and another boat of their own to board the steamer but were beaten off by the crew using the steam hose. Shots were fired at the steamer from the two boats. During the following morning, a small Royal Navy vessel, HMS *Richard Welford*, came up but was unable to give help as her boat, and a crew of seven were also captured by the natives, one man being killed and others wounded. The two European sailors of the *Eburna* were later exchanged for provisions and tobacco and rejoined their ship. A British torpedo boat now arrived on the scene, and the crew of the stranded steamer took refuge aboard her. It was now time for a spot of gunboat diplomacy, and HMS *Caesar* was duly summoned from Gibraltar to attend to

matters. On arrival, Marines duly boarded the *Eburna*. Lieutenant Smith and an interpreter were sent to negotiate with the natives, protected by the rifles of Marines in the *Eburna*. In the meantime, a steel hawser had been attached, and while negotiations were proceeding, the *Eburna* was floated off. As *Eburna* and her contingent of marines drifted off into the distance, Lieutenant Smith was devoid of the protection from their rifles, and he too was taken prisoner, along with the tobacco intended as an exchange for the other prisoners. The 'Moors' then attempted to move off the beach with their prisoners, but were persuaded otherwise by a salvo from the twelve pounders of HMS *Caesar*. Lieutenant Smith was released but made to swim back to his ship, the whole time being used as target practice. Fortunately, their aim was not good. After firing eleven rounds from her twelve-pounder guns, a picket boat, steam pinnace and a cutter were dispatched to rescue the prisoners. No further mention has come to light regarding the fate of the other prisoners, so it is assumed they were unharmed. On return to Gibraltar, each watch was given special leave in turn. The Royal Navy were eventually awarded £4,000 for salvaging *Eburna*. This would have been distributed amongst the crew.

The following month saw much activity on HMS *Caesar* as she prepared for a voyage across the Atlantic to Bermuda. She departed on 9 June and arrived on the 20th having covered in the region of 280 miles per day. Little did her crew know at this point that they would be away from home for another three years. Being that they were frequently at sea for long periods, they received scant information about the progress of the war. Consequently, the Comforts for Fighters Fund parcels that arrived sporadically, containing local newspapers, must have been a valuable source of information, as were the frequent visits from another Aberystwyth contingent – James Pugh, F. O. Jones, D. Jenkins, D. James, E. J. Davies, R. Jones, B. A. Jones, J. L. Pugh and R. Roberts. These Aber boys were serving on HMS *Berwick*. Her role was to escort convoys crossing the Atlantic and patrol for German raiders. Bermuda was a starting point for many of these convoys across the Atlantic. Merchant vessels would assemble at Bermuda before being formed into convoys and escorted across the Atlantic.

In contrast, HMS *Caesar* served as a training vessel with groups of ratings, often over a hundred embarking on a course of gunnery practice lasting in the region of three weeks. Extensive attention appears to have been given to non-swimmers, as 'non-swimmers under instruction' is a frequent entry in the log book. Most of the ratings were accommodated aboard HMS *Charybdis*, an even older battleship laid up in Bermuda after suffering collision damage in 1915.

In March 1916, *Caesar* was to venture to Halifax, Nova Scotia, for a refit. Frequent entries in the log refer to snow, something of an unpleasant jolt to sailors used to subtropical warmth. Excepting the gunnery practice, 1917 started quietly the main excitement being the stranding of the steamship *Prophet* on Stag Island. For those left on board, or who had returned from leave, 4 August saw a new entry in the log book – 'Hands to Bathe'. This was to be a frequent entry for the whole August. What sparked this sudden interest in the personal hygiene of the crew is not known. The entry appears less often from mid-September onwards. From October 1917, mention of receipt of mail becomes more frequent. Whether this is due to improved communications, or more detailed log-keeping, is not known; for example 19 November received three bags of mails. However, not all news received was to be good news. J. W. Davies of Borth probably learned of his brother Richard's funeral in this manner. His brother's ship was lost with all hands, probably after hitting a mine.

By now, Canadian troops were being used to guard Bermuda and even amongst these were men with Aberystwyth connections.

March saw the arrival in Bermuda of an old acquaintance in the form of *Eburna*. Two ratings were required to remove her deck gun. The log at this point contains increasing references to pairs of ratings being assigned to merchant vessels. Merchant vessels were increasingly being armed with mounted guns to provide protection against German U-boats.

In mid-March 1918, twenty-six ratings were transferred from HMS *Berwick*, and twenty-seven ratings transferred to the same vessel. This may have included four of the Aberystwyth sailors, as in April four of them – W. Brown, W. Wright, R. Parry and E. D. Lewis – were back in Aberystwyth for four weeks' leave, their first in more than three years.

July 1918 saw a little more excitement with a month long voyage to Hampton Roads and Chesapeake Bay. Here time was spent on gunnery, torpedo and seamanship classes. Having taken on 620 tons of coal, 12 soldiers, 2 military prisoners and suitable provisions of fresh meat, vegetables and bread HMS *Caesar* was ready for her next adventure. At 7.30 a.m. on September 1918, HMS *Caesar* weighed anchor and made for Murrays Anchorage off the north-west of Bermuda. After negotiating around the north coast of Bermuda to the accompaniment of swells from the east and south-east, she was heading into the Atlantic with Bermuda at her stern, disappearing over the horizon for the last time. Many of the Aberystwyth contingents had now been away from home for four years. They may not have faced the same dangers as those on the Western Front, or Palestine, but four years away from loved ones was something of an ordeal in itself.

Whether or not the crew knew their destination isn't clear, but they were not just going to sail across the Atlantic but also the Mediterranean. HMS *Caesar* was sailing to Corfu to become the new flagship for the senior naval officer of the British Adriatic Squadron to replace the aged HMS *Andromarche*.

Those who are known to have served on HMS *Caesar* are D. J. Evans, J. W. Davies (Borth), Ernie Davies, Albert E. Davies, William J. Davies, F. G. Evans (discharged in February 1915 due to ill health), Richard Parry, William S. Davies, David Hughes, E. D. Lewis, W. R. Jenkins, M. D. Parry, David Davies, John Daniel, David Edwards, W. Wright, W. Brown, J. J. Davies (Borth) and Sam Evans (Llanilar).

Aboard HMS *Challenger*, two other Aberystwyth reservists were experiencing different adventures. Evan Daniel and Llew Williams both were part of the thirty-seven-strong contingent who left Aberystwyth in August. By 7 September 1914, they were aboard the light cruiser HMS *Challenger*, rendezvousing with *Appam* off Las Palmas. *Appam*, a two-year-old passenger liner owned by the British & African Steam Navigation Company, was to be the depot ship and hospital for the joint British and French expeditionary force sent to capture the German colony of Kamerun (Cameroon today) in West Africa.

Nine days later, *Challenger* was at Lome in Togo and after a stop at Lagos was anchored off the Cameroon Estuary on 23 September in company with six transport ships containing the British contingent of the expeditionary force. The captain's instructions were to find a safe passage over the outer bar of the Wouri Estuary for *Challenger* and anchor 5,000 yards or so off the port of Duala, the colony's largest settlement and the commercial and administrative hub situated a few miles upriver. In anticipation of this, the German defenders had sunk six ships to block the entrance to the Estuary and were believed to have mined the river.

The main task for the captain was to navigate *Challenger* over the bar that had twenty feet depth of water at high tide. *Challenger* was drawing eighteen inches more than this. Consequently, the crew, including Messrs Daniel and Williams, were immediately set to work lightening the vessel. This they succeeded in doing. Two days later with a draft

of nineteen feet seven inches, *Challenger* gingerly made her way up the river, briefly touching bottom. She then proceeded towards Duala, with orders not to fire unless fired upon. The threat of a light cruiser with her guns aimed firmly at the town was enough to induce the Germans to surrender two days later. Before surrendering, they blew up their magazine and wireless station. The crew of the *Challenger* were then engaged in boarding ships belonging to the Woermann Line, while Messrs Daniel and Williams were engaged in transferring six-inch guns into lighters. Evan Daniel then spent thirteen weeks onshore in the Cameroons as one of a gun crew, probably as one of the fifty men from *Challenger* delegated to garrison nearby Bonaberi. In September 1917, he was back in Aberystwyth. Also engaged in the Cameroons campaign was third engineer Albert Lloyd from Queen Street who was involved in coaling the Royal Navy vessels involved. He wrote to Jackie, father of Llew Williams, telling him that he had met Llew in October (1914), and they had time to exchange a few words in Welsh that both were well and hoped to be home for Christmas.

Stoker William Shewring later served on HMS *Wallflower* and was involved in the hunt for submarine *U-32* while serving in Malta. After two days of cat and mouse, *Wallflower* was able to shell and then depth charge the submarine north-east of Malta.

James Silcock and Dick Brodigan both were sent to serve on HMS *Aurora* and were in action at Dogger Bank in January 1915. James Silcock was later transferred to HMS *Macedonia*, an armed cruiser employed in patrolling the South Atlantic. The vessel played a minor part in the rescue of Ernest Shackleton's Imperial Trans-Antarctic expedition from Elephant Island.

CHAPTER 5

THE CARDIGANSHIRE BATTERY – A LUCKY BAND OF BROTHERS

The Territorial and Reserve Forces Act of 1907 established the Territorial Force, the forerunner of today's Territorial Army, by combining the Yeomanry and Volunteer Army. Locally, this meant that the Cardiganshire Royal Garrison Artillery Volunteers were transferred into the Territorial Force and became the Cardiganshire Battery, 2nd Welsh Brigade, Royal Field Artillery. Men who signed up did so for a period of four years, after which they were 'time-served' and could choose to leave the force (at least until conscription was introduced in 1916). If time-served they could, should they so desire, sign up for a further four years.

At the outbreak of war, the Cardiganshire Battery (known colloquially as 'The Battery') were part of the 2nd Welsh Brigade Royal Field Artillery along with the 2nd Welsh Ammunition Column and the 3rd and 4th Glamorgan Batteries. All were also part of the 53rd Division. The total of embodied and effective local territorial soldiers on 1 August 1914 was 111 men.

In the days prior to the formal declaration of war, 'The Battery' was told to be ready for home defence. On the day that war between Great Britain and Germany was declared, orders for the mobilisation of the local territorials were posted in Aberystwyth in the evening and the members of the Cardiganshire Battery reported themselves at the (recently demolished) Drill Hall. Major J. C. Rea,[1] the commanding officer, had the arrangements in hand and was awaiting further orders. In the meantime, the men were to eat and sleep in the Alexandra Road Schools, which had been placed at their disposal by the education authority. More recruits were being sought, and it was reported that 'there are a few vacancies for intelligent men as gunners with the view of making the Battery up to full strength'. The recruiting process may not have been as rigorous as implied. After the war, Major Abraham Thomas, the doctor responsible for medically examining recruits, remembers passing as thirty-four years old a school friend with whom he used to play marbles. Dr Thomas was then forty-nine years old.

At night sentries patrolled the streets of Aberystwyth, and guards were posted at the Drill Hall. In the daytime, preliminary training was conducted. The Battery was expecting orders to proceed to Pembroke Dock. More recruits joined taking the number to 136. The following Saturday they paraded through the town with the purpose of obtaining nine more recruits[2] to bring them up to full strength of 145 men. Following the parade, a raucous public meeting was held at the Town Hall. Following what must have been an inspirational speech by Major Rea, a number of recruits came forward so that on departure the following Monday, the Battery was 150 strong.

CARDIGANSHIRE BATTERY
R.F.A.

Recruits Wanted

Recruits are required for this unit:—
AGES 19—35.

Height—Drivers 5ft. 4in.
Gunners 5ft. 7in.

Full particulars, may be obtained from:—

MAJOR REA,
O.C. Cardiganshire Battery, R.F.A.,
Defensible Barracks,
Pembroke Dock.
or
LIEUT. G. D. ELLIS,
Drill Hall,
z591 Aberystwyth.

Advertisement for recruits for the Cardiganshire Battery, August 1914.

The battery duly left for Pembroke Dock on 10 August, arriving in two detachments, where they were housed in dormitories rather than camping out as per their summer camps. The spirits of the men were high, no doubt buoyed up by crowds of local well-wishers coming to see them, the Cardis being the first Royal Field Artillery to be quartered at Pembroke. Trenches were dug for the guns, in case of emergency. They paraded daily with inspections of stables, drill order and harness cleaning. Their accommodation was regarded as being satisfactory for men in warfare (it would get much worse), and the men, though on war rations, were reported to be looking fit and strong. It may have been the mention of war rations that started a rumour around Aberystwyth that the men of the Battery were starving. The *Cambrian News* later printed a paragraph contradicting the rumour. The same source was also asked to contradict another rumour current at home, that their leaving for Foreign Service was imminent. Major Rea was given full command of the defensible barracks. These sit on the top of Barracks Hill, designed to defend the dockyard from a landward attack. Built in 1845, they had walls many feet thick, had fields of fire to sea and landward and covered 6,000 square yards. A former commander of the Battery, Captain George Fossett Roberts (son of David Roberts, the brewer), was drafted to the Army Service Corps at nearby Neyland. The townspeople of Pembroke opened the Market Hall to enable the soldiers to have supper 'suitable to their means'. By way of entertainment, concerts were organised each evening by different regiments. The concert given by the Cardiganshire Battery was chaired by Corporal C. E. Stephenson. Amongst the items enjoyed was 'Jesu, Lover of My Soul' to the tune of 'Aberystwyth' which was sung both in English and in Welsh, followed by 'Hen Wlad fy Nhadau' and 'God Save the King' the solo being taken by Gunner R. Corfield.

By the end of August, the Battery had been transferred to Northampton to join the rest of the 53rd Division, a full strength division at this time being approximately 15,000 men. In November 1914, the Cardiganshire Battery were told to be ready to sail for India on 23rd. In consequence, thirty or so men came home on forty-eight-hour leave. A further batch due to have leave were stopped from doing so, all leave cancelled. Rumours were rife that the Germans had landed on the East Coast. However, the orders to proceed on Foreign Service were rescinded at the last minute, giving rise to more rumours. Their Christmas

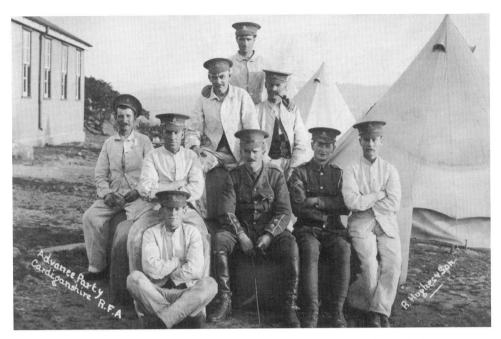

Members of the Cardiganshire Battery, Summer Camp 1914. (Courtesy Peter Henley.)

was spent billeted in Cambridge. Their New Year's present from Captain Mathias was 50 cigarettes per man.

On St David's Day in 1915, all the troops of the Welsh Division, still at Cambridge, were granted a holiday. Rugby tournaments had been arranged in each group area, and the Cardiganshire Battery came 'very near' winning the medals of their own area, being beaten in the semi-final by the minor score of three points to nil, no tries being scored. At midday, each member of the Battery received a shirt that had been sent by the ladies of Aberystwyth, and also cigarettes donated by Mrs Arnold Greene, sister of Lieutenant E. Tudor Jones of Frongog Mansion, Llanbadarn. Later in the day, the musical members of the Battery gave their assistance at the St David's Day (Welsh) service, presided and arranged by the senior chaplain of the Division.

In late March, they were on the move again, this time to Letchworth Garden City where they were billeted two to five per house. The local newspaper *The Citizen* quoted one member of the battery as saying that they had already received more kindness in Letchworth than in all their time in Cambridge. The rich baritone voice of Gunner Corfield was in demand again where he performed 'The Bedouin Love Song' and 'The Village Blacksmith' at a grand concert in the Primitive Methodist church.

In July 1915, several members came home on leave prior to departure from Bedford for further training. It was at Bedford that they suffered their first loss. Robert Corfield, previously a hairdresser, was riding on a gun carriage. He lost his balance, fell back under the wheels and was killed instantly on 26 August. He was buried with full military honours in Aberystwyth Cemetery, aged twenty-seven years.

In late October, the Battery were told to prepare for overseas service, in either Serbia or France. The two Cardiff batteries were showered with gifts and luxury items from their townspeople. Colonel Rea wrote to the mayor suggesting the townspeople have the

opportunity of doing likewise. Suggested items were hair clippers (one pair of fine and one pair of coarse), packs of cards, mouth organs, concertina, or accordions, sets of draughts and any other games that they may suggest themselves, small quantities of medical comforts such as chlorodyne, tincture of chlorodyne, castor oil, boric wool, bandages and oil silk. The mayor opened an account for donations, which duly arrived. Not only was there sufficient for the suggested items but also for a Gramophone. By early December, they had arrived 'somewhere in France' after a sea crossing[3] and a long train journey. In fact, they were in the Vaux area of the Somme, attached to the 32nd Division and waiting to go into the firing line. Reports suggest that they had been in the firing line for some days when the first of the parcels from Sgt Fear's Comforts for Fighters[4] Fund arrived. The parcels were delivered to the wagon line some three miles to the rear. The news of their arrival led to anticipation of joys to come on Christmas Day. Alas, this was not to be as the Battery were given orders to move on Christmas Eve and kept on moving throughout Christmas Day covering a distance of twenty miles. Christmas dinner for most was a piece of bread and a tin of bully beef shared between three men. One correspondent, Evan Jenkins of Penparcau, proudly wrote that not one grunt of complaint was heard as all realised that duty came first. By the time the troops had settled themselves and horses down, it was seven o'clock in the evening. Consequently, they decided to postpone Christmas festivities for a day. At 1 p.m. on Boxing Day, after midday stables, all lined up and received a parcel from Major Rea. After the handing out of the parcels, the troops were dismissed for the rest of the day and then gave three cheers for the people of Aber. As can be imagined at this point, all thoughts turned to home. All tucked into their festive and calorific dinner of Christmas pudding, cake and chocolate, which 'tasted champion'. In the evening, an impromptu concert took place. Evan Jenkins went on to say that the men were healthy and happy as ever and that an English cigarette was worth a dozen French ones. (This condemnation of French cigarettes is nothing compared to that meted out to those encountered in Egypt.) Their respite was brief as the next day they were on the move again, this time trekking fifteen miles. The Ammunition Column and the 4th Battery were now six miles away from the Cardiganshire Battery. This forced Major Abraham Thomas to ride that distance daily to see the sick and wounded. More Christmas mail arrived on 29 December, including the remainder of packets of cigarettes posted on 10 and 16 December.

During Christmas 1914, there had been instances of British and German soldiers fraternising on Christmas Day. The authorities were nervous of this happening again in case the troops started to realise how much they had in common with their counterparts. Consequently, the army top brass arranged for artillery barrages on Christmas Day to discourage fraternisation and drown out the sound of German carol singing coming from trenches that were sometimes only a few hundred yards away. This is why the Cardiganshire Battery was so busy on Christmas Day. How successful this was is open to conjecture as D. Rees Davies of the King's Shropshire Light Infantry wrote of 'Our boys and the Bosch calling to each other. You would hardly think we were enemies'.

In January, Major Abraham Thomas paid a surprise visit to the Penparcau Women's Sewing Circle assembled for their weekly Thursday afternoon gathering. He offered to convey to the six Penparcau boys in the Cardiganshire Battery (Gunners Morris, Jenkins, Hutchings, Jones, Farrier Morris and Driver Myring) a parcel each from the sewing circle. Needless to say his offer was promptly accepted, and he took charge of a package containing shirts, socks, soap, candles, writing materials, etc., made up into separate parcels for the recipients.

The Battery was not to remain in France for long. In February, they were withdrawn from the firing line and left behind the mud and squalor of northern France for warmer

parts. Although no record of their journey across France has been found, a similar journey was made by Private Richard Williams of the Royal Field Artillery in December 1915. His journey by train took two days, with twenty-five men per truck and only iron rations to eat. He remarked on the splendour of the scenery. The destination was probably Marseilles, the most likely port of embarkation for the Battery. Although no detailed description of the Battery's journey has come to light, Lt Cookson wrote of the problems encountered with their mules, in particular securing them in their railway trucks. Their harnesses were to be secured to fixtures hanging from the carriage roof. This had to be achieved with the aid of one man holding the mule's tail through the window on the opposite side of the carriage.

Writing from their troopship, Private Thorpe from Skinner Street described the routine aboard ship in a letter sent to RSM Fear.

Battery sail from France. The Cardigans crowd to the upper deck and sides of the vessel and watch the receding shores of old France until it is no longer possible to see them. Even the least susceptible has a curious feeling and tugging at heart-strings, "When will they again see dear old England" is the silent thought in everyone's mind. However, the hustle and bustle of the life on board soon dispels all sentimental thoughts and longings. The clarion notes of the bugle call forth all and sundry to tea, bringing the boys up with a jerk to a remembrance of the reality of things. Tea over, the biggest excitement of the day follows shortly after. That is the drawing of hammocks for the first time. This is a ceremony that is always accompanied by much excitement. At nine p.m., or, two bells according to ship's time, every man must have himself tucked away in his hammock. "Lights Out" then sounds. All the smaller electric lights on the troop decks are then extinguished; but three or four big ones remain alight all night. This is in order to provide against emergencies. At 9.15 p.m. the orderly officer on duty, in company with one of the ship's officers, makes a tour of the vessel to see that all is safe and sound. The officer's task is not by any means a pleasant one when travelling the troop decks, for all the time they have to walk bent double in order to escape the swinging hammocks. The Orderly Officer has also to frequently visit all the military sentries who are, as soon as she sails, posted all over the ship. He ensures that they are on the alert and that they thoroughly understand their orders. Briefly, the duties of the sentries are to 'prevent smoking in unauthorised parts of the vessel, prevent waste of drinking water; and most important of all, to report direct to the ship's officer on the bridge any outbreak of fire. The boys rise on board a transport at six a.m. and stow away their hammocks. After their morning ablutions, breakfast is partaken of by all the boys. At least that is so after the first few days of the voyage. At the beginning many men have an intense loathing of food; it is unnecessary to say why; but they soon get over mal-de-mer, and then don't they make up for lost time? After each meal time the boys are cleared up to the top decks in order to give the orderly men an opportunity to clean the troop decks. The clarion notes of the bugle sound the submarine alarm. Men previously warned for the task immediately take up armed guard over all the ship's boats and others assigned to different duties at once proceed to carry them out. The remainder of the troops fall in on their respective parade quarters and wait for orders that may be issued to them. Every soldier on board parades in the life belt allotted to him Excitement on the upper deck; eager eyes out over the horizon; and then Egypt boys.

The 53rd Division to which the Cardiganshire Battery were attached was involved in the Gallipoli landings. Due to the nature of the fighting, the Battery were not required, the Royal Navy being able to provide far superior artillery cover. Arriving in Alexandria on

13 February, they rejoined the battered and under strength 53rd Division. By the end of March, they were camped at Beni Salama, forty miles or so north-west of Cairo, on the edge of a desert and experiencing sandstorms such that they couldn't leave their tents. Feeding and watering the horses was an almost impossible task until the storm died down. In response to the weather conditions, Major Rea wrote to the Comforts Fund requesting 150 Welsh flannel belts and 150 pairs of hand-knitted socks to be sent in a few days to the Battery. The knitting of the socks and making of the belts were done by members of churches and chapels, Belgian refugees and other groups, as well as numerous individuals. These duly arrived in late June.

Life in Egypt continued with new experiences for all coming to terms with sand flies, sand storms, camels and heat. At times, temperatures reached 48°C, though it was reported that the men were fit, strong and coped well with the conditions. Being from Cardiganshire, it must have been a novelty to go for eight months without rain. St David's Day 1916 was much different to a year earlier. Rugby was replaced by camel races (two men per camel), donkey races and a sack race.

In late April, the Battery, along with most of the 53rd Division, were sent to guard the southern section of the Suez Canal. Colonel Rea wrote to Sgt Major Fear about the move writing in embarrassed terms of the Battery embarking on their train in a shameful time. However, they were redeemed by detraining at their destination in record time. They were further redeemed in a subsequent inspection by some of the top brass in which their equipment and camp were declared the best and cleanest in the division.

Although able to bathe twice daily in the blue waters of the Suez, the sand was not the pure sand encountered previously, but was mixed with a chalky dust capable of penetrating anywhere. While the troops in the trenches were now, at last, getting steel helmets, those on the banks of the Suez were adopting the slouch hats favoured by the Australian and New Zealand Army Corps troops as they gave such good shelter from the sun.

It was while sitting on the banks of the Suez, smoking a cigarette and reading the *Cambrian News*, both courtesy of the Aberystwyth Comforts Fund that Driver J. Emlyn Jones and Tom Clements watched the *Cliftonian*, an Aberystwyth-owned and registered steamer pass by. Only later did they realise that she was once under the command of Captain Enos from North Road and had a number of Aber boys in her crew.

Cigarettes continued to be a source of comfort not only to relieve the boredom but also to keep the flies away. Troops writing home often referred to them as 'rattlers' as in, a 'rattling good smoke'. Letters home also often mentioned the value of newspapers in helping to keep up with news of friends in other theatres of war.

One complaint was about the monotony of their existence in the desert and that most of them would rather be back in France. A recreation room is available for their use and the gramophone presented to the Battery on departure 'is like "Charley's Aunt," still going strong. This instrument has done its duty in fine style and if honours were given to musical instruments it deserves the Victoria Cross. It kept us smiling many a night in the barns of France and is still doing it in the deserts of Egypt. We are all enjoying the best of health, wishing the best of success to your good work'. Also enclosed were a few lines composed by an anonymous Battery poet:

Of all the places I have seen this camp's the blooming worst,
You sigh all day for pastures green and try to quench your thirst.
Oh take me back to Aber where the sun is not so hot,

There let me stay forever and this camp be forgot.
Rather than live here a year I'd sooner far be shot ,
E'en hell for me holds little fear, it's cooler than this spot.

Whilst it was vividly apparent that the parcels with comforts from home, especially cigarettes and local newspapers, were a great morale booster to the Battery, RSM Fear was having difficulty in raising sufficient funds to keep sending parcels at the rate of one a week. He was forced to issue an appeal for funds in June 1916 in order to continue this work.

I desire to make a special appeal to the people of Cardiganshire on behalf of the Cardiganshire Battery. There is a large number of lads from all parts of the county in the Battery, and a parcel of the value of £2 12s (£2.60p) carriage free, has been sent out every week since this unit has been on active service until a month ago. Now, owing to lack of funds, a parcel can only be sent every other week, and unless funds are forthcoming it will not be possible to send it more than once a month. I feel confident that this appeal will not be in vain. Contributions will be thankfully received - at Dinas Terrace, Aberystwyth, and duly acknowledged. – I am, etc., T. R. Fear, RSM.

The fund eventually had to settle for monthly parcels for the Battery. One positive aspect of being in Egypt was that food was rarely in short supply, though the diet was a monotonous one of rice and beef. The close proximity of Indian troops probably ensured that curry made regular appearances on the menu.

In December 1916, the Cardiganshire Battery, still guarding the Suez, was renumbered the 267th (previously they were the 266th) and reorganised into a two-battery brigade with six eighteen-pounder guns to each battery. On 20 January 1917, the entire division was organised into two columns and commenced marching to El Arish on the Mediterranean, a feat that took until the end of the month.

Later in 1917, they were involved in the Second Battle of Gaza. Just as they were to go into action and fire their first shells in anger, Major Abraham Thomas was surprised to see the Reverend Herbert Williams from Aberystwyth (who was attached to the 53rd Division) come into view. It was during the second battle when the division was attempting to capture Turkish defences to the west of Gaza that one of the original Aberystwyth Territorials, Frank Bennison, was killed on 21 April 1917. He was the only member serving with the Cardiganshire Battery to be killed on active service, though others would succumb to Spanish flu. His parents ran the Lisburne Arms in Northgate Street. As well as keeping a public house, the family also took visitors on excursions, and Frank had been in charge of his father's horses since leaving school. He was known as a steady driver and popular with excursionists on outings during the summer months. At the time of his demise, he was riding 'Goldfinch', a horse belonging to Lieutenant Tudor Jones. A stray Turkish shell landed nearby, killing both Bennison and Goldfinch. During the same battle, Regimental Sergeant Major Brinley James, whose parents lived in Loveden Road and who grew up in Aberystwyth, was recommended for the Military Cross after 'showing great pluck, bravery, and coolness under heavy shell fire from the Turks during the heavy fighting'.

Driver J. Emlyn Jones wrote of the value of the cigarettes sent by the Comforts Fund and gives an insight into army life:

I had just enough cigs to last me one night and was thinking what to do for a smoke the next day when somebody shouted, "Fall in E. Sub. for your Aber. cigs." Then we were marched to our officer's dug-out to be issued with the rattlers so we had a good smoke together and while so doing had a chat about the kindness of Aber friends. We have done splendidly here and we are in close touch with the Turkish trenches. We generally see the Turks bathing in the sea and they are able to see us also, so we have to be careful as they are shelling us. The prisoners and wounded tell us that their food is finished.

In late August, the Battery was resting after five months without a break. The summer of 1917 had been particularly hot and the men given only a bottle of water each per day. As regards military action, things were now quieter. Most days were livened by the appearance of an infantry officer at an observation post, thrusting a piece of paper at the occupants and mumbling test support. On the paper was a set of coordinates. The idea was that, within one minute, a round fired from the gun would land on the chosen coordinates. This exercise speeded up team reactions and was apparently enjoyed by all.

The second Battle of Gaza having ended in stalemate, the Southern Palestine Offensive was put into operation, of which the third Battle of Gaza was one of the first actions. The Cardiganshire Battery was again involved, but some miles to the west. For reasons unclear, any military action became known as a stunt. To the men of the Cardiganshire Battery, the third Battle of Gaza became known as 'Stunt y Diawl'. On 31 October 1917, 800 Australian soldiers commanded by Brigadier General William Grant, armed only with horses, and bayonets charged the Turkish trenches, overran them and captured the wells of Beersheba in what has become known as the 'last successful cavalry charge in British military history'. The next day the 53rd Division were on the move, east then north. The Cardiganshire Battery were due to move off at 8.45 and join the convoy to Beersheba and beyond. The roads on which they marched were little more than tracks, and many had been built by the Romans and barely maintained since. Neither were they designed for anything heavier than a small cart – definitely no tarmacadam or white lines. The Imperial Camel Corps, which now included Private Evan Lewis from Aberystwyth, were to be adjacent. No doubt most members of the Cardiganshire Battery were familiar with the Old Testament stories involving Beersheba but were disappointed with what they saw. The town of Beersheba proved less than exciting with a mosque, a few modern houses, a new police station built by the Ottomans and a couple of hundred mud houses (the biblical Beersheba is thought to be about three miles or so from the present settlement). The day finished inauspiciously for the Aber boys when the food convoy got lost leaving them without food or water for twenty-four hours. Later on Sergeant Burbeck, now transferred to the Royal Engineers, learned that he had been awarded the Distinguished Conduct Medal. He was in charge of a party detailed to lay cables and establish an advanced report centre close to the attacking troops during operations of the brigade forward party. The work was carried out in the face of many difficulties and under heavy shrapnel and rifle fire with great courage and coolness. It was principally due to his initiative and devotion that communication was maintained with the most advanced troops.

Shortly after, starting on 5 November, the Battery was in action. In what came to be known as 'The Battle of the Wells', the Battery were to provide artillery cover for infantry who were to capture three hills (similar to Pen Dinas in one description), on which the Turks had placed machine guns. These hills were at Tell-el Khuweilfeh on the southern fringe of the Judaean Wilderness. Behind these hills was a plentiful water supply, an important consideration in an area with little water. The Cardiganshire Battery was on

The town of Beersheba, *c.* 1910.

the right-hand side of the action and responsible for a rolling barrage lifted 100 yards at a time for the infantry following. They were involved in manoeuvring their guns into all sorts of situations – the bed of a dry river, on the plain and once high upon a hillside. Drivers managed to get their horses (which maintained their reputation for being the finest in the division) to drag the guns through terrain that only weeks before they would have regarded as impossible. Later Major Abraham Thomas was to single out Privates Messer and Phillips in particular for their work in this respect. 'Johnny Turk' also tried to shell the Battery, but there were no direct hits and no casualties although there were some near misses, including one shell that landed amongst their biscuit tins and deprived them of their dinner for a day. The gunners had never before been asked to work so hard. The battery fired off more rounds in a short time than ever before. Their work did not go unnoticed, and praise was forthcoming from the top brass. Two bravery awards resulted from this action – Bombardier Griffiths received a Military Medal and Lieutenant A. Jones a Military Cross. This battle was really a diversion aimed at pinning down Turkish troops, while the rest of the Egyptian Expeditionary Force set their sights on a water supply at Sheria and the town of Gaza forty or so miles further to the west. In this respect, it was successful, and on 7 November, the Egyptian Expeditionary Force entered Gaza to find that the Turks had abandoned it during the night.

Not so lucky were three other Aber boys serving with other Regiments – Captain T. G. Deane Burdett of the RWF, Captain Cyril Mortimer Green of the Royal Sussex Regiment (both ex-Ardwynians) and Evan Richard Jones of the Welsh Regiment, all of whom were killed on 6 November and are buried in Beersheba Military Cemetery.

The Battery continued on the move and got within fifteen miles of Jerusalem before being brought out of the line and allowed a rest. Jerusalem was captured on 9 December by the Egyptian Expeditionary Force. News did not filter back to Britain for a few days, but in recognition of this victory, schools were given a half-day holiday on 12 December.

After all their efforts, the Battery deserved a decent Christmas, and if you couldn't be at home with your loved ones, what better place to spend it than in the Holy Land?

Unfortunately, 'Johnny Turk' had other ideas, and the Battery spent Christmas repelling a Turkish attack.

By March 1918, the battery had moved further north, and the 53rd Division were tasked with capturing Tel Asur. Dr Abraham Thomas gave details of the encounter in a letter to his sister, which must have evaded the censor. 'We have had a very stiff week fighting in the hills. You will have read of our doings in the papers. The advance was to strengthen our positions, and our division had the stiffest task, as we had to take Tel 'Asur, the highest mountain, 3,300 feet high, which gave the old Turks a very commanding position. Our brigade did its part exceeding well and especially our battery. The latter earned splendid praise all through and especially after the mountain was taken by taking the guns down the mountain side through which no path had been made by the engineers. I have walked the way four times, and I cannot possibly understand how they did it. By doing so, they helped the infantry immensely. The boys are delighted with their work.' In a speech in Aberystwyth in 1919, Dr Thomas claimed that this was the biblical Mount Ephraim.

A joint letter from Gunner H. Cullum, Driver R. R. Jones and Bombardier Tom Thomas to RSM Fear played down their exploits and reads, 'The "Rattlers" came at the right time. We have had it pretty rough lately. We have experienced terrible weather, rain and hail; but the boys stick it well'.

Dr Thomas adds that there were no casualties amongst Aber boys, but a lad from Llangwyryfon was wounded in the arm. The officers and men of the Battery subscribed to

Major J. C. Rea, later promoted to Colonel. (By permission of Llyfrgell Genedlaethol Cymru/National Library of Wales)

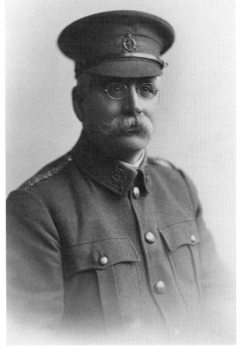

Dr Abraham Thomas. (By permission of Llyfrgell Genedlaethol Cymru/National Library of Wales)

a present for RSM Fear, but it was lost in transit. It was entrusted to a senior officer, but unfortunately, the vessel he was on was torpedoed, and it was lost.

In November 1918, the Battery were moved from Palestine to Alexandria and were in high hopes of embarking on a ship for home. However, it seems they had a long wait as it was not until March that members of the Battery first appeared back in Aberystwyth. Dr Abraham Thomas, by now a Major, who looked after his troops so well, did not arrive back until early June, having himself been taken ill in Italy. Deservedly, he received a tumultuous welcome, with train whistles and fog signals being sounded and cheering crowds lining the streets as he walked the final few yards of a long, long journey back to his home in North Parade.

Although the town took much interest in the accomplishments of the Battery, the nature of their arrival home in batches between March and July 1919, along with many hundreds of other demobilised men, precluded any form of civil reception. Instead smaller, local tributes were paid to returning soldiers. In February 1919, a concert was held in the Woodlands, Devils Bridge to welcome back Richard Messer; in March, Sergeant Hughes was welcomed to the YMCA, while in July, it was the turn of Drivers J. H. Thomas, Rowland Jones and E. Evans to enjoy a concert, picnic and sports at Ebenezer Chapel, Comins Coch. In August, it was the turn of Stanley Jones to be entertained at Bow Street Congregational Chapel. By early July, it seems all the Battery had been repatriated home.

The Cardiganshire Battery saw action in two theatres of war, and though their time in the mud of France was limited, their privations in Egypt and Palestine were of a different nature but equal to those of the trenches. Only one of their number was killed in combat, though influenza and accident took their toll later on – John Emlyn Jones died in Egypt after peace was declared. He was kicked in the knee by a mule, the wound turned septic, and he died. All in all the Battery came home relatively unscathed to tell many tales. How unscathed is difficult to assess. Evan Jones of Llanbadarn fought with the Battery and was assaulted in November 1919. In the subsequent court proceedings, he was described as a disabled man, suggesting that for some all those years in the desert may have taken their toll.

CHAPTER 6

MERCANTILE MARINE

War of a different sort was fought at sea. Initially, the threat was from surface vessels – raiders or small battleships. With the German declaration of Unrestricted Submarine Warfare in January 1915, life became more dangerous, and often shorter, for merchant seamen.

The Germans were quick to see the advantages of submarine warfare. In the six months commencing October 1914, U-boats sank only nineteen vessels out of a total of over 5,000 during the war as a whole. Initially, Germany was concerned about international opinion and therefore did not attack unarmed merchant vessels. Instead, their U-boats concentrated on trying to sink Royal Navy vessels. However, by January 1915, it was evident that the war would not be a short one and resolve hardened. Unrestricted submarine warfare was declared, and by August, German vessels were sinking approximately 100,000 tons of shipping a month, or 1.9 vessels per day. As Britain's merchant fleet then stood at over twenty-one million tons, the losses were negligible. However, as a result of a number of high profile sinkings in which American lives were lost, most noticeably the *Lusitania*, the Germans suspended operations against the merchant fleet in the North Atlantic. Instead, they chose to operate U-boats in the Mediterranean. In 1916, the merits of this tactic were evident – 415 ships totalling over one million tons were sunk in the Mediterranean. On 1 February 1917, the Kaiser ordered unrestricted submarine warfare. The peak of incidents in 1917 reflects the increased submarine activity and efforts to starve Britain into submission.

The list below includes incidents in which Aberystwyth sailors were involved.

5 August 1914 – Mr John Morris of No. 3, Portland Street, Second Mate aboard *Glyndwr* was interned in Memel (now in Lithuania). He is eventually released in October after being ill-treated by his captors.

Early October 1914 – German light cruiser SMS *Karlsruhe* captures *Farn* off the coast of Brazil. Aboard was David Lloyd Edwards, boatswain, from South Road, Aberystwyth. The crew were taken prisoner and released later in the same month.

7 October 1914 – steamer *Lynrowan* intercepted and sunk by SMS *Karlsruhe* off the coast of Brazil. The Captain was Arthur Jones of Llandre and aboard was his wife and Mrs Davies, both from Aberystwyth.

18 January 1915 – *George Royle*, a Sunderland registered steamer, foundered on a shoal three miles north of Sheringham Beach, Norfolk. Although flares were sited from Cromer, the lifeboat could not reach the vessel that had broken in two. The ship was captained by

Mr John Thomas, whose mother lived in Rheidol Terrace. He was not amongst the five survivors of the wreck.

18 February 1915 – *Mary Ada Short*, sailing ship, sank by German auxiliary cruiser *Prinz Eitel Friedrich* off the coast of Brazil. Crew, including David Lloyd Edwards of Melbourne, South Road, were taken prisoner.

22 February 1915 – *Chasehill*, sailing from Newport to Montevideo with 6,000 tons of coal was captured by the German auxiliary cruiser *Kronprinz Wilhelm*, a converted ocean liner. After shots were fired across her bow, she was stopped and boarded. The crew, including Evan Jones, were taken aboard the *Kronprinz Wilhelm*, while the crew transferred the cargo to their own holds. Later, she encountered a French liner, *Guadeloupe*, that was sunk after evacuating her crew and passengers, nearly 300 in total. Evan Jones said all were well treated on the whole, though their food was salty, water was in short supply, and all 300 were confined to the ship's hold between 6 p.m. and 7 a.m. As this was in the tropics, the heat was stifling. *Chasehill* had a contract with the French government to return from Montevideo with a cargo of meat to be landed at Marseilles. Consequently, the Germans threw the refrigeration gear overboard. She was then rammed several times by *Kronprinz Wilhelm* in order to render her unseaworthy, and all prisoners were transferred to *Chase Hill* and released off the Brazilian coast, where they were able to reach Pernambuco safely.

12 March 1915 – David Lloyd Edwards and crew of sailing ship *Mary Ada Short* were released at Newport News, Virginia, after being locked in the hold of *Prinz Eitel Friedrich* for twenty-two days with no daylight.

1 May 1915 – David Albert Lloyd, of No. 36, Queen Street, wireless operator, watches as his vessel the *Edale* sinks after being torpedoed without warning, forty-five miles north-west of the Scilly Isles. There were no casualties. Fifteen minutes after being torpedoed and evacuated, the vessel showed no sign of sinking. The submarine resurfaced and fired nine shots into the vessel. *Edale* left San Nicholas in South America with linseed and grain for Manchester. The linseed kept the vessel afloat, which was why the submarine had to resurface to finish the job.

13 August 1915 – A. P. Jones of South Road was torpedoed near Kandeloussa in the Greek Islands on the troopship *Royal Edward*.

4 October 1915 – Captain D. James of No. 11, Sea View Place, master of Admiralty Collier *Craigston*, watched as she was sunk by gun fire in the Aegean Sea.

December – The steamer *Tyninghame*, under the command of Captain D. H. Jones of Morolwg, Buarth Road, set sail from New York with a cargo of sugar. Shortly after departure, fire broke out, forcing the vessel back to port. The fire was extinguished, and the vessel went on her way. A similar fate had befallen another vessel at the same time, and the fires were blamed on German saboteurs.

5 March 1916 – T. W. James, son of the above Captain James, torpedoed for the first time aboard *Rothesay*, thirty miles south-west of Bishop Rock.

9 April 1916 – Captain Willie James of Queen Street and Mr John Morris were torpedoed on *Glen Almond*. Captain James was to be torpedoed again at a later date.

20 September 1916 – D. Herbert of Lyndon, Stanley Road, was torpedoed on the *Bagdale* near the Brittany coast. Injured, he died shortly after reaching shore.

4 October 1916 – the vessel *Electra* sank after a collision off Hartland. Two crew members from Aberystwyth were landed safely at Swansea. Men were E. Davies from Trefechan and E. D. Jones, formerly a caretaker at Aberystwyth County School.

17 October – Captain David Williams, chief officer of *South Pacific*, died at Bona (now Annaba) from dysentery aged sixty-seven years.

11 November 1916 – the unfortunate Captain James of 11, Sea View Place watched as his vessel *Corinth* is sunk by gunfire twenty-eight miles south-east of Flamborough Head.

6 February 1917 – *Cliftonian*, an Aberystwyth registered steamer, is hit by a mine or torpedo four and a half miles off Galley Head, Southern Ireland. Aboard were Capt. J. R. Brown of No. 7, High Street, Harry Davies of Portland Street, J. T. Salmon of William Street, W. Lloyd Evans of Queens Road, and Ivor Cowley of Poplar Row.

February 1917 – Captain R. Clayton arrived home to Baker Street having recently been torpedoed.

13 April 1917 – *Argyll* was carrying a cargo of iron ore from Port Kelah (Algeria) to Middlesbrough and sunk without warning. Amongst the 22 casualties were third engineer John Parry Williams aged twenty-three years and David Jones previously of Brynhyfryd, Buarth Road.

14 April 1917 – *Lena* ran aground on the coast of Nova Scotia. Fatalities included William Jones of No. 15, North Parade, second engineer.

18 April 1917 – J. Richards of No. 30, South Road was on the *Trekieve* carrying government stores when she is torpedoed without warning 100 miles west of Gibraltar.

20 April 1917 – *San Hilario* put up an eight-hour fight but eventually sunk 270 miles west by north from Fastnet without casualties. At over 10,000, tons she was one of the largest vessels sunk by a U-Boat. Aboard was John Hughes, the son of Captain Thomas Hughes, Tudor House, Bridge Street.

29 April 1917 – *Daleby* was torpedoed without warning 180 miles north-west of Fastnet, carrying a cargo of copper and silver ore from Huelva to Garston. Included amongst the casualties was Second Mate Lewis William Marles-Thomas.

21 May 1917 – J. Jones of South Road and Hugh Evans were aboard the *Don Diego*, sailing from Swansea to Alexandria with government stores. Their ship was intercepted and sunk by *U-65* forty miles South-East of Linosa Island near Sicily, but not before firing sixty-six shells at her attacker before going down. Hugh Evans was one of the five crew members killed.

7 June 1917 – *Errington Court* was torpedoed or mined off the French Mediterranean coast. At the time of the explosion, A. E. Lloyd Edwards of Trinity Road was flat on his back repairing a boiler. The crew evacuated safely as the ship started to take in water and go down in the bows. After half an hour, the ship was still afloat. The crew reboarded and started the engines. After seventy-two hours of continuous work, they managed to beach the ship. Although damaged, the vessel was later repaired.

8 June 1917 – Captain J. O. Enos of Gerymor, North Road, was taken prisoner after the Mathias-owned and Aberystwyth-registered steamer *Cheltonian* was sunk on a voyage from Genoa to Oran, North Africa. The ship headed back towards Marseilles and evaded a submarine for two hours before a shell eventually penetrated the stokehold of *Cheltonian* starting a fire. Captain Enos was in his pyjamas when the Germans came alongside, though fortunately he was allowed to collect his clothes. He subsequently spent eighteen days on the submarine before being landed in Montenegro. Also in the crew was Ivor Cowley, who was also on the *Cliftonian* when she was sunk.

22 June 1917 – Now feeling that the Kaiser has really got it in for him Captain James of Sea View Place watche a German submarine surface and approach his latest command '*Charing Cross*'. The vessel escaped after engaging the submarine for forty-five minutes. (On 1 July 1918, SS *Charing Cross* was torpedoed without warning and sank four miles off Flamborough Head while carrying a cargo of coal.)

19 July 1917 – *Eloby* was torpedoed without warning seventy-five miles south-east of Malta while carrying a cargo of explosives. Not surprisingly, fifty-six of the crew were killed, including wireless operator Llew Hughes of Moel-y-Don, Prospect Street.

24 July 1917 – J. Richards of South Road was injured in the leg when torpedoed for the second time in four months, this time aboard the *Blake*, thirty miles from Cape Wrath. The vessel sank in two minutes, the crew having to jump overboard, there being no time to lower the lifeboats. David Albert Lloyd, third engineer, of No. 36, Queen Street was not so lucky and lost his life, as did four other crew members.

29 August 1917 – *Grelhame* (previously named *Tyninghame*) was torpedoed four miles from Start Point (near Dartmouth) while carrying a cargo of sugar from Cuba to Le Havre. Aboard were two Aberystwyth seamen – J. Jones of Caron Villa and J. E. Roberts of No. 7, North Parade. Both survived.

29 September 1917 – Thomas William James of No. 11, Sea View Place, first engineer aboard *Kildonan*, was killed when torpedoed without warning by *UB-35*. At the time, she was sailing from Santander to Ardrossan with a cargo of iron ore.

8 October 1917 – Captain D. H. Jones of Morolwg, Buarth Road, was killed with twenty-seven other crew when his vessel *Greldon* was torpedoed without warning seven miles from the North Arklow Light Vessel.

2 November 1917 – *Margam Abbey* was torpedoed off the coast of Algeria; crew included wireless operator E. W. G. Farrow of No. 57, Marine Terrace.

20 December 1917 – Loaded with zinc ore, phosphates and naval stores, *Polvarth* was sailing from Gibraltar to Swansea when torpedoed near Ushant. The crew included D. Jones of Arfryn, Buarth Road.

31 January 1918 – D. Davies of North Parade was torpedoed aboard *Eggesford*, but the vessel managed to reach Alexandria, Egypt.

25 February 1918 – *Rubio* hit a mine and sank near Shipwash Light Vessel. One of the crew is John Davies from Great Darkgate Street.

11 March 1918 – Arthur Miller, a nineteen-year-old Marconi radio operator, was one of the last to leave his ship, the Cunard liner *Folia*, after she is torpedoed with the loss of seven lives off the southern coast of Ireland. He spent six hours in the water before reaching the Irish mainland. Previously, he had celebrated his eighteenth birthday in Sierra Leone, West Africa, in May 1917 and been hospitalised with typhoid the following August in Karachi, quite a *curriculum vitae* for an nineteen-year-old.

9 March 1918 – Boscowen Lloyd Isaac of Elm Tree Avenue was torpedoed aboard *Anteross*. The crew spent thirty-one hours in an open boat.

24 March 1918 – David J. Davies from Aelwyn, Penparcau, was torpedoed on the *Etonian*, thirty-four miles off the Old Head of Kinsale, Ireland.

19 May 1918. *Snowdon* was torpedoed eighty-four miles south-west on Malta while part of a convoy sailing from Malta to Milo. Aboard is ship's carpenter Thomas Edwards from William Street.

27 May 1918 – *Leasowe Castle*, a troopship, was sunk 100 miles from Alexandria. Aboard was Engineer J. J. McPherson of Clyde House, Queens Road, who had been involved in the building of the vessel.

21 August 1918 – *Boscawen* was sunk twenty-three miles WNW of Ynys Enlli (Bardsey Island) by UB92. Crew included Captain Edwards, previously of No. 7, Marine Terrace, and seamen John James of High Street and David Lewis Daniel of the Sailors Arms.

9 September 1918 – Chief Engineer Thomas Hughes of Solway, Buarth Road, was torpedoed. Contemporary accounts state that the crew all survived and were landed in a

foreign port. The only vessel sunk on this date that corresponds with this description was the *War Arabis*, sunk eighty-eight miles off the Algerian coast carrying a cargo of wheat from Bahia Blanca to Marseilles.

October 1918 – Mr J. Edwards, Frondewi, Dinas Terrace, arrived home on Thursday after having been on a torpedoed ship. Only a few of the crew were saved. This was the second time that Mr Edwards had been torpedoed within the previous two months. Details of his earlier sinking have not yet come to light.

Two Firsts for Aberystwyth

The first steamer flying the British flag to enter Antwerp, after the signing of the Armistice, was commanded by Captain James Jones, Arfon House, High Street, Aberystwyth, master of the SS *Abbot*, which has been engaged in the Belgian Government Naval Transport Service for most of the war. As the vessel passed up the River Scheldt, with flags fluttering in a fresh breeze, she was loudly cheered by crowds of people, pleased to see a steamer enter their once busy port.

Another first for Aberystwyth was recorded by Harri Richards from Stanley Road, one of the crew of the *Querida*. Writing home, he claimed that their ship was the first merchant vessel to enter Ostend. In order to enter the port, they had to pass within six feet of the wreck of HMS *Vindictive*, scuttled at the start of the war to stop the Germans using the port. On arrival, they were greeted by a crowd of well-wishers. He went on to comment that the harbour was spoilt by all manner of craft having been sunk to impede shipping. Barbed wire entanglements and concrete dugouts were plentiful. Food was scarce and expensive, and sadly, it was a common sight to see children on the quayside begging for biscuits.

CHAPTER 7

WOMEN AT WAR

At the outbreak of hostilities, the prospects for women to contribute to the war were limited. The situation changed rapidly once conscription was introduced.

For the early years of the war, the role of women was confined to two activities. Naturally, nurses were much in demand. For those without nursing skills, there were more mundane activities to help the war effort, centred around sewing and knitting.

One of the first local nurses to be called up was Miss Emily Evans, matron at the infirmary on North Road, who went to work as a nursing sister at the Welsh Hospital in Netley. Miss Evans spent three years in South Africa during the Boer War and was present at the relief of the siege of Kimberley. She was subsequently awarded both the Queen Victoria and King Edward medals before resuming her nursing career in Birmingham, later returning to Aberystwyth. She was to become matron of the Welsh Hospital in Netley by April 1915 and received the Royal Red Cross from King George V in March 1917.

Nursing also provided an opportunity for travel not available to most young women. Sister S. C. Kenrick spent a year as a theatre sister in the Welsh Hospital in Netley before sailing for India in May 1916 with another Aberystwyth nurse, Evelyn Evans of Loveden Road. They both had spells in Bombay and Deolali. In 1918, Sister Kenrick wrote home telling of having attended a moonlight party at the site of the original Garden of Eden in Mesopotamia.

Another notable nurse with local connections was Gwenllian Morris. Before the war, she was a Queen's Nurse, similar to a district nurse today. She joined the St John's Ambulance in October 1914 and was soon in France. An article in *The Nursing Times* states that the hospital where she worked was a girls' convent school near St Malo, converted by the French authorities as a supplementary hospital under the St John Ambulance Association. The hospital contained 100 beds, with room for fourteen officers. It was the only hospital in that area which contained British sick and wounded, and in addition to nineteen Britons, there were thirty-one French and thirty-six Belgians. After contracting diphtheria, she returned to London to recuperate and on recovery volunteered to go out to Serbia with the second unit of the Serbian Relief Fund. On their way to Serbia, the unit was commandeered at Malta to nurse the first batch of wounded soldiers from the Dardanelles. From Malta, they proceeded to Niš, where they were again commandeered for a month, this time to assist Russian doctors and nurses. Finally, they were stationed at a large typhus camp of 5,000 patients at Pozarevatz, three miles from the Danube. Writing of her experiences, Nurse Morris wrote of going out on an ambulance, picking up the stricken soldiers who

had fallen by the wayside with typhus and bringing them into hospital. During the daytime, working conditions were extremely hot and unpleasant. Not only were they working under canvas, but in order to protect themselves from the lice that spread the disease nurses had to wear masks, heavy boots, gloves and heavy canvas overalls taped at the sleeves before treating the patients. In a letter home, she praised the work of their Austrian prisoners who acted as orderlies, many of whom spoke English. Her unit remained in Pozarevatz until the Austrian and Bulgarian advance. Nothing of Nurse Morris was heard until a postcard was received in January 1916, in which she states that she is in good health, though now a prisoner at Villa Zava. Her unit had been captured by Bulgarian forces who treated them well, eventually releasing them in early February 1916, though the journey home took two months.

In the era before the discovery of antibiotics, nursing could also be dangerous. Nurse Muriel Evans from Brynymor Road died of typhoid fever in Warrington.

At the start of the war, for those without nursing skills, their contribution was to be of a domestic nature. Knitting circles sprang up in many groups – chapel, community and school. Local newspapers are filled with donations of socks, scarves, gloves, etc. to local servicemen, especially the Cardiganshire Battery and the RNR. In early December 1914, the first batch of articles produced by Bethel Chapel Sewing Circle were sent to London for onward distribution, while the Women's Conservative Association sent a batch of socks to Colonel Rea for distribution to the Cardiganshire Battery, then in Northampton. On a lighter note, the local branch of the British Women's Temperance Association invited the wives and dependents of soldiers and sailors to a social gathering at Salem Schoolroom. The event was popular, with an attendance of 250.

One of the most prolific of these groups was the Penparcau Sewing Circle, inaugurated on 13 October 1914. The circle met on Thursday afternoons, though much knitting and sewing was also done at home. Meeting in the Darllenfa (reading room) in the village, they soon became known as the Darllenfa Sewing Circle. The circle had sixteen members, including professional shirt makers, though the average attendance at meetings was nine. By February 1915, the circle had produced 245 articles of clothing, including 77 flannel shirts (2 energetic members being responsible for 39), 44 pairs of socks, bed jackets, Balaclavas and mittens. These were dispatched to the Red Cross Society for Indian soldiers, the motor machine gun service, the Army Flying Corps, Belgian women at the Alexandra Palace, Welsh troops and local servicemen. As well as making the garments, the women organised a number of fundraising events to buy materials for making the items.

During August 1916, the Darllenfa Sewing Circle sent, by request, parcels of pyjamas and nightshirts to the Red Cross Hospital in town and the Welsh Hospital, Netley, and also, after an urgent call from a Colonel Claud Matthews, a parcel of eleven shirts for use of soldiers in Mesopotamia. The same month a sale and an exhibition were arranged at Penparcau School. Included in the exhibition, under the guidance of George Eyre Evans, was an exhibition of antiquities including the Nanteos Cup. George Eyre Evans also displayed his War Book, a collection of newspaper cuttings and printed ephemera relating to the war since its declaration. This was eventually to run to four volumes and is now safely lodged in the National Library of Wales. By the following August, the circle was able to boast that they had produced over 1,100 shirts and knitted comforts.

The Tabernacle Knitting Circle was also active, sending out forty-five parcels in 1916, each containing a shirt, scarf, socks, balaclava and mittens to serving members of the congregation. In addition, their sewing class had despatched 121 parcels to soldiers and sailors connected with the chapel over the winter of 1915–16. Alexandra Road Girls

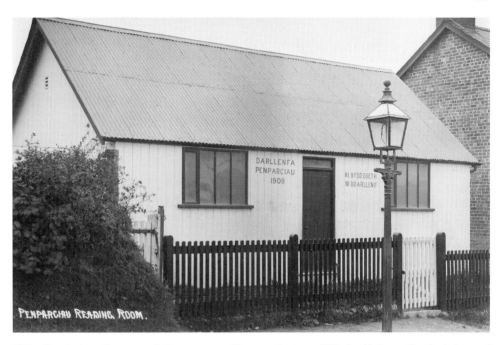

Y Darllenfa (reading room), Penparcau. (By permission of Llyfrgell Genedlaethol Cymru/
National Library of Wales)

School, Seilo, Holy Trinity, St Pauls, Bethel and the English Baptist Church all had knitting
or sewing circles that did likewise.

By mid-1916, opportunities for women to contribute to the war effort had broadened
considerably. Conscription, introduced in March 1916, opened up numerous opportunities
to enjoy other roles in the workforce. At tribunals where men sought exemption from
conscription, one of the first questions asked was, 'Can't you get a woman to do the work?'
For a time this was so, but not unnaturally women sought out the better-paid jobs, such as
in munitions factories in other parts of the country.

The opening of the Red Cross Hospital in June the same year also opened up
opportunities to be more directly involved in the war effort through the local Voluntary Aid
Detachments as local women were encouraged to volunteer for nursing duties. In order to
prepare for the opening of the hospital, numerous training courses were held, culminating
in the presentation of certificates, badges and bars in May 1916 by Miss Morris, Matron of
the Red Cross Hospital.

First-year certificates were presented to Mabel and Rosina Attwood, Olive Brown,
Elizabeth Davies, Claudia Edwards, Myfanwy Ellis, Gertrude Garner, Annette Graham,
Katie Griffiths, Eleanor Griffiths, Mary and Kate Hopkins, Maud Hughes, Margaret
E. James, Nora James, Ursula James, Nora Davies James, Myfanwy Jones, Dorothy Jones,
Katie Jones, Pollie Jones, Elizabeth Jones, Gwladys Jones, Annie Jones, Margaret Jones,
Gwladys Lewis, Annie Lewis, Eunice Lewis, Kate Long, Charlotte Long, Jeanie Lunt,
Winifred McLoughlyn, May Morgan, Sarah Jane Morgan, Gwen Morgan, Mary Noke,
Kate Powell, Martha Parry, Lucy Price, Margaret Clayton Rees, Mabel Ricks, Sydney
Rowlands, Essie Rowlands, Jennie Richards, Constance Roberts, Nellie Thomas, Gertrude
Thomas, Margaret Thomas, Eleanor Warrington, Maggie Williams and Jennie Lloyd.

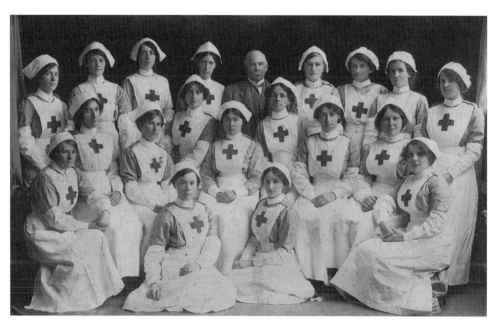

Aberystwyth Red Cross Nurses, 1916. The nurse in front and to the right of the doctor is Rosa Jane Owen of Llanfarian. Her sister, Kate Hutchings, is seated on the floor on the left. She spent 5,183 hours volunteering as a cook at Aberystwyth Red Cross Hospital.

In receipt of second-year certificates were Annie Evan, Annie Hopkins, Anne Humphreys, Liza Jenkins, Florence Kate Hutchings, Mary Ellen Lewis, M. J. Lloyd, Muriel Morris-Davies, Lily Morrison and Ceri Williams.

Third-year proficiency badges were gained by Mary Davies, Gwladys Evans, Edith Harries, Amy Hollier, M. E. James, E. J. Lloyd, Dot Richards, Elizabeth Thomas and M. Warburton.

Fourth-year bars – Mrs E. C. Edwards, J. Jenkin Humphreys and Hugh Pugh.

A large number of these volunteers gave unstintingly of their time; for example, Jeannie Lunt of Castle Terrace worked a total of 5,300 hours, all voluntary, at the Red Cross Hospital between 1916 and 1919. This equates to over 660 eight-hour shifts. Florence Hutchings of Bridge Street volunteered as a cook and clocked up 5,183 hours, again all unpaid.

Two members of Aberystwyth Voluntary Aid Detachment, Dot Richards and Charlotte Davies, moved to the 3rd Western General Hospital in Cardiff. Charlotte Davies, originally from Lisburne Terrace, was awarded the Royal Red Cross Decoration by King George V, in recognition of two years' service, having moved to being a full-time Voluntary Aid Detachment (VAD) nurse in 1915.

The VAD was not the preserve of townspeople. VAD No. 20, Cardiganshire was formed by staff and students of Alexandra Hall. Many of Alexandra Hall's students spent the summer of 1916 doing a whole variety of jobs, most of which had previously been regarded as men's work. These included harvesting, turnip-hoeing, fruit-picking, tending cattle, driving carrier's van, general service work, clerical work in labour exchanges, bookkeeping, packing for prisoners of war and helping in canteens and war clubs. The enthusiasm for the cooking, cleaning and nursing doesn't seem to have lasted long, as by 1917 numbers in VAD No. 20 were just eleven.

In Aberystwyth, telegrams started being delivered by girls from September 1916, and in October, eight women from the steam laundry were cheered as they left by train to work in munitions factories in Barrow-in-Furness. In December 1916, the first conductress was appointed on the Aberystwyth–Aberaeron motorbus. This latter job rapidly lost its shine when a few weeks later the bus got soundly stuck in mud.

Attempts were made to attract a munitions factory to Aberystwyth, but this met with little enthusiasm outside of Aberystwyth. Such was the number of local people involved in munitions work that it was said that on a Saturday evening in Birmingham, you could see as many local people on the streets as at home.

The summer of 1915 had produced a poor harvest. This, combined with the German commitment to unrestricted submarine warfare, coerced the government into paying more attention to food production. A consequence of this resulted in a meeting being organised in the Agricultural Lecture Theatre at the university on 24 April 1916 to discuss women's war work with respect to agriculture. The meeting was convened by the district committee of the movement to organise agricultural war service for women. Mrs Crawley Boevey, Birch Grove, has been appointed president of the committee, and Mrs Doris W. Stapledon, the Secretary. The object of the meeting was to consider how to secure women to replace male labour, which had been taken off the farms and was likely to be taken off in future. George Stapledon spoke eloquently, emphasising the seriousness of the position. Food was needed, not just for the troops but also to feed the inhabitants of our cities and was every bit as important as munitions. If any farmer was in difficulties with regard to the harvest or other work necessitating help, then Mrs Stapledon would be pleased to drive four or five women in a motor car to the farm. Mr Morgan, the agricultural organiser for the county, pointed out that there were already more women working on the land in central Wales than any other part of the kingdom. He did not see prejudice against women as the problem, more a shyness in employing them and that if anything was characteristic of Welsh farm life, it was the amount of work done by the farmer's female relatives. To say that women were no good on the land was perfect rubbish, and every farmer knew that well.

Shortly after the meeting, Mrs Stapledon recruited friends and female university students to tend root crops, work traditionally done by casual labour. In six weeks, 790 rows of 160 yards each, mainly swedes, were hoed earning the gang over £17. The success of the scheme ensured a write-up in the *Board of Agriculture Journal* in August. It may well have been the enthusiasm of Mrs Stapledon that led to the dwindling of numbers in the Alexandra Hall VAD, along with the possibility of paid, as opposed to voluntary, work.

By October, and now called the Women's War Agricultural Committee, a meeting was held to discuss what steps could be taken to procure a greater number of women to work on the land. The Countess of Lisburne was elected as the new chairwoman of the Committee. It was proposed that lectures should be given in the villages on intensive cultivation, poultry keeping, gardening, etc. The Board of Agriculture gave a grant to cover sixty per cent of the expenses, and applications for lectures should be sent to Mr D. J. Morgan, Tregaron. Mrs Abel Jones also made suggestions for starting village institutes for women on the lines of those already existing in Canada, where the farmers' wives and daughters and the village women could meet and where lectures on matters agricultural were held at frequent intervals.

A national appeal in early March 1917 was made for young women to enrol in a new Women's Land Army, an organisation staffed entirely by women. Those who enrolled were eligible for payment during short training courses and a free outfit including high boots, breeches, two overalls and a hat. Wages were to be a minimum eighteen shillings (90*p*)

weekly, or the wage rate of the district wherever it is higher. No prizes for guessing which applied in this area!

By February 1919, the organisers were able to claim that Cardiganshire had the largest Women's Land Army in the kingdom and that they had trained 120 girls in aspects of farming such as dairying, stock keeping, poultry and butter-making. Many of them had worked in disagreeable and arduous conditions, dealing with rough, lonely and difficult linguistic conditions. The Women's Land Army was disbanded in November 1919.

In the summer of 1917, advertisements started to appear for women to join the Women's Auxiliary Army Corps. Women could not become officers but could enter, after adherence to strict criteria, one of four units – mechanical, clerical, cookery and miscellaneous. Candidates were to be aged between twenty and forty years and could expect pay to start at twenty-three shillings (£1.15p) a week for typists but rising to thirty-two shillings (£1.60p) for those on higher duties. Accommodation of a high standard was to be provided. The recruitment process required references from persons, including a minister, who had known the applicant for three years, as well as a thorough medical examination.

The first local woman to be accepted was twenty-year-old Maud Jepson, whose parents ran a boarding house at No. 63, Marine Terrace. On being accepted, she was told she would be given seven-day notice of being called up. She subsequently left Aberystwyth for France in June 1917. She commented that her fellow recruits were 'a superior type of girl'. She was followed shortly afterwards by Miss Thomas from Brynymor, previously employed by Mrs Dudlyke, a draper of Northgate Street. Miss Beryl Morgan of Ceris, Trinity Road, was a cookery instructress before the war, but by the summer of 1917 found herself in Salonika working as a cook in a military hospital for Australians. Whether she was also recruited as a member of the WAAC or by another route is unclear.

CHAPTER 8

RED CROSS HOSPITAL

The Red Cross established over 3,000 auxiliary hospitals and convalescent homes for wounded soldiers in Britain. Regarded as more informal and homely than the military hospitals, these were preferred by the soldiers, especially as they also tended to be less crowded.

The Cardiganshire branch of the Red Cross Society (President, Lady Pryse of Gogerddan) established a small temporary auxiliary hospital in the Old Bank House in Bridge Street during the months when troops were billeted in the town. This closed when the troops departed.

Like the university, the theological college, now Cambria, had seen a reduction in student numbers by half in the first term following the outbreak of war. Many students were

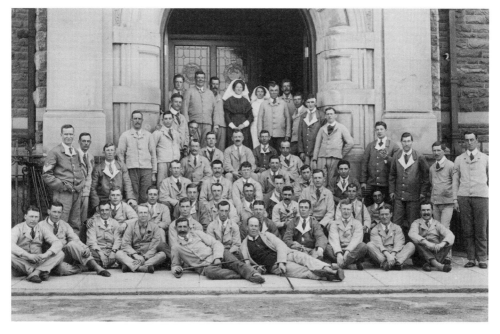

Wounded soldiers wearing their 'hospital blues' outside the Red Cross Hospital.

away at training camps, working for the YMCA. Those students who were present spent most of their second term preparing concerts and entertainments for the troops billeted in the town. Most staff and students spent the summer of 1915 assisting the YMCA or the RAMC and felt this to be an important part of the war effort. In consequence, a meeting of the committee of the college was held in November, at which it was decided to merge the theological colleges at Bala and Aberystwyth for the duration of the war. The college building was to be offered to the Red Cross for use as a hospital free of rent.

The following month a letter from the War Office was received by the local Red Cross branch noting that Cardiganshire and Merionethshire were now the only counties in England and Wales not to have established auxiliary hospitals for wounded soldiers. It will come as no surprise that the next step was to appoint a committee in response to the letter. Neither will it come as a surprise to learn that this consisted of the great and the good from amongst the university and the townspeople.

A meeting in the town on 8 December heard that the South Wales Methodist Association had offered the use of the theological college (now known as the Cambria) opposite the pier as a venue for such a hospital. In addition, local doctors had undertaken to assist where necessary. Nursing would be carried out by the local VAD. It was estimated that £1,000 would be required to run a fifty-bed hospital for twelve months. This £1,000 would be in addition to any grant from the War Office (two shillings a day per bed occupied) and the cost of providing furniture and other necessities. It was up to the Cardiganshire branch of the Red Cross Society to find these funds.

The meeting also heard that the hospital would not receive serious cases, but convalescent patients not requiring operations. Most patients at Aberystwyth seem to have come from Neath, where they had been treated, before being sent here to convalesce. No information has come to light regarding the injuries suffered, but of the four photographs of groups of convalescing patients seen by the author, only one appears to feature an amputee, suggesting that the men sent here were not severely disabled. Many seem to have been gassed.

Miss B. L. Collins, a member of the Territorial Army Nursing Services, was appointed matron in April 1916. Since the outbreak of war, she had been employed at Leicester Military Hospital. The following month, a number of open days were held for the general public to view the arrangements.

Despite the fact that this £1,000 was the equivalent to £95,000 in current prices, within a fortnight over £200 was raised and a list of donors was published in the local papers – The Chrysanthemum Society, Aberystwyth, £100; the Earl of Lisburne, £50; Mr E. Roberts M.D. and Mrs Roberts Penwern, £30; Mrs David Davies, London, £5 guineas; Mr and Mrs Stapleton, Llanbadarn, £5 guineas; Mr D. R. Roberts, Calcutta, £5; Mr T. W. Waddingham, Hafod, £5; Professor R. W. Genese Aberystwyth, £3; proceeds of concert by Church Sunday School, Strata Florida, Mr T. W. Arch, £1; total, £205.

A whist drive in aid of the hospital was held in the Queen's Hotel and no fewer than 264 people attended. Another whist drive on St David's Day yielded another £15 17 shillings towards the hospital funds.

The first six patients to arrive at the hospital were admitted in mid-June 1916. Each had the honour of being named in the local newspaper. The men were Drivers C. G. Dennison and B. Kerlin of the Royal Field Artillery; Private H. W. Baxter of the 8th Norfolks; Private G. E. Davies of the King's Shropshire Light Infantry; Private L. Walker of the 6th Northants; and D. Howard Tripp of the London Irish. The last named of these went on to edit the hospital's own magazine that first appeared less than a month after their arrival. The next five patients appeared shortly afterwards. The men, it was noted, seemed to make friends

rapidly and soon had company on their walks along the prom. Those citizens fortunate enough to own motorcars also took the men on outings into the countryside. Typical of the hospitality was that offered by Mrs E. Hughes Davies of Ystrad Teilo Farm, Llanrhystud, who invited a number of the men to a traditional Welsh farmhouse tea of homemade bread and butter with cream and milk straight from the cow. It was a War Office rule that on any of these visits at least one member of staff had to be present. In late July, there were 43 inmates. Capacity was soon to be expanded to sixty-five beds, and an urgent appeal for extra furniture and sundries was made. It comes as no surprise that the list included twelve large ashtrays. One patient, Rifleman Joseph Bridgman of the 1st Monmouthshire Regiment, came to Aberystwyth to recuperate after being gassed at the Battle of Loos in October 1915. Through the hospital he met Elizabeth Rees, a sister of one of the Red Cross Nurses. The couple were subsequently married in Tabernacl Chapel and settled in the town. Joseph Bridgman later drove a lorry for the council, though was prone to occasional bouts of ill health as a result of having been gassed.

By early August, the hospital was full to capacity, and in all £1,657 had been raised locally to fund the hospital. No doubt the spectacle of the National Eisteddfod was the source of much interest to troops unfamiliar with the idea. On 1 September, they were engaged in digging a trench on the beach and in doing so collected the sum of £12, which was donated to the Young Helpers' League. As their season drew to a close, the bowling club was the venue for an afternoon's entertainment on the green and a tea.

As the weather changed, so did the nature of the entertainments arranged for the patients. Mr and Mrs Teviotdale entertained to supper at cafe in North Parade some eighty of the wounded soldiers from the Auxiliary Hospital, accompanied by Red Cross nurses. Wounded men who were unable to walk were taken down in the family motor car.

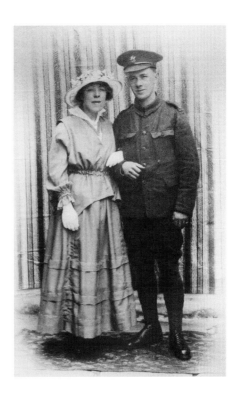

Mr and Mrs Joseph Bridgman on their wedding day.

One of the first to arrive was a fellow Scotsman from Mr and Mrs Teviotdale's home in East Lothian. After supper, the tables were cleared, and the remainder of the evening was spent in music, singing, dances in Highland costume by the Misses Teviotdale, recitations and comical stories told by soldiers Fordo, Singleton and R. Griffiths, most of which were encored. The evening was brought to a close by a hearty vote of thanks to Mr and Mrs Teviotdale for their kindness followed by the singing of 'Auld Lang Syne' and the National Anthem.

Apart from numerous concerts, there were a series of whist drives at the St George's Hotel in Portland Street and lectures on various subjects available to both patients and staff. It will come as no surprise to read that at the forefront of these was the Reverend George Eyre Evans, a font of knowledge on a wide range of subjects and, judging by the reception he received, an entertaining speaker. The lecture room was filled to overflowing with the voluntary attendance of both staff and convalescents on the occasion of the first of his three lectures titled 'Mountain Top Mysteries', dealing with traces of early man and his work, as seen in the meini hirion, cromlechs and stone circles. He also bought flint knives and wool samples cut by them to add to the interest of the talk. The subsequent lectures dealt with tumuli, cairns, earthworks and Norman mounds. Professor Levi gave a series of three lectures on the war. During an account of airships and bombing raids, one soldier fell backwards through a pane of glass, adding sound effects to the lecture. There were also physics lectures and art classes. Enough of the patients were sufficiently recovered to organise a soccer team and beat a local team 4–1, but later lost 1–0 to the university. Surprisingly popular with the patients were needlework classes under the auspices of Sister Katie Davies. Items made by the soldiers were popular at local sales of work and included a quilt worked on by a number of men with 'Aberystwyth Red Cross Hospital 1916' embroidered in gold.

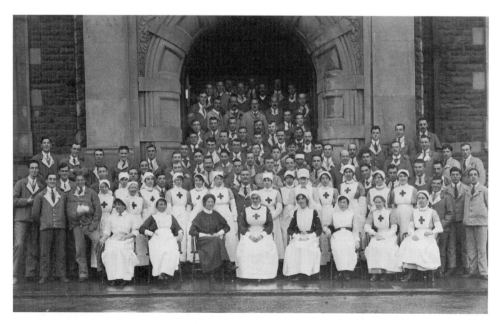

Staff and patients on the steps of the Red Cross Hospital.

The Red Cross Society also appealed for donations of food and advertised that they were particularly grateful for eggs, potatoes, fowl, tobacco, cigarettes, jams, marmalades, cakes and statioeary. In fact, the local newspapers listed donations made each week by inhabitants of the district. Whereas today we are used to obtaining most foodstuffs all year round, a century ago things were very different and many fruits and vegetables were only in season for a short while. In one week, the following gifts were recorded:

Cauliflowers, Mrs Foster, Gwynfryn; mushrooms, Nurse Lloyd, Brynyrychain: carrots, turnips, beetroot, apples, pears, beans, Mrs Morgan, Blaendolau; lettuces, cabbages, swedes, the Rev. E. M. Davies, Devil's Bridge; cabbages, swedes, beetroot, carrots, Llanbadarn Horticultural Show; mushrooms, Nurse Bonsall, Fronfraith; cucumbers, marrows, Mrs Perkins, Brooklyn; plums, Mr R. Fear and Miss Bonsall, Pendibyn; cabbages, lettuces, mint, parsley, Miss Marles Thomas; books, Mrs Barrett; apples, the Rev. J. Morgan Lewis, Carrog; and marrow, Mr William George, Cartref, Llanbadarn; apples, Lady Prvse.

During August, visitors to the town were asked to pick blackberries to make puddings for the patients. Swedes, it seems, were never out of season and only rarely out of the weekly list of donations.

Groups of recuperating patients continued to arrive, usually from Neath, and men were discharged back to their units. Amongst these arrivals, in October was Bombardier Horace Blair from Aberystwyth who was reported wounded in France in July, probably at Mametz Wood.[1] In the weeks running up to Christmas, a further appeal was made asking for donations of turkeys, geese, poultry, fruit and crackers for a festive meal. On the Friday preceding Christmas, a Fancy Dress Ball was held, where it seems there were far more townswomen than wounded soldiers. The event enabled Father Christmas, Nero and Charlie Chaplin to rub shoulders with snake charmers, Swiss peasants, Cinderella, Spanish dancing girls, Grace Darling and Florence Nightingale to name a few. The costumes were put to good use again when waxworks were laid on with various patients as dummies.

On Christmas Day, a dinner of the donated items was followed by the erection of a tree on which was a present for each patient, paid for from the proceeds of a collection at Borth over the summer months for the purpose. For most, it was a far better Christmas than that they had endured in the trenches in 1915 or would celebrate in 1917.

By January 1917, the hospital was running smoothly and a routine observed. Gifts of foodstuffs, seasonal in nature, were donated regularly, and the donations continued to be recorded in the local newspapers. Concerts of various types were arranged by local choirs and numerous amateur performers entertained the patients. George Eyre Evans was invited back to give a series of lectures on Aberystwyth Castle, the first of the series being on the original castle at Tanycastell and its removal to the present site. It was stated that, bearing in mind the men's recent experiences, a lively discussion followed. Dr Fleure arranged a trip to the College Museum; Madame Barbier gave French classes, Professor D Morgan Lewis lectured on electricity, and shorthand classes were arranged, with Pitmans providing stationery free of charge.

On another occasion, the patients were invited to tea with the inmates of the workhouse at Bronglais. A vote of thanks was given by a Mr Campbell, an inmate who was a soldier during the Indian Mutiny in 1857. He spoke of the benefits of temperance, though he was speaking to the (possibly temporarily and grudgingly) converted as patients at the Red

Cross Hospital were only allowed alcohol under doctors' orders. It was also an offence to supply the men with alcohol.

In mid-February 1917, a further 23 men arrived from Neath and were welcomed by Dr Bonsall and Mr Jenkin Humphries, manager of the Coliseum Cinema. Departures from the hospital were less well reported, but Private Wigmore and F. J. Summer, a recipient of the Military Medal, must have made an impression on the town as both their departures were deemed newsworthy. The following month twelve more patients were admitted and, presumably in anticipation of a spring offensive, the War Office requested the hospital to increase the number of beds to one hundred. This may have been achieved, but press reports do not indicate there being more than eighty patients at any one time.

With the arrival of the summer weather and being located on the seafront, it is not surprising that the patients hit upon the idea of boating to pass their days and aid their recovery. To this end, they arranged a number of fundraising events in June to purchase a rowing boat. These included a concert by Ellison's Entertainers. In addition, Mr T. V. Lewis allowed the men free use of his bathing machines. By late June, it was reported that 'the boat provided great pleasure and recreation and has proved a great assistance in their recovery', suggesting that the fundraising had been successful.

In the same month, and to mark the anniversary of the opening of the hospital, an excursion to Devils Bridge was arranged for all patients and their nurses. Tea was provided by Mr Lightfoot of the Hafod Arms Hotel, and free admission granted to view the falls. Leaving at 9 a.m., they did not return until 10 p.m. Bearing in mind that the journey takes an hour each way, the reader may like to ponder on what exactly the men found to do in Devil's Bridge for the intervening hours.

George Eyre Evans was on hand in July to give open air lectures on the histories of Pen Dinas and Llanbadarn church, while another Aberystwyth stalwart, the tireless RSM Fear,

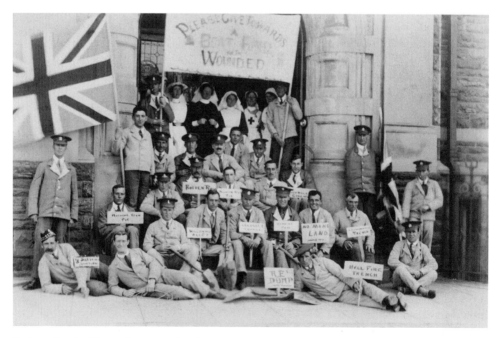

Patients fundraising to buy a rowing boat.

ensured that each patient in the Red Cross Hospital was given enough strawberries for a strawberry tea. The offer was also open to all soldiers in civilian clothes wearing the gold stripe. This was a piece of gold braid worn on the left sleeve to denote that a soldier had been wounded in battle.

In late August, another twenty-four additional recuperating patients were received from Neath.

By late October, the weather had changed, and an appeal was made for new or second hand soccer and hockey kit. Seven pairs of boots and sundry kit along with a number of footballs duly arrived.

On 21 November, a further fifty-one patients arrived from Neath. Shortly afterwards, arrangements were made for Sunday evening services to be held at the hospital.

Christmas 1917 at the Red Cross Hospital was celebrated with similar fun and frolic as the year before. On Christmas Eve, the patients spent their evening watching *The Wild Goose Chase* at the cinema and afterwards held a short dance. The patients were allowed to go out earlier than usual on Christmas morning. After the dinner, a message was read from the king wishing all a Happy Christmas. Amongst the toasts was the health of the boys at the front and afterwards a short sing-song. In the evening, a Christmas tree was set up in the hall from which presents were distributed to the patients. Later on, a go-as-you-please concert was held. To add to the night's pleasure, an hour's dance was held. The hospital had been decorated for the occasion, and one and all greatly enjoyed themselves. To add to the festivities, Boxing Day saw Private Samuel Albrighton from the Red Cross Hospital marry Miss Silcock from Trefechan. The bride was given away by her brother, Seaman Gunner J. J. Silcock. The friends of the groom formed an archway with their walking sticks as the couple left St Michaels. A further highlight of the Christmas season was a Fancy Dress Ball in which a number of inventive costumes were remarked on, and at which it seems, again, young ladies far outnumbered the patients. Also popular were a comedy duo known as Monty and Carlo, otherwise Drummer Wagner and Private Harry Bason, who performed at many concerts until being discharged from the hospital in mid-January 1918.

The winter months saw a continuing round of entertainments for the wounded. Once again, Mr and Mrs Teviotdale were to the fore. Many of the evening concerts involved both townspeople and patients giving performances. During one such concert in St Davids schoolroom, five of the servicemen including a rifleman by the name of Lott performed a sketch 'Just Called Up' set in a recruiting office. This seems to have been something of a hit as they were asked to perform it on two more occasions in the next few days.

The continuing toll taken on the economy by the war put an end to the publication of the *Hospital Magazine* as the costs of production became prohibitive. Weekly teas continued at the YMCA, and a set of twelve volumes of Cassell's *History of England and South Africa* were donated. A little easier to digest was a salmon tea arranged for the patients on Good Friday.

The arrival of the tank *Julian* as part of War Weapons Week also involved the more able of the convalescents, who were able to accompany the tank on its perambulations around the town. Many are to be seen in their hospital blues in the photographs taken in North Parade (Sgwar Owain Glyndwr today).

Due to the holiday season, early August saw a temporary shortage of VAD nurses, but not so as to prevent seventy of the patients being treated to an outing to Teifi Pools by Lady Pryse. Later in August, a recreation in miniature of a Red Cross Hospital on the beach raised £21.10 shillings, which was again donated to the Young Helpers League. Also busy was Alfred J. Jackson, a patient from Maesteg who proposed to, and was accepted by, Alice Edwards of Gogerddan Place.

By late autumn 1918, the Spanish flu epidemic was evident in the town. Initially, no late passes were issued to the patients and shortly after, visits to private homes were stopped to prevent the outbreak gaining a foothold in the hospital. Such was the scale of the epidemic that many businesses in town were forced to close temporarily as they had insufficient staff. The Red Cross Hospital seemed to escape unscathed. Perhaps there was something to be said for eating all that swede!

Owing to the special Christmas leave, only twenty patients remained in the hospital for Christmas. On Christmas Eve, the usual weekly whist drive took place, followed by dancing, which was kept up until midnight. On Christmas Day, the patients and staff had a dinner of roast turkey, plum pudding and mince pies. Apples, oranges, grapes, nuts and chocolates helped to decorate the table, which had been arranged by the quartermaster. After dinner, presents were handed out by the matron. The majority of the patients witnessed the army and navy football match on the Vicarage Fields in the afternoon (Army 9, Navy 2), and in the evening, there was dancing and games from 7 to 10 p.m.

On Boxing Day, the remaining patients spent the evening at the new Convalescent Home for Discharged Men in Baker Street, and on Friday morning, all the remaining patients proceeded on their twelve-day leave.

The last waltz for the hospital was, literally, on 3 February when a dance with singing and recitations was held. As usual, most of those present were in fancy dress. Dancing continued until 3 a.m. The singing of 'Auld Lang Syne' marked the end of an institution where patients and staff had worked together in harmony.

All dressed up and nowhere to go. Three convalescing servicemen ready for a fancy dress ball, *c.* 1917. The man on the left is M. Stomachien of the RAF.

Advertisements then appeared requesting those who had lent equipment or furniture to write in and request the return of their items.

Miss Collins, the matron, was presented with a fitted attaché case as a farewell present from the local VAD. Later on, she was awarded the Order of the Royal Red Cross, 2nd class, in recognition of her work.

The Red Cross Hospital had a positive impact in a number of ways. Evidently, the patients enjoyed their convalescence in the town and were well treated by the townspeople. For their part, those patients with ability to entertain added to the social life of the town. For the womenfolk of the town, it represented an outlet through which they could make a positive contribution to the war effort and receive a degree of recognition for their efforts. The hospital brought together a number of young men and women in reasonably congenial circumstances in an era when the social conventions governing mixing of the sexes were less relaxed than today.

CHAPTER 9

ABER EXPERIENCES

Over 1,000 men from the Aberystwyth area were involved in the First World War, serving in every theatre. Other than for those who served together in the Battery, it is difficult to generalise on their experiences except to say that most saw service on the Western Front. Some men served throughout the war, some honourably discharged, while due to their youth some saw service for only weeks or months.

Much of our understanding of the ordeals experienced by Aberystwyth soldiers and sailors is down to the hard work and thoughtfulness of one man. Regimental Sergeant Major T. R. Fear (a retired Grenadier Guard) was a successful businessman in Aberystwyth with years of military service behind him. On 22 June 1915 when it was obvious that the war 'would not all be over by Christmas', RSM Fear instigated a scheme for sending small parcels of luxury items to those serving in his majesty's forces. This came to be known as the Aberystwyth

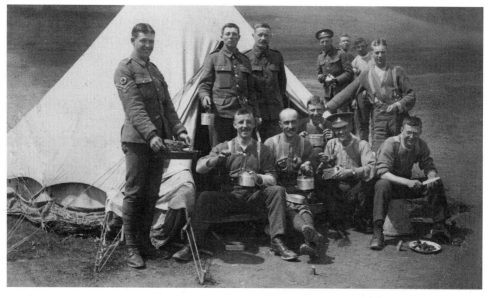

Postcard dated 1914 – the message on the reverse reads 'Life in Kitchener's Army somewhere in France. RAMC'.

Comforts Fund. Cigarettes and local newspapers were seemingly ever present in the parcels but also included might be any combination of the following items – chocolate, cake, sweets, Oxo cubes, socks or mittens. Allowances were also made for the conditions under which the recipient served; for example, there would be no point sending chocolate to Egypt. Later on, non-smokers and pipe smokers were catered for accordingly. Particular efforts were made to ensure that Christmas parcels were special with Christmas cake and plum pudding included. In addition, each parcel contained a handwritten card from RSM Fear carrying words of encouragement. The idea was simple – a parcel was sent to the soldiers' last known address. If the parcel was acknowledged by letter, then another parcel would follow in due course. Servicemen were encouraged to write of their experiences, and many of these letters were later published in the *Cambrian News* or *Welsh Gazette*. For various reasons, many men chose not to recount their experiences, merely to express their gratitude for parcels received. All these replies are now in the National Library of Wales and have been made available online. Initially, the fund was for Aberystwyth servicemen only but included Llanbadarn and Penparcau from September onwards. Later on, the Cardiganshire Battery were added en masse when they were sent abroad. As well as those on active service parcels were sent to the wounded and prisoners of war. Following the Armistice, parcels were restricted to men home on leave, probably because with so many men on the move, many parcels would have gone astray. Instead, men home on leave could call at RSM Fear's house in Dinas Terrace to collect their parcels and thank him in person for their previous parcels.

By the time the Fund was wound up in February 1919, a total of 6,645 parcels had been distributed to 1,035 men on his list. The total sum raised by public subscription from businesses, individuals and through fundraising events was £1,559 5s 6d (£1,559.28p).

Later on, RSM Fear, who was also a leading supporter of the YMCA in Aberystwyth, was presented with a walking stick and £250 in respect of his tireless efforts on behalf of the town's servicemen.

The importance of including local newspapers in the parcels seems to have been immense to the recipients. Not only did it keep them up to date with local news, family and friends serving their country elsewhere, but also supplied them with information on the progress of the war in general. When Corporal Edwards was recuperating in hospital in Malta, he was surprised to receive a visit from an Aberystwyth sailor James Edwards, who had read of his hospitalisation in a recently sent copy of the *Cambrian News*.

Whereas armies are said to march on their stomachs, judging by the letters received by the Comforts Fund Aberystwyth soldiers and sailors seemed to rely more on cigarettes, Afrikandi being an often-mentioned and favoured brand. Arthur Williams serving with the Royal Flying Corps summed this up succinctly 'Be that as it may in tight corners when the pulses beat high and one wonders up to how much one can count before the end, the tender ministrations of Dear Nicotiana are very soothing'. In most instances on receipt of a parcel, the recipient would share his good fortune with those around him, with many letters of thanks including the sentiments that those from other towns wished they had an RSM Fear to provide such luxuries.

Joseph Thomas

One of the first accounts of life on the Western Front was provided by Private Joseph Thomas, of the 3rd Royal Scots, a career soldier and son of Mr and Mrs John Thomas, china dealers of Llanbadarn. Private Thomas returned to Aberystwyth from Cardiff Hospital, where he had been treated for a bullet wound in the thigh. He recounted his experiences in an interview to

a local newspaper. He had been involved in some of the heaviest fighting of the war until that point, taking part in the retreat from Mons in 1914 and what was later known as the First Battle of Ypres in October and November 1914. Private Thomas received his wound during a lull in the fighting at La Chapelle. In order to replenish a water canteen, he volunteered to run across to a deserted barn about forty yards from the trenches. He got across and was returning with the water when he was shot by a sniper. The bullet passed right through the fleshy part of the thigh and emerged just above the knee. He managed to regain his trench, where he was quickly bandaged but could not be removed until some hours later. He was subsequently taken to the hospital at Boulogne and afterwards removed with the others to Cardiff Hospital. At the time he gave his interview, he was on a month's leave.

Putting a brave face on life in the trenches, Private Thomas said things were not as bad as many people imagined. (The author says, yes they were.) At one time, Private Thomas was sixteen days in the trenches. He claimed they got used to the continual shelling, and the men are well supplied with all sorts of comforts, especially cigarettes. One of the great drawbacks, however, was that the men were half up to their knees in water, 'and in order to keep rheumatic out of our legs we always looked forward to our customary allowance of rum'.

In February 1916, he wrote to his parents in Llanbadarn telling them he had just been told he was to receive the Distinguished Conduct Medal (DCM). Joseph Thomas was the first soldier from Aberystwyth to receive the award. His battalion took part in the Battle of Hooge in July 1915 and were to charge and, if possible, capture German trenches. Thomas 'with his party of bombers advanced to the communication trench between the British and German lines from where they bombed the enemy and held their position for thirteen and half hours, being all that time under a fierce shell fire. During this time they were also subjected to three separate attacks from German bombers; but they did not yield an inch of ground'. This enabled the Battalion to capture three lines of German trenches. Again, on 30 September, he led his party in a bombing attack on the German trenches, some of which they captured and afterwards successfully held against counter-attacks by the enemy. His actions were brought to the attention of his superior officers, and he was recommended for the DCM. A collection was held for him back in Aberystwyth, and in April 1916, a ceremony was held in a crowded North Parade at which a captured German field gun was presented to the town for safe keeping (and as an aid to recruitment). At this ceremony, the mayor presented Lance Corporal Thomas with a clock (which costs £4 12 shillings – £4.60p) as well as a purse containing ten gold sovereigns. The mayor himself presented Lance Corporal Thomas with 200 cigarettes. Lance Corporal Thomas thanked the mayor and subscribers for their generous presents, saying that when he returned to the front, he should again do his duty and hoped to come home again with more decorations. After applause, the presentation ended with the singing of 'God Save the King'.

Thomas was later promoted to sergeant. He was listed as missing, presumed dead in the Battle of The Scarpe on 12 April 1917 aged twenty-nine years. Newspapers reported that he was wounded and left near a ruined building. When stretcher bearers went to pick him up, there was no trace of him.

The idea that people at home knew little about life in the trenches is something of a misnomer. Knowledge of the physical discomforts – wet, mud, cold, fleas and rats – was well known though the psychological effects of sporadic bombardment, sniping or a night raid were not so well understood. The winter of 1915 was particularly severe and a frequent topic in letters from those months. Troops would usually spend a week or so in the trenches before being relieved and sent back to safety. Some letters spoke of their horses being constantly knee deep in water. Men spoke of taking two days to get their uniform and kit cleaned up following a spell in the trenches.

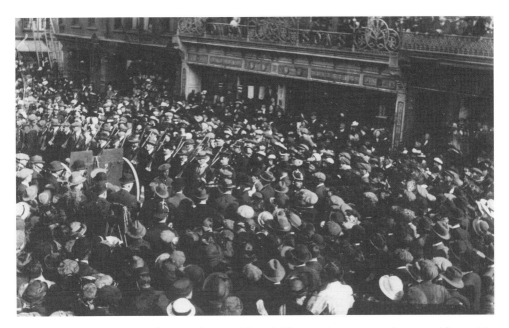

A captured German gun and Lance Corporal Joseph Thomas (centre, wearing tam o'shanter) in North Parade.

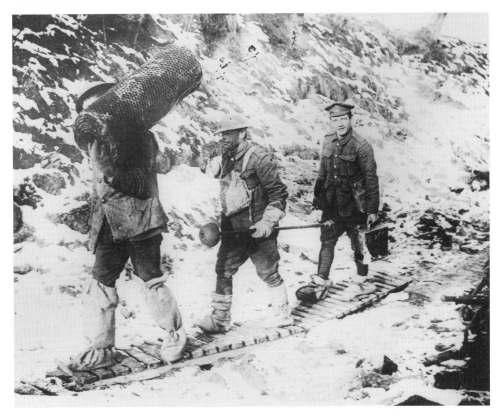

The Western Front, winter 1915. A sharp contrast to life in Kitcheners Army.

David James Evans

Another career soldier was David James Evans, who joined the Royal Welsh Fusiliers WF in 1911. At the outbreak of war, he had been transferred to the 2nd Battalion of the South Wales Borderers, then in China. Along with Japanese forces, they were tasked with capturing the German outpost and naval port of Tsingtao. This was achieved by November 1914. After returning to Britain in January, he enjoyed a brief visit to the family home, Dolguan, Brynmor Road, before his unit were sent to Gallipoli in March 1915. Three days after landing in Gallipoli in late April he was wounded, shot in the back by a Turkish sniper. The full impact of the bullet was absorbed by his braces, parts of which entered his lungs. He then spent six weeks in hospital in Egypt before returning to his unit, only to be shot in the back again on 28 July by another sniper, this time while he was filling sandbanks. He was then sent back to Britain to convalesce. In March 1917, he was transferred back to his original regiment and promoted to sergeant three months later.

On 20 September, he was in action at Zillebeke (better known as Hill 60) where he was awarded the Military Medal for carrying messages several times to the front line despite murderous shell fire.

We next here of him on 8 January at Neuville-les-Dieppe, where he married Miss Alice Pype. Barely was the honeymoon over when he was in action again. On 23 March, he was captured by the Germans and became a prisoner of war. Forced to work in a coal mine at Prusen, he lost teeth and broke his nose in an accident. He arrived home in either December 1918 or January 1919. The first released prisoners of war to arrive back in Aberystwyth did so quietly and usually unexpectedly, having no time to inform their family or friends of their release and imminent arrival.

In March 1919, Aberystwyth's bank managers paid for a meat tea at the YMCA for 100 returned servicemen. D. J. Evans was one and won the prize for the best story from the battlefield. D. J. Evans was presented with his medal by the mayoress at a Peace Day dinner held to commemorate the signing of the Treaty of Versailles.

Later, known to all and sundry in Aberystwyth as Dai Military Medal, he settled into life as a postman in Aberystwyth.

David John Davies

David John Davies, his four younger brothers, sister and parents lived in Pembroke House, Queens Road. His father was an ex-mariner turned jeweller. He was educated at the National School on North Road, now the site of Llys Hen Ysgol. After a spell as a pupil teacher, he studied at Carmarthen Training College, where he passed for his Masters Certificate and became a qualified teacher. At the outbreak of war, he was an assistant master at Trinity Road Boys' School in Tooting, London. Along with D. C. Rowe, also from Aberystwyth, he joined the London Welsh Battalion of the RWF on its formation in October 1914 and proceeded with it to France in the following year. In January 1915, both Davies and Rowe were promoted from corporal to sergeant. D. J. Davies became quartermaster sergeant. He saw much fighting during the next two years. In February 1917, he was given a commission in his regiment and also managed to come back to Aberystwyth on furlough. In May, he was mentioned in despatches. His battalion of the RWF were part of a division, which made a heroic stand in the German offensive in April 1918. Lieutenant Davies was wounded in the back and evacuated first to Etaples. Having had his injuries assessed as

Sergeant D. J. Davies.

what was known to the troops as a 'Blighty', he was sent to a hospital in Manchester to recuperate. The term 'Blighty' was used to refer to any wound serious enough to warrant being sent back to Britain, that is, Blighty. However, his actions prior to being wounded had not gone unnoticed. He was awarded the Military Cross for 'conspicuous gallantry and devotion to duty. By his personal example and by the excellent fire control which he maintained he kept his front intact against repeated enemy attacks. At night he went out on patrol on three occasions, capturing a prisoner and killing a machine-gun crew and bringing in the gun'. His brothers who also served in the forces had mixed fortunes. Ernest was a member of the RNR and was one of the Aberystwyth contingent on HMS *Caesar*. George H. Davies was a sergeant in the Cheshire regiment and earned the DCM for bravery in June 1917. Days later, he was killed in the Battle of Messines aged twenty-eight years. Youngest Brother Willie joined up at sixteen years of age and achieved the rank of trumpeter. It is not recorded whether the family's friends and neighbours were as appreciative of Willie's military accomplishments as those of his brothers.

David Lewis Morris

David Lewis Morris grew up in No. 33, Northgate Street, the only son of J. R. Morris, a blacksmith. Born in 1899, he attended Ardwyn School and on account of his promising intellect was selected to be a pupil teacher. (This was a system under which promising youths taught in schools under the supervision of qualified teachers prior to attending college.) On reaching his eighteenth birthday, he received his conscription papers, though through the testimony of the headmaster David Samuel he obtained a short exemption to

David Lewis Morris.

sit his Central Wales Board examination, which he subsequently passed. His exemption expired in September 1917, and he was conscripted into the Royal Engineers. His military service was of short duration, and by 1921, he had graduated from the University of Wales, Aberystwyth, with a degree in Geography. Turning his back on teaching as a profession, he took holy orders in 1925, studied for a year at Lampeter and served first as a curate in Llanelli, then moved on to Pwllheli, Bryncoedifor, Llandinam and finally Holyhead in 1948. In recognition of his long service, he was later appointed Canon. While in the army, he took up boxing, which remained a passion throughout his life. He also maintained a lifelong interest in rugby, league soccer and test and county cricket. He passed away in January 1960.

Lewis Pugh Evans

Of all the awards given to Aberystwyth soldiers, there is one that stands head and shoulders above the rest. This was the Victoria Cross awarded to Lewis Pugh Evans. Evans was a career soldier who had been educated at Sandhurst in 1899, joined the Black Watch as a second lieutenant and then had gone straight to the Boer War in South Africa. A stint in India followed, and in 1906, he was promoted to Captain. Never one to shy away from adventure, he obtained his pilot's licence in 1913. He first came to prominence at Hooge, Ypres, where on 16 June 1915 an action earned him the Distinguished Service Order (DSO). His citation read 'When the troops became mixed up he moved up and down the line under continuous heavy fire for fourteen hours, reorganising units and bringing back reports'.

He was subsequently promoted to major and later lieutenant colonel. His Victoria Cross was awarded following an action at Passchendale on 4 October 1917. His citation read:

> Lt. Col. Evans took his battalion through a terrific enemy barrage, personally formed up all units and led them in the assault. While a strong machine gun emplacement was causing casualties and the troops were working round the flank, Lt. Col. Evans rushed at it himself and by firing his revolver through the loophole, forced the garrison to capitulate. After capturing the first objective he was severely wounded in the shoulder, but refused to be bandaged, and reformed his troops, pointed out all future objectives, and again led his battalion forwards. Again badly wounded, he never the less continued to command until the second objective was won, and, after consolidation, collapsed from loss of blood. As there were numerous casualties, he refused assistance, and by his own efforts ultimately reached the dressing station. His example of cool bravery stimulated in all ranks the highest valour and determination to win.

After recovering from his wounds, he took command of the First Battalion Black Watch and was in the front line again at Givenchy between 18–20 April 1918. Here the Germans launched a last big push, in the hope of defeating the Allies before the Americans arrived in strength. On arrival, Pugh Evans moved about the forward areas offering encouragement to his troops. The following day he conducted a reconnaissance with a view to organising a

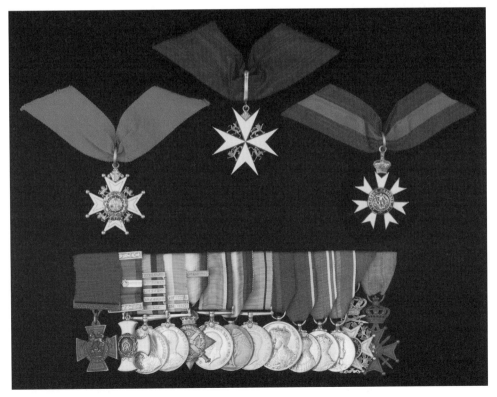

Medals awarded to Lewis Pugh Evans. His Victoria Cross is bottom left. (Courtesy Lord Ashcroft)

counter-attack. This he did on the 20th, driving the Germans back from their forward lines. For this, he earned a second DSO. For various actions, he was mentioned in despatches no less than seven times. He was later promoted to brigadier and settled at Lovesgrove near Aberystwyth until his death in 1962. His exploits are recorded on a plaque to be seen behind Llanbadarn Fawr War Memorial.

Harry White

Harry White, a blacksmith by trade, signed up at the recruitment meeting at the Coliseum soon after the outbreak of war. He was the eldest of four brothers, sons of Mr and Mrs George White, of No. 15, Thespian Street. All his brothers also joined the service – Ben White (who served on HMS *Jupiter*); Driver George White of the Cycling Corps, Italy, and Private W. White, who like Harry, joined the Royal Engineers. After a few months' training at Chatham, he proceeded to France in late 1915, where he took part in much fighting. In September 1917, he was wounded by shrapnel and lost his right leg. He was brought over to the Barry Road VAD Hospital, Northampton, and was recovering slowly. After some weeks, his condition deteriorated, and on 15 February 1918, he passed away. His parents, had been summoned by the authorities to the hospital and, were with him. The parents returned on Saturday morning, and the body was brought home by the mail train the following day for a military funeral.

His funeral was typical of those given a military send-off in the town. The coffin was met at the station with a general salute by an escort of servicemen home on leave from the front; wounded soldiers; the Aberystwyth Silver Badge Detachment[2], and the local Girl Guides. The coffin was draped with the Union Jack on top of which were wreaths, one from the Mayoress of Northampton and another from his fellow patients, commandant and staff at the Barry Road Hospital. The cortège, marshalled and headed by RSM T. R. Fear, proceeded along Terrace Road, North Parade and thence to his parents' house at 15, Thespian Street.

That evening tributes were paid to Sapper White during service at the Red Cross Hospital and at the YMCA service the following Tuesday evening when 'For Ever with the Lord' was sung in his honour. His grave space was purchased and given as a token of respect by the members of the YMCA.

The funeral procession was led by RSM Fear, followed by the firing party from the UCW Officer Training Corps; town band, under the leadership of Mr Jack Edwards; wounded from the Red Cross Hospital; Red Cross nurses; University Officer Training Corps; Aberystwyth Silver Badge Detachment; Aberystwyth Special Constabulary; Church Lads Brigade; Cadets; 2nd Aberystwyth Scouts; Girl Guides; boys of the National School; members of the YMCA; the ex-mayor, Corporation and officials, and Rheidol Lodge of Oddfellows.

The cortège proceeded through Alexandra Road, Terrace Road, North Parade, Northgate Street and Llanbadarn Road to the cemetery, the band playing the 'Dead March in Saul' and Welsh hymns. At the Cemetery, the service was conducted by Rev. Joseph Edwards, (minister of Bethel Welsh Baptist Chapel in Baker Street) and the hymn 'O Fryniau Caersalem' was sung. At the conclusion of the service, three volleys were fired, a drum roll given by Mr E. T. Lewis, and RSM Fear called for a general salute. The Last Post was sounded by Trumpeter A. Burbeck, RFA, who, with his comrade, Gunner Howard Hammond, RFA, took part in the band.

William Eustace Davies

William Eustace Davies was a stoker in HMS *Dublin*, one of 250 vessels involved in the Battle of Jutland. During the engagement on 31 May and 1 June 1916, HMS *Dublin* fired 117 shells and helping sink a destroyer, and received thirteen direct hits, killing three sailors and injuring twenty-seven. Throughout the engagement, Davies was in the bowels of the ship hearing the guns firing, feeling the impact of shells hitting the vessel but knowing little or nothing of what was going on, surely a terrifying experience. After hostilities ceased, Mr and Mrs Davies moved to Cambrian Street, naming their house Jutland in commemoration of the battle. It retains the name to this day.

John Purnell

John Purnell was a Royal Naval Reservist serving as a stoker serving on HMS *Hussar*. A veteran of the Boer War, he was one of five brothers who served in the forces, but the only one in the Royal Navy. During the landings at Gallipoli, the idea was adopted of grounding a ship on the beach with holes already cut into her hull for troops to disembark. Due to (correctly) anticipated difficulties, the beach chosen was 'V' Beach on the Helles Peninsula and the vessel the SS *River Clyde*. Crew of HMS *Hussar* (supposedly) volunteered to crew the *River Clyde* and run her ashore. All did not go to plan, the two barges that were supposed to be used as bridges to facilitate the troops transfer from ship to shore failed to reach their proper positions, and the water was too deep to disembark otherwise. The result was carnage at the hands of Turkish machine guns of those who attempted to land. John Purnell was part of an action that saw the award of four Victoria Crosses, one to a shipmate from HMS *Hussar*.

David John Jones

David had enlisted in the Royal Navy in 1912. His parents lived in Rheidol Terrace, Penparcau. By February 1917, he was serving on Q27.[3] Q-ships were small merchant vessels with concealed armaments. Their aim was to lure submarines to the surface with their innocent looking appearance, then when in range open fire. Vessels were chosen to appeal to U-boat captains as victims worthy of being sunk only by gunfire rather than by a valuable torpedo. Q27, aka *Warner*, was sunk by a torpedo on 13 March 1917 off Loop Head, County Clare, Ireland. David Jones was one of the casualties.

Medallists

Sergeant C. E. Stephenson was mobilised with the Cardiganshire Battery on 4 August 1914. He was subsequently transferred to one of the Highland Brigades. His gallantry during the advance from Cambrai earned him the Military Medal. Previous to Cambrai, he had been in the great retreat of 21 March 1918, the breakthrough in April and more heavy fighting in the cecond Battle of the Marne.

Sergeant H. Pateman, from Llanbadarn, was one of three brothers in the forces. He was awarded the meritorious service medal for unspecified valuable services in France. He had also been wounded three times.

Other local recipients of medals included Gunner Alfred J. Hughes of the Royal Garrison Artillery who received the Military Medal, as did Mr Le Feuve, of the University College of Wales School of Music, for gallant conduct at the front.

Mlle Jeanne Barbier, sister of Professor Barbier, UCW, was awarded the Croix de Guerre with distinction for service in Compiegne, northern France, at the head of the ambulance service during the German bombardment and occupation.

Corporal. T. J. Keane, Rose Villa, was in charge of the telegraph branch at the signal section of the headquarters of the Royal Flying Corps. On more than one occasion, he had been complimented on the performance of his duties and was awarded the Meritorious Service Medal. He had previously worked in Aberystwyth Post Office.

In 1917, twenty-year-old Lieutenant Harries of South Road was awarded the Military Cross for conspicuous gallantry and devotion to duty when in charge of digging and wiring parties in no man's land in France. His coolness and courage set a fine example to his men at a time when great presence of mind was required and greatly assisted them in carrying out a dangerous operation. Lieutenant Harries was presented with his medal by the ing at Buckingham Palace.

Signaller J. Arthur Jones also received the Military Medal. Writing to his mother in October 1918, he explained that as a telephonist he was on duty with four others when the Germans opened up a terrific fire. His comrades crawled to safety through a field, but he stayed at his post, then volunteered to go out and reconnect broken wires under fire but was stopped by his commanding officer ringing him up. He later evacuated the buildings, after the instruments had been smashed up. He was recommended for the medal by a Canadian officer. Private Jones enrolled soon after the outbreak of war when only sixteen years of age. By the time of his award, he had seen service in France and Mesopotamia with the 9th Battalion Welsh Regiment but was transferred to the Cameron Highlanders. He was now nineteen.

Two brothers from Llanbadarn both received medals. Second Lieutenant W. A. Evans won the Military Cross for his actions on 26 December 1917. Lieutenant Evans was educated at Aberystwyth County School and at the University College, where he obtained a degree in science before enlisting at the beginning of the war. After two years as sergeant, he was given a commission. Another claim to fame on his part concerned election to membership of the Carmarthenshire Antiquarian Society under unique circumstances. His nomination paper was signed in an aeroplane by a member who was engaged at the time in operations over enemy lines and seconded by another member while on active service on the front line. His brother Sergeant R. O. Evans, Welsh Regiment, was awarded the Military Medal. Sadly a third brother, Private E. H. Evans of the Cheshire Regiment, and previously an employee of the National Library of Wales, was killed in France on 26 March 1918.

Corporal E. W. Davies, Royal Garrison Artillery and of 7, Lisburne Terrace, was awarded the Military Medal for an act of gallantry on 21 March 1918, the first day of the German offensive. A fortnight before his presentation, his sister Charlotte, a member of the VAD, had been to Buckingham Palace to receive the Royal Red Cross decoration (2nd class) for her services in nursing.

Prisoners of War

Apart from Captain Enos, captured along with his gunner when his vessel *Cheltonian* was sunk by *U72* on 8 June 1917, all other local prisoners of war were captured on the Western Front.

For the families of those taken prisoner, the wait to hear of their loved ones must have been excruciating, not to mention lengthy. John Arthur Hughes was captured on 11 April 1917. He wrote his first communication home on 30 June. He wrote that the other prisoners were half Australians and half British. He added that the work was not too hard. This letter did not leave Limberg Camp until 23 August. It arrived at Reliance House, his parent's home, in late September, the same day as an official letter informing his parents he was officially listed as missing, along with yet another official letter confirming he was now a prisoner of war.

Most Aberystwyth soldiers were captured during Germany's 'Big Push' in March and April 1918. This was an attempt to reach the coast and force back the Allies before the American troops landed in force. Six Aberystwyth soldiers including William Pugh from Greenfield Street were captured within a few days of each other in March 1918. Pugh sent a postcard confirming he was a prisoner of war (POW) at Quedlinburg Camp, which arrived in May. Nothing more was heard until a knock on the door early one morning in late December. At the door was William Pugh who had travelled through Denmark, by ship to Scotland, then to Aberystwyth arriving on the early morning mail train. Since being captured, he had been forced to work in lead, salt and coal mines as well as on farms.

Sergeant Albert Hughes and John Morris Jones were part of the same detachment of the King's Shropshire Light Infantry. Consequently, both were captured the same day, 21 March 1918. Later Jones' parents received an official communication relating the sad news that their son had died in a POW camp. The next day a postcard arrived from their son, dated some two weeks after his supposed death, confirming he was alive and well.

In fact, most returning prisoners of war arrived home in a fashion similar to William Pugh. Some had little opportunity to contact their families to tell of their imminent arrival (telephones were still a rarity). Some preferred to arrive home in modest fashion, away from the limelight. Others had no choice about a quiet homecoming once word got out that they were expected back. When it became known in early January 1919 that J. A. Hughes and Tom Humphreys, both of whom were captured in 1917, were due home, all the stops were pulled out. Those prisoners of war now back in Aberystwyth contacted RSM Fear (who else?) with a view to making arrangements. When the train duly arrived at 6.30 p.m. on a cold evening, the station and streets were lined with thousands of well-wishers. The town band conducted by Mr J. H. Rowe struck up 'See the Conquering Hero Comes' and 'For He's a Jolly Good Fellow'. After a raucous three cheers from the assembled crowd, the two returnees were ushered along with their comrades into a motor bus. The procession, accompanied by other ex-servicemen carrying flaming torches, processed slowly through the town depositing J. Arthur Hughes at the door of Reliance House at the top of Great Darkgate Street and then working their way down to Thespian Street to the home of Tom Humphreys. At each house, a brief speech was given by the returning prisoner, each one no doubt desperate to get inside and see their respective families. At the end of the proceedings, accompanied by more cheers, Lance Corporal David Evans (Dai Military Medal) gave a vote of thanks to RSM Fear.

The next week Albert Hughes and Richard James Davies arrived home on the same train, again to a hero's welcome. They too were greeted by a cheering throng of people, the town band, Mayor, RSM Fear and those previously released. Once again, they were escorted by torchlight through the town to their homes.

Later on, the full extent of their sufferings emerged. Those captured during the 'Great Push' seem to have been particularly ill-treated. They were forced to work on farms, in lead, coal and salt mines; load barges; build railways and dig trenches. All complained

that the food was pitiful. Each morning they received 'coffee' made from burnt barley and sometimes acorns. Their lunch was thin soup, the evening meal another bowl of thin soup and black bread. Most said they would have starved without Red Cross parcels. On hearing of the signing of the Armistice, all the prisoners at Tom Humphreys' camp refused to work. As punishment, they were forced to stand by their beds for six hours, their heads looking up. William Pugh was working on a farm owned by a rich farmer at the time the Armistice was signed. He was told of the signing by a German woman who had befriended HIM.

Shortly after arriving back in the town, Tom Humphreys and J. A. Hughes were back in action of a different sort. Both participated in a football match between a combined navy and army team against the university. The services team won 2-1, one of the goalscorers being seaman and champion swimmer Albert Davies.

CHAPTER 10

THE HOME FRONT

Before and after the billeted troops had left Aberystwyth, there were plenty of reminders to be had in the town that there was a war ON. There were Belgian refugees, wreckage washed up on the foreshore as a reminder of the carnage out at sea and the ever-present call for more soldiers and a need to conserve food.

Belgian Refugees

Britain declared war on Germany in 1914, ostensibly because Germany had invaded (neutral) Belgium. Britain and Belgium had signed The Treaty of London in 1839, which committed Britain to protecting Belgium. Consequently, there was great sympathy for the Belgians, fuelled by stories in the press of outrages committed by German troops.

Margaret and Gwendoline Davies were granddaughters of David Davies, Llandinam, an industrialist and Member of Parliament (MP) for Cardiganshire 1874–86. They inherited his wealth and undertook many philanthropic works as well as furthering the causes of the arts in Wales. Perhaps with both interests in mind, they approached a number of Belgian artists and musicians with the offer of sanctuary in Wales, where they could continue with their work and contribute to cultural life in Wales.

In total, fifty-two persons escorted by Professor Fleure[1] and described in a contemporary report as being 'distinguished professional teachers, musicians and painters of a high station in life' arrived on the express train from London on 3 October to be greeted by a throng of cheering well-wishers. The local Boy Scouts were entrusted with delivering their luggage to the Queen's Hotel where they were to stay courtesy of the Davies sisters until suitable boarding houses and apartments could be arranged. In the evening, well-wishers gathered outside the Queen's Hotel, and national anthems were sung, in which the Belgians joined in. The next night the Rheidol United choir performed in the Queen's Hotel for the refugees, the singing of whose anthem was much appreciated.

Several local families had made arrangements to take in these refugee families and were disappointed that all were to be accommodated in the Queen's Hotel.

A further twenty-seven refugees arrived the following Friday and more the day after. Smaller groups arrived the following week taking the total to over a hundred, many of whom had little more than the clothes they stood up in. Many were from an artist's colony at Saint-Martin Laethem, near Ghent.

Of particular note were four artists and their families. Georges Minne (1866–1941) was an artist and sculptor. After a short spell in Aberystwyth, he moved to Llanidloes. While

in Wales, he went on to produce over 400 drawings but no sculptures, possibly due to financial constraints.

Raphael Petrucci was a well-known collector of Japanese and Chinese art as well as being a philosopher and sociologist, his wife being the daughter of another Belgian artist. Shortly after his arrival, he promised to involve himself in university life.

Gustave Van de Woestijn (1881–1947) was at the time an up-and-coming expressionist painter. After an initial stay in Aberystwyth, he moved to Llanidloes and, by 1917, London, where his work was so well received that he considered staying there after the war finished. A portrait by Van de Woestijn of Valerius de Saederleer painted in 1914 shortly before the outbreak of war recently sold for €481,000.

Of all the Belgian refugees who came to Aberystwyth, it was Valerius de Saederleer (1867–1941), a landscape painter, who had the strongest link with Aberystwyth. He took a house in Ty'n Lon, Rhydyfelin, and he and his family entered into local life staying until well after the war had ended. Soon after his arrival, he declared himself to be already fascinated by the scenery of Wales and particularly of Cors Fochno, the Dyfi Estuary and the hills beyond.

Amongst the musicians who came to Aberystwyth was Nicolas Lasureux, a well-known exponent of musical art and professor of the violin. His son Marcel was an accomplished piano player. Others were professors at the Brussels Academy. A group of musicians already here swiftly made arrangements to give a concert with the support of the College Musical Club. This took place on 15 October and by popular demand was repeated the following evening at which Lasureux'S father and son were prominent.

The National Library of Wales was fortunate in obtaining the services of a Belgian lawyer, a Mr Broeckart, who helped to classify books received under the Copyright Act and to catalogue the law section, for which his legal background was of immense help. This work was in turn of great benefit to the university'S faculty of law.

Perhaps more in line with the ideals of the Davies sisters, a number of refugees assisted with different aspects of the College Museum, which housed numerous works of art. Restoration and rehanging were carried out by Messrs Minne, Hanard and de Saedeleer.

Not all the Belgian families stayed in the Aberystwyth area. Offers to house them came from many towns in mid wales. Many moved to Barry, while at Lampeter a house capable of accommodating fifteen persons was put at their disposal and arrangements made for their food. Another family moved out to Ysbyty Ystwyth. The Davies sisters encouraged others to settle in Llanidloes and form a small artist's colony. By September 1915, there were reported to be seventy-two Belgians still in the area.

Valerius de Saedeleer produced a number of paintings during his stay in Aberystwyth and held an exhibition in Alexandra Hall in February 1916 and again in the Assembly Rooms in 1919. He also contributed local scenes to the arts, crafts and science exhibition held as part of the Eisteddfod celebrations in August 1916. His works are to be found in the collections of the National Library of Wales and the School of Art. At an auction in Amsterdam in June 2014, one of his paintings, a winter landscape, sold for £115,710.

Not all those who arrived were musicians or artists. M. Heynen, who escaped via Holland with his wife and children, was the manager of a shell and gun factory at Liège. During the bombardment of Liège and the resistance of the Belgian forts against the German invasion, the factory was busy night and day producing 12,000 rifles a day as well as shot and shells. When news was received by telephone that the forts had fallen, 12,000 rifles ready for use, along with three truckloads of shells and ammunition, were thrown into the river to prevent them falling into German hands. His home was not far from the

railway, and one day when a train packed with French and English prisoners of war was passing through, his daughter took a quantity of bread and butter that she handed to the prisoners. A German soldier who was on guard ran after her with fixed bayonet, but she succeeded in reaching the house in safety. Previously, all the windows in their house were shattered when Liège was bombarded. After the entry of the Germans, a man, to whom M. Heynen had given employment and whom he had fed for three weeks, came, to his house dressed as a German officer and pointed him out to a superior as the manager of the works. By then, M. Heynen had sent his wife and children to safety in Holland. He was taken as a prisoner into Germany and was kept there for a fortnight. On promising to continue making shells, he was taken back to Liège and was allowed four hours to secure workmen and start working. Taking advantage of his liberty, he crossed the frontier to Holland where he eventually rejoined his family. The family stayed in Llwynffynnon Lodge in Llanbadarn until September 1915 when they left for London, M. Heynen and his son having obtained work in a munitions factory.

The National Eisteddfod

The outbreak of war led to the postponement of the 1914 National Eisteddfod in Bangor until 1915. However, 1915 was the year the Eisteddfod was due to be staged in Aberystwyth. Consequently, the Eisteddfod was not held here until 1916, but not without much debate. There were many people opposed to the idea. Many thought it tactless to hold such an event during a period of such austerity, turmoil and suffering. Others, perhaps more pragmatic, were concerned about the cost implications to the local ratepayers, especially as there were to be no special trains to bring visitors to the event. The opinion of David Lloyd George was sought, and he came down firmly in favour of holding the event but suggested

Gorsedd ceremony to proclaim the 1916 national Eisteddfod.

a more muted affair than normal. A marquee capable of holding 6,000 seated and 2,000 standing spectators was erected on Vicarage Fields, while the arts and crafts exhibition was displayed in the Alexandra Road School. A number of competitions were dispensed with in order to fit everything into three days, 16–18 August. The consciences of those who thought that such an event should not have taken place under the circumstances were eased by a telegram that arrived on the first day of the Eisteddfod. It read, 'Greetings and best wishes for the success of the Eisteddfod and Gymanfa. Welshmen in the field. Next Eisteddfod we shall be with you. 38th Welsh Division.' In reply, the following telegram was sent 'National Eisteddfod assembled at Aberystwyth, president, Mr Lloyd George, much touched by heartening greeting from Welsh heroes in the field; wishes them all safe and speedy return, and promises great welcome when the time comes. Welsh soldiers will be glad to hear that Aberystwyth Eisteddfod is great success.' This response met with overwhelming approval by those present.

There were a number of local schoolboy winners in the arts and crafts section, especially woodworking. David Lloyd George attended and gave a rousing speech. The Rheidol United Choir won the main choral competition. The marquee was kept in place until the Sunday when a Gymanfa Ganu was held, an event aimed at those who had been unable to attend during the week due to work commitments. The whole event was a success and despite the earlier misgivings of some made a considerable profit, over £1,100.

Recruitment

At the commencement of hostilities, the belief was that this would be a short and chivalrous war. It was viewed in the popular imagination as a series of set piece battles in the traditions of the nineteenth century rather than the all-encompassing stalemate and industrial-scale slaughter that was to follow. Against this belief and the intense patriotism of the period, plenty of recruits came forward, initially in Aberystwyth to join friends in the Cardiganshire Battery but soon after to join other regiments.

For many, the opportunity to sign up to the colours also represented a chance to break away from the monotony of factories, farms, mines or offices for the perceived romance of adventures in foreign parts.

Initially, the task of recruiting officer fell to Sir Edward Pryse of Gogerddan. However, on his volunteering to join the 9th Battalion of the Welsh Regiment the role of recruiting officer for Cardiganshire passed to Major L. J. Mathias, whose family had built up the Cambrian Steam Navigation Co. Ltd.

In October 1914, two recruitment rallies, one at Cardigan on 11th, the other in the Coliseum at Aberystwyth on 23rd were held. Having been an officer in the Cardiganshire Battery until 1912, a prospective parliamentary candidate for Cheltenham in 1910 and with his extensive business experience, Mathias had a skill set that few in the county could match.

At the meeting in the Coliseum, national anthems were sung, the Rheidol Choir performed, and Miss Annie Jones of South Road sang 'Your King And Country Need You'. There followed an impassioned speech by the Rt Hon. Ellis Jones Ellis-Griffiths, MP for Anglesey and Undersecretary for Home Affairs. In his words, '... the great need of Germany was colonies for her surplus population and international trade. She could not have colonies without maritime expansion, and could not have maritime expansion without sea supremacy, and could not have sea supremacy without a victorious war against Britain.

That was the kernel of the war.' Sir Edward Pryse then spoke, ending with 'As a profession the army offered many advantages and was composed of gallant men. The old vice of drunkenness had been done away with. The bulk of the men were teetotallers and well educated, and took pride in their profession. I make an earnest appeal for recruits. When the war was over they would be able to say they had done their duty, while those who preferred to loaf about and smoke cigarettes ought to be jolly well ashamed of themselves'. At the end of the meeting, thirty (some reports said twenty-five) men made their way to the stage to sign up for King and Country.

Major Mathias, on taking up the role, was known for his diligence in travelling to every part of the county in his quest for recruits. Fortnightly, lists giving the names and addresses of the latest recruits were published in local newspapers. By November 1915, he had recruited over 1,000 men from the county.

What was known as the Lord Derby scheme was introduced in autumn 1916, whereby men could 'attest' their willingness to serve. This was not a great success, consequently conscription followed in January 1916.

All single men aged between eighteen and forty without dependents were now liable to be called up. However, reserved occupations, such as munitions workers or food production, were exempt from military service. Those wishing to appeal against conscription on grounds of conscientious objection, hardship or other pressing need had to appear before the Borough or Rural Tribunal to determine whether they could be exempted from military service. Exemptions could be granted until a certain date, such as those studying for examinations. Alternatively, exemptions could be conditional on the appellant remaining in a reserved occupation. The borough tribunals commenced in February 1916 and were convened every Friday. Below are some examples of exemptions

John Richards, farmer, Brynllwyd, Cliff Terrace, aged thirty-four years and single was exempted. He explained that his parents were elderly, both in indifferent health, and he was the only other male on the land. They had thirteen acres under plough, five more than previously, also six milking cows, four yearlings, two calves, four horses, eighty-one store sheep, twenty-one breeding ewes and the same number of lambs. He also worked as an assistant overseer, doing the farm work mainly in the evening.

James Williams was a slaughterman aged thirty-eight years and responsible for killing 400 to 500 pigs a year as well as 100 to 150 carcasses in the surrounding countryside.

Richard Morris, aged forty, married, worked for Mrs Smith of Penynant and looked after six acres of land and a large kitchen garden. The produce of the garden was sold to Miss Tremain of Alexandra Hall.

Frank Smith, UCW, lecturer, Underwood, Iorwerth Avenue, whose application was adjourned from a previous sitting, was exempted, the tribunal clerk stating that he had received a reply to his communication that the appellant's work was of national importance and having regard to Mr Smith's exceptional qualifications he should be allowed to remain at his present post in the Teachers' Training Department.

Edgar Perkins, electricity works engineer and manager, of Brooklyn, Llanbadarn Road, stated that the works were now carried on with the minimum of staff and if further reduced could not be carried on. Five men had joined the forces, and now only he and two qualified men were left.

More contentious were the cases of conscientious objectors, in particular of Dr D. J. Davies, language teacher at the County School, who applied for absolute exemption. His application stated he believed all life was sacred and that he could not take on himself the responsibility of depriving any human of life. He would rather a thousand times give

his own life than take another. They had all received their lives from God, and none but He had the right to take them away. He endeavoured to be a true and faithful follower of Jesus Christ who enjoined them to love their enemies. To him, all war was wrong. It was a sin against the solidarity of the human race and the brotherhood of man. To show that he had held those views for years, he produced articles he had written as well as personal testimonies. He also contended that his work as a teacher was of national importance. He was then subject to a rigorous questioning by the panel.

Mr Henry Bonsall – I am sure you are a brave man and you would be prepared to die for your convictions? – I hope so. I am quite prepared to take any consequences that will happen to me.

HB – Would you object to go on a minesweeper? – Yes. I cannot take part in the military machine in any way.

Would you go in the RAMC, and help to save life? – No. In helping to save life I would be helping to kill at the same time.

Mr D. C. Roberts – Are you not helping the war by not fighting the Germans? – I cannot say that I am.

Capt. Doughton – If you look at it in a proper light you will see that you are assisting the Germans. Supposing the Germans came over here, what would you do? Would you allow them to kill you? – I cannot fight against them. I would not resist them.

Mr Morrison – What Nationality are you? – I am a Welshman, born and bred in Cardiganshire. Mr Bonsall – Supposing the Germans cut your mother's throat and outraged your sister? – I do not say I would not try to defend them; but I would not go so far as to take life.

The Deputy Town Clerk said he failed to see that anyone present could not say Amen to the views expressed in the application. There were thousands of men in the field to whom killing was equally repugnant in ordinary circumstances. He continued questioning Dr Davies.

Where did the difference come in? – I suppose my convictions are deeper.

It is simply a question of degree? – That is the only conclusion I can come to. I do not judge any man.

Mr Morrison – But are you not putting yourself on a pedestal? I hope he does not teach these doctrines in the County School? – I teach no doctrines there.

The Deputy Town Clerk – I am sure Dr Davies is a better man than his views show him to be. – I cannot take human life.

Mr Bonsall – You do not object to enjoying the security the men are fighting for? – I do not ask anyone to give his life for me. – You would not like to preach your gospel in Germany? – I would if I were in Germany.

Other conscientious objectors were a railway clerk and two ministerial students who submitted that it was impossible for them as Christians to undertake service in the furtherance of war which was diametrically opposed to Christianity. Each said they would not object to tending the wounded and alleviate suffering so long as they did not have to take the military oath.

In the case of Dr Davies, exemption was granted as long as he remains a teacher. In the other three cases, exemptions were granted except from service in the RAMC.

This however was not the end of the matter for Dr Davies. Later in the year, the school governors were cajoled by C. M. Williams (mayor in 1916) into terminating his employment.

However, after many protests from past and present pupils, trade unionists and others, the governors were forced to reconsider. After heated meetings and name-calling, the governors withdrew his notice of dismissal and reinstated him. On his return, he received a joyful and noisy welcome from his pupils.

War Weapons Week

In October 1916, the Aberystwyth War Savings Committee organised a public meeting at which churches, chapels, schools, workplaces and any other group were invited to form savings associations. Members were to save a small sum, sixpence or a shilling each week. This money was to be invested in Government War Bonds. In all, 29 local associations were established, their membership ranging from 160 at Alexandra Road Girls School to 8 at the Central Hotel. Others included the Welsh Baptist Chapel with 26, Tabernacl with 92, Teviotdales with 32 and the *Cambrian News* with 12.

By January 1917, the associations had raised £9,328, and by November double the amount. When War Weapons Week was arranged, it was this level of enthusiasm that helped persuade the War Office that Aberystwyth deserved a visit from a tank. This was to be a real-life battle scarred veteran. Thus, backed by promises to raise £250,000 for War Savings, on Monday 9 July at 4 p.m., train whistles were heard across the town. *Julian*, twenty-seven tons and thirty-feet long had arrived. The mayor, corporation, Girl Guides, Boy Scouts, and women farm workers assembled, and, at five o'clock, the procession left the station, *Julian* in the rear. The procession walked and rumbled along Terrace Road

Julian in North Parade.

to the promenade. Opposite the Belle Vue, a mound of earth and timber had been placed for the tank to negotiate. This it did, also a barbed wire fence. The procession turned into Pier Street, down Great Darkgate Street stopping in North Parade. The Mayor and dignitaries then climbed onto the tank. This, said the Mayor, was the kind of weapon their money would buy. He also threw the gauntlet down to the townspeople pointing out that Aberystwyth was one of sixteen towns across Britain holding a War Weapons Week that particular week. By that evening, £29,564 had been raised. On Wednesday, *Julian* repeated the exercise on the promenade helping take the total raised to £67,649. It was reported that one person brought in twenty-five pounds in gold sovereigns, another £50 in loose silver. Each evening meetings were held and people queued to have their photograph taken alongside *Julian*. By Saturday, the sum had reached a staggering £682,138, the equivalent of £76 per head. Although the local inhabitants were generous in their contributions, it was large institutions that invested really large sums. This, it seems, was due to the canvassing work of Major Mathias who secured deposits of £50,000 each from the Manchester Unity of Oddfellows and two banks. A third bank deposited £25,000. Aberystwyth raised £76 per head of population, more than any other town in Britain and second in the British Empire only to Singapore.

On Saturday, *Julian* left North Parade, initially for repairs at the Cambrian Railways repair yard, then on to Dumfries.

After hostilities had ceased, the town was rewarded with a tank of its own which stood in the castle grounds until 1939. The brass plate once attached to it recognising the town's contribution during War Weapons Week, is now in the local museum.

A Boat in the Bay

An aspect of the war unfamiliar to many visitors was brought home to them one afternoon in August 1918 by the appearance of a rowing boat in the bay. The coast watchers alerted local boatmen who went to investigate and found the boat contained ten exhausted and dishevelled sailors from a vessel torpedoed in Cardigan Bay, one badly scalded. Four other crewmen had been killed. The vessel was the *Boltonhall,* en route from Manchester to Gibraltar with coal. Crew and Captain Hugh Jones from Nefyn were taken first to Miramar, in South Marine Terrace, the home of Captain Lloyd the harbour master. They were given a change of clothing, hot food and a bath. For one of the crew, a Spaniard, this was his third time to be torpedoed. Sleeping accommodation nearby was then arranged. A visiting vicar organised a collection and raised £52 for the crew. News arrived later that a further boat carrying nineteen more crew had landed safely at Tywyn.

Influenza

The first outbreak of a strain of influenza that came to be known as Spanish flu arrived in Aberystwyth in July 1918 but did not result in any deaths in the town. The outbreak returned in October and was of a more virulent and infectious nature. How many were killed is open to conjecture, but numerous deaths of younger people were recorded – Spanish flu seemed to effect young adults in particular. This is thought to be because the virus causes the body's immune system to overreact and attack the body of the sufferer. The very young and old having weaker immune systems therefore suffered less. Others

died from related complications such as pneumonia. The virulent nature of the strain was thought to be in part as a result of war time conditions, in particular rationing of foodstuffs that had led to a weakening of people's immune systems.

In order to protect the population, schools were closed, and in late October, an announcement that all meetings and entertainments within the borough that could possibly be dispensed with should be postponed or abandoned until further notice. One concert alone was blamed by the authorities for one hundred and twenty new cases of Spanish flu, some fatal. The public library was closed for cleaning and fumigating; the university was closed until further notice; patients at the Red Cross Hospital were prevented from visiting local families, and a number of shops had to close temporarily as there were not enough staff available due to illness. Despite these precautions by the end of November, the epidemic was still spreading. The threat of Spanish flu did not, however, prevent crowds thronging the streets on hearing of the signing of the Armistice.

By late November, in desperation and to try and stop the spread of flu, Dr Harries, the acting Medical Officer for Health for Cardiganshire, employed the town's bellman to walk the streets and advise people not to attend church or chapel services. The Free Church Council was up in arms complaining that Dr Harries had overstepped the mark. However, Dr Harries' judgement was backed up by many others in the medical field. The epidemic seems to have subsided by Christmas with the number of deaths of young people being very few and a return to social gatherings and meetings. Dr Harries wrote in his report for 1918 that there were a total of sixty deaths from influenza in the Urban districts of Cardiganshire, thirty-four female and twenty-six male. As Aberystwyth is the largest of the urban areas, it can be surmised that the outbreak killed in the region of forty persons in Aberystwyth.

Aberystwyth Month by Month

1914
May
- College held its 33rd Annual Sports Day. The 34th Annual Sports Day would not be held until 1919.
- Golf Course on Brynymor officially opened.

June
- Former Borough Accountant Charles Massey brought back from New Zealand to face charges of embezzlement. He is committed to trial.
- Reopening of Plascrug Bowling Green.
- 28th – Archduke Franz Ferdinand of Austria assassinated in Sarajevo.

July
- UCW Officer Training corps left for their annual camp near Edinburgh, Scotland.
- Hot-air balloons land in vicinity of Aberystwyth.
- Territorials arrive at Capel Bangor for their annual camp.

August
- RNR mobilised and marched to the railway station through cheering crowds on Sunday 2 August.
- Britain declared war on Germany on 4th.

- Two bronzed and weather-stained men arrived on foot from Aberaeron. The previous day their suspicious appearance – one of them was wearing spectacles – had led to their being interrogated by the local police in Aberaeron and accused of being German spies. It transpired one was a doctor from Bristol and the other a clergyman.
- Leonard Douglas Ponting and Alfred Silverstone arrested for obtaining money by false pretences – selling 'exemptions' from military service in Llanilar.
- Thirty-five persons of other than British nationality – so-called 'aliens' – registered with the police in Aberystwyth.
- 23rd–24th Battle of Mons, also known as the retreat from Mons. George Hicks from Aberystwyth is involved.

September
- Llewellyn George Hicks, a veteran of the Boer War, was invalided home after fighting with the South Wales Borderers at Mons. Extracts from his diary are published in the *Welsh Gazette*.
- Two hundred men enroled at Aberystwyth as Special Constables.
- The town's tobacconists started collecting cigarettes for the Battery and wounded soldiers. In the first two days, 1,456 cigarettes are collected.
- A balloon released on Marine Terrace was blown over the town and mistaken by some of the more imaginative visitors for a German Zeppelin.

October
- 9th – News received from France that Tommy Williams of Bryn Place, Eastgate who had enlisted in the French Army had been wounded.
- 13th – First Belgian Refugees arrive in Aberystwyth.
- 14th – Protest demonstration against Dr Ethe and other Germans working in town. Dr Ethe hurriedly leaves town.
- 19th – Commencement of First Battle of Ypres, lasted until 22 November.
- 22nd – Ponting, who had a long criminal record, was jailed for two years with hard labour. Silverstone acquitted. Prisoners of ships sunk by *Karlsruhe* released at Tenerife.

November
- Both Nanteos and Gogerddan mansions were to be made available to wounded Belgian soldiers. Neither offer seems to have been taken up.
- Two ladies sketching in the harbour were mistaken for German spies.
- Aberystwyth's first fatality of the war – Lt Anwyl Ellis (RNVR) drowned when motor launch *Lady Lel* sank in Loch Ewe.
- Public House opening hours to be restricted from 7 a.m. to 10 p.m.
- Two milk floats collided in Cambrian Street.
- Five 'aliens' from Aberystwyth moved to a concentration camp at Newbury.

December
- Mail carts between Aberystwyth and Aberaeron are taken out of service.
- Arrival of troops for billeting over the winter. In all, 179 officers and 7,055 men arrive in three days.
- The local YMCA organise a concert at the Skating Rink on Christmas night for the troops.
- On Boxing Day, the troops organise their own Eisteddfod.

- An Aberystwyth soldier in the Pembrokeshire Yeomanry complained that soldiers from other towns in his unit get parcels but not those from Aberystwyth.
- British Women's Temperance movement organised a social gathering for wives of soldiers and sailors. No lfewer than 250 attended.
- Arthur Owen, tailor and outfitter, of Chalybeate Street had undertaken contracts for several hundred pounds to make officers uniforms.
- From 12 December, the price of a four-pound loaf will rise to 7*d* (4p).
- Public houses in Aberystwyth, Llanilar and Llanbadarn allowed to open only between 9 a.m. and 9 p.m.

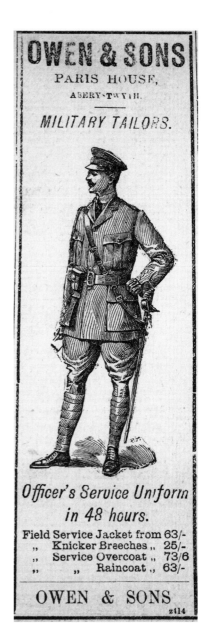

Advertisement for Owen & Sons, 1914.

1915

January

- The Aberystwyth-born poet, Alfred Noyes, appealed to America to enter the war.
- Battle of Dogger Bank. Two Aberystwyth sailors – J. J. Silcock and Dick Brodigan were on board HMS *Aurora* during the battle.
- Red Cross Hospital established in Bridge Street for billeted troops.
- An ex-Aberystwyth graduate interned in Germany wrote to say that he had met three other Aberystwyth graduates in his camp.

February

- HMS *Jupiter* sets sail from North Shields to the White Sea.

March

- Second Lieutenant Arthur Evans, Broniarth, North Road, killed in motorbike accident at Porthcawl.

April

- Commencement of the Second Battle of Ypres. It lasted until 25 May.
- Cardiganshire Battery lose 3-2 to Letchworth at soccer.
- Divisional parade on Vicarage Fields for presentation of Royal Humane Society medals.
- Bronpadarn mansion sold to Major Mathias for £6,000.
- Seaside landladies now have to issue all guests with registration forms requesting details of nationality.

May

- Troops billeted in Aberystwyth since December start to leave for Northampton.
- *Aberystwyth Observer*, goodwill and copyright offered for sale. No bids. Printing equipment sold off in lots.
- Sinking of *Lusitania* with loss of 1,198 lives including Frederic Robert Jones of Aberystwyth and Walter, the brother of J. C. Maclean, organist at Tabernacl.
- Price of a four-pound loaf increases to nine pence.
- Last edition of *Aberystwyth Observer* published.
- Ivor Christmas Phillips became the first Aberystwyth soldier to be killed in action, at the Battle of Aubers Ridge.
- Fifteen RNR sailors from HMS *Jupiter* home for fourteen-day leave.
- Devastating fire at St Davids Club.
- Elwyn Thomas, whose home is at Castle Lane, Trefechan, evaded a military escort at Chester, having deserted from the 10th South Lancashire Regiment. After his escape, he joined the 3rd Queen's West Surrey Regiment and again deserted, this time from Chatham. He succeeded in reaching Aberystwyth on Monday but was arrested by P. S. Thomas Davies.

June

- Proclamation ceremony for 1916 Eisteddfod held in castle grounds.
- A total of 551 appeals for recruits posted to men aged between nineteen and forty locally. Only 102 replies are received, with 24 signifying their intent to enlist. Reasons given

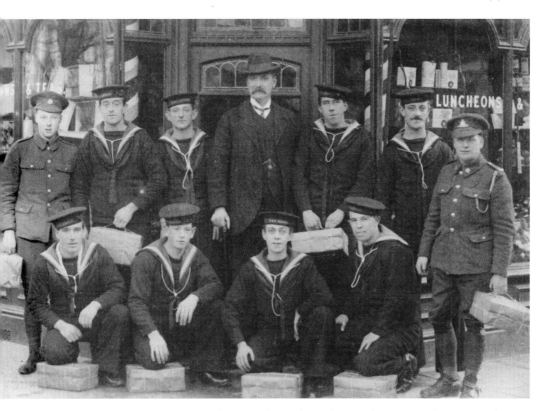

RSM Fear with the first batch of Comforts Fund parcels. Back Row (l-r) T. Humphreys, J. Pugh, W. J. Roberts, RSM Fear, R. A. Jones, W. James, T. Doughton. Front row E. J. Davies, R. Jones, J. Pugh, T. O. Jones.

for not enlisting included: 'Yes, when all the single men have gone' and 'Yes, when the government compels me'.

- Complaints that the price of bread has being reduced in many places, but not in Aberystwyth.
- RSM Fear instigated the Aberystwyth Comforts for Fighters Fund.
- Town council was criticised for spending £30 per month on a band for the promenade. Many see this as frivolous and distasteful bearing in mind the suffering of those in the trenches.

July

- Wreckage from *Strathnairn* washed ashore (torpedoed near Pembroke).
- Messrs Bostock and Wombwell's menagerie visited the town.

August

- Suffragette Flora Drummond addressed a patriotic meeting for women in the Coliseum on 'The Dangers of German Invasion.'
- Belgian refugee Mr Vervoordt, his wife and seven children who have been living in Ponterwyd for six months decided to move to London.

September
- Aberystwyth and Aberdovey Steamship Company entered into an agreement to sell their remaining vessel *Grosvenor* ending the last regular steamer service to and from Aberystwyth.
- Defence of the Realm Act came into force. As a result, numerous guest house owners appear in court for not obscuring lights that could be seen out at sea. R. Rowlands 'The Pioneer', North Parade offers double-width casement cloth in green, saxe, cinnamon, navy or cream with which to darken windows.
- A photograph of three Aberystwyth men ha been sent to friends in Alexandra Road by a member of the 5th RWF who picked it up on the Gallipoli peninsula. The photograph taken by local photographer William Jenkins was given to one of the 4th Cheshire battalion billeted in the town last winter.

October
- A five-zeppelin raid on London killed seventy-one people including Miss Katie Jones who was returning home after working in the family business when struck in the back by a piece of shrapnel. Both Miss Jones' parents were from the Aberystwyth area. Her coffin, accompanied by forty wreaths, was returned to Aberystwyth by train the following Monday night and taken to Seilo C. M. Chapel where it rested until the funeral and internment the following day.
- Councillor Robert Doughton recommended the construction of a marine lake near Castle Point.
- A letter home from Private E. Worthington, one of fifteen or so Aber boys in the 9th Battalion of the Welsh Regiment related the sad details of the failed attack at Pietre, part of the Battle of Loos in which Lt W. H. K. Owen of Aberystwyth was killed. Worthington was to be wounded three times subsequently before his luck ran out at the Battle of Messines.

November
- Application made to turn theological college into Red Cross Hospital.
- First meeting of the Borough Profiteering Committee. (Their aim is to stop profiteering, not to profiteer themselves.)
- Major Mathias, Recruiting Officer for Cardiganshire, has now obtained over 1,000 recruits.
- At the annual hiring fair, there was a shortage of male labourers; consequently, those available were able to command higher wages. Female farm workers were in demand, but there was no rise in the wages offered.

December
- Confirmation that patients at the Red Cross Hospital are to be convalescents, no serious cases necessitating operations to be sent. Around £1,000 needed to meet the expenses of the hospital with fifty beds.
- Aberystwyth War Services Committee raised £104 through a sale of agricultural stock and produce. The greater part of the proceeds will be donated to the National Fund for Welsh Troops, the rest to other deserving war funds.
- Cardiganshire Battery was in action in France over Christmas.
- Tenants were informed that the Abermad estate has been sold to an undisclosed buyer.

1916
January

- Photographers E. R. Gyde and Pickford enter into a business partnership.
- Convalescent soldiers are being taken on drives in the locality.
- Tobacconist Jack Levenson advertised 'Archdruid cigarettes are now packed in strong boxes suitable for postage abroad'.
- Five members of the 'Red Globe Gang' arrested and appear in court for breaking into a sweet shop.
- Sixty men signed up for the Volunteer Training Corps, the First World War equivalent of the Home Guard.
- Sub-post office in Terrace Road closes on 31 of the month. Postal services are to be reduced to only two deliveries a day.

February

- The reign of terror continues with two members of Red Globe gang arrested for breaking into a shoe repair shop.
- Sister G. Morris, town district nurse before the war reported taken prisoner by either Austrian or Bulgarian hands, was there under the auspices of the Serbian Relief Fund.
- Battle of Verdun commenced on 21st.
- Y. Goeden Fawr, a landmark near Penparcau, falls in a storm. Its circumference was measured at eighteen feet. Unfortunately, the interior of the trunk was diseased.
- First meetings of the Borough and Rural Military Tribunals held to examine appeals for exemption from military service.

March

- First sitting by Borough Military Tribunals hears twenty-seven cases. Meetings are to be held every Friday morning until all cases are dealt with.
- Wm. J. Roberts killed in an accident while at work in Lion Quarry below the golf links.
- W. T. Jones of the RWF arrested in the town for being a deserter.
- Married men organised a meeting to protest against the government's policy of calling up attested (those who have voluntarily enlisted) married men before unattested unmarried men.
- War Services Committee to arrange collection of Sphagnum Moss for use in military hospitals.
- Assistant bishop Monsignor De Wachter visited Belgian refugees in the vicinity and said Mass in St Winifred's Roman Catholic Church. His sermon is delivered in Flemish.
- Dr D. J. Davies, a teacher at the County School appealed to the Military Tribunal for unconditional exemption on the grounds of conscientious objection. Appeal granted, but not the end of the matter.

April

- Three Belgian refugees were mistaken for escapees from Frongoch POW.
- Letters appeared in the local press from serving soldiers ridiculing appeals to the Rural Military Tribunal by members of the farming community.
- David Roberts & Sons, brewers, obliged to increase the cost of Table Ale from 3/6d per dozen to four shillings (20p). Before the war, Table Ale sold for 2/6d a dozen.
- Tercentenary of Shakespeare's death celebrated.

May

- *Cambrian News* started being published in a smaller format due to an increase in the cost of paper and a shortage of materials.
- Newsagented start charging a penny a week to deliver newspapers.
- Mrs Pugh, No. 38, Portland Road, had received from her husband, Seaman James Pugh, RNR., a silver medal which he has received from the tzar of Russia in recognition of services rendered to the Russian Government in the White Sea last winter in salving SS *Thracia*, a 2,891-ton Cunard liner with a valuable cargo on board. Medals have been awarded to thirteen members of the crew of HMS *Jupiter* belonging to Aberystwyth.
- Local schoolchildren are allowed to attend a rehearsal of Shakespearian plays in the college examination hall.
- School governors discuss the matter of Dr D. J. Davies and vote 5–4 to retain his services.
- The Red Globe gang struck again, this time stealing from grocer Richard Ellis. Apprehended, the two miscreants were sent to reformatory schools.
- A deputation of Welsh MPs successfully canvas the Chancellor of the Exchequer for an extra £10,000 for the National Library of Wales. The money will be forthcoming if the Library itself raises a further £10,000.
- Empire Day – County School pupils got a half-day holiday. In the evening, a procession was organised.

June

- Battle of Jutland 31 May–1 June involved three Aberystwyth sailors – W. E. Davies, Tommy Brodigan and John Warrington.
- First Aberystwyth Boy Scouts held their annual camp at Gogerddan.

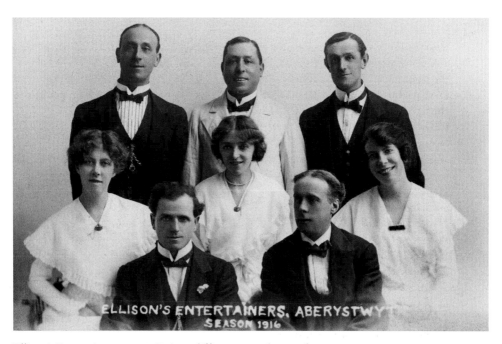

Ellison's Entertainers, 1916. Quite a different complement from 1914.

- Ellison's Entertainers commenced their third season in Aberystwyth, performing three times daily at 11 a.m., 3 p.m. and 7.30 p.m.
- Governors of the County School discussed the future of Dr D. J. Davies, a language teacher at Ardwyn County School and conscientious objector.

July

- Second Battle of Somme commenced on 1st of the month. It was to last until 18 November.
- St David's Club reopened after last year's fire.
- A proposal was made to keep the Eisteddfod marquee until the Sunday of the following week so that a Gymanfa Ganu (singing festival) can be held.
- Pier Pavilion showed 'Williamson Expedition Submarine Moving Pictures' – at the time the first and only moving pictures to be taken under the ocean.
- Rumours that the Aberystwyth Volunteer Corps had fallen through are denied, merely that drills have been stopped for the summer months. Members continue to meet on Wednesdays to practise rifle shooting on the Buarth range.
- Seaman Gunner Thomas Owen Jones, Portland Road, was honoured by the Russian Government. Mr D. Williams, North Parade, has received a communication that on Thursday on board HMS *Nepaulin*, Seaman Gunner Tommy Jones was presented with the Russian medal for services rendered in the White Sea aboard the HMS *Jupiter*. The presentation was made by Commander Biggs, DSO.
- An appeal against enlistment for country blacksmith Evan Tom Jones of Llanfarian is supported by a petition signed by seventy-three farmers, four wheelwrights and a timber haulier. Many blacksmiths were called up leaving many rural areas without their essential services.

August

- Second anniversary of the outbreak of war commemorated at St Michaels with a day of solemn supplication and intercession for God's blessing on the nation during and after the war.
- Death from Malaria of Captain William Edward Jenkins, Tanycae. As master of the supply ship *Benshaw*, he had been at the Battle of the Falkland Islands and at Coronel.
- Seaman James Lewis Pugh, son of Mr and Mrs John Pugh, of No. 5, Glanrafon Terrace, was presented with the Russian medal on board the HMS *King Alfred* by the Commander in the presence of the whole of the ship's company, for service rendered while serving on HMS *Jupiter* in the White Sea.
- Seaman Gunner Thomas Owen Jones married Margaret Wright at Shiloh chapel.
- National Library of Wales admits readers for the first time on 19th.
- Price of a four pounds (1.8 kilo) loaf reduced from 9d to 8d.
- Alexandra Day on 21st is held in honour of Queen Alexandra. Wild roses were worn in the town in her honour. These were sold by local ladies, including Belgian guests, in aid of war service funds and worn in button holes. The arrangements for the sale were made by the War Service Committee.
- Llanfihangel Genau'r Glyn officially changed to Llandre. The new name was first used in Talybont sessions, on 2 August.
- Patriotic Sale in National School, Penparcau.

- Wounded soldiers entertained at Borth, by watching sports on the sands and tea at the Grand Hotel. They are each given forty cigarettes and a souvenir group photograph.
- National Eisteddfod held in Aberystwyth. Marquee erected on Vicarage Fields capable of holding 6,000 seated and up to 2,000 standing spectators.

September
- First Zeppelin shot down over Britain.
- Girl telegraph messengers appeared in Aberystwyth for the first time.
- An impromptu concert in the castle shelters by locals and visiting colliers raised £12 10s 6d (£12.53p) for the Red Cross Hospital.
- Forty members of the Volunteer Training Corps attained proficiency badges.
- A marine lake 160 feet long and 44 feet wide is in the course of construction near Castle Point. The remains can still be seen today.
- A rumour went around the town that a portion of land will be made available to women only for growing vegetables for the hospital and the Fleet.
- Private Trefor Lewis died of wounds from the Battle of the Somme at Hampstead Military Hospital on 20 September and was buried subsequently in Aberystwyth. Being the first local funeral for a fallen hero from the front, it aroused considerable attention. Prior to joining the RAMC, he had been employed in the National Library of Wales.
- A Flag Day was held in Penparcau to raise money for wounded British Army horses; £2 14s (2.70p) is raised.

October
- Comforts for fighters – Seaman E. James Davies wrote,

 It is very nice to know that someone is thinking of the boys of dear old Aber. I can tell you that the cigs come in very handy to us. I was very sorry to see in the '*Cambrian News*' of the death of Johnny Howard, one of my old school chums; also Oswald Green. I am very glad to state, that I have been awarded the silver medal for services in the White Sea on board H.M.S 'Jupiter'. I am now on a foreign station.

- Tobacconist Jack Levenson of St Davids Road married Kitty Goldstein at the New Synagogue, Cheetham Hill Road, Manchester.
- New lighting restrictions came into force on 16th – shops will now close on Tuesdays, Thursdays and Fridays at 6 p.m.; Mondays at 7 p.m.; Wednesdays at 1 p.m.; and Saturdays at 8 p.m.

November
- *Edith Eleanor*, the last ship to be built at Aberystwyth, sold to owners in Wexford for £1,650.
- Women from the steam laundry left Aber by 8 a.m. train, amid cheers, to work in a munitions factory.
- Price of a 4lb loaf of bread increased from 9d to 10d (4p).
- Appeal for more men to join the Volunteer Training Corps.
- Troops writing home complained about mud.
- Soldiers from the Red Cross Hospital took a stall at the Chrysanthemum Show to sell their handicrafts. Their stall proves very popular and soon sells out.

December
- Football match played between Aberystwyth Wednesdays and Padarn United to raise funds for RSM Fear's Comforts for Fighters Fund.
- The first lady conductress is appointed on the Aberystwyth–Aberaeron motor bus.
- Numerous complaints were made about doorbells being rung at night and the miscreants running away.
- Memorial service held at Holy Trinity Church for Private W. H. Jones, the first member of the church to die on active service. A member of the choir and a sideman, he died from malaria in Salonika.
- Council roadmen asked to go to France to construct military roads.
- At Edgware Road, magistrates 'Professor Melini Morgan', a palmist, clairvoyant and astrologer, was convicted of fortune telling and fined £50 plus £10 10s (£10.50p) costs. The magistrate called him a charlatan and a humbug. His real name was Thomas Morgan, originally from Brynblodau, Trefeurig. Before moving to London, he carried on a business of palmist in Aberystwyth.[3]

1917
January
- Boy Scouts picking sphagnum moss to be used for wound dressings.
- Sapper George P. Rees of Trinity Road was recovering from shell shock at a London hospital. An explosion at Silvertown munitions factory in the east end of London blew a window in over him. The blast killed 73 people and injured over 400. It was heard fifty miles away in Cambridge.

February
- The town's remaining plumbers had a meeting at which they discuss the best way to serve their community. They agree to act as one firm to ensure that they are able to assist each other and provide a reliable service with as little delay as possible.
- Allotment holders met with the Corporation Food Committee to urge them to lower their rents.
- Captain the Rev. D. Cynddelw Williams was awarded the Military Cross by the king. He continued to serve as chaplain and cater for the spiritual needs of troops throughout the war.

March
- Hundred and twenty-five soldiers were made available to Cardiganshire farmers to help with ploughing.
- The cyclist section of the Boy Scouts collected nine sacks of sphagnum moss at Goginan.
- The university allows Cae Siencyn on the Buarth to be used for allotments.

April
- The United States of America declares war on Germany.
- On 20th, Thomas Owen Jones was at the helm of HMS *Nepaulin* when she hit a mine near Dyck Light Vessel, not far from Calais. Jones was drowned.
- The Cardiganshire Battery were in action during second Battle of Gaza.
- There is now a scarcity of potatoes in the district. Market gardener Tom Morgan is taken to court for illegally selling potatoes from his cart in Princess Street. A hundred local women attended to offer him their support.

- Due to restrictions on brewing beer is set to rise in price. Local beer is to go up from 4.5 to 6 pence a pint; Burton beer from 4.5 to 7 pence and half-pint bottles from 3.5 to 5 pence.

May

- Sixth Private Joachim Bonner, South Wales Borderers, son of Mr and Mrs Evan Bonner, No. 3 Brewer Street, killed in France.
- Thomas Herbert Morgan from the Cardiganshire Battery reported missing. He was alive and well – it was an administrative error.
- On 16–18, food economy exhibition at the rink.
- The Ministry of Food sent out a letter to every household regarding food economy – 'We must all eat less food, especially bread, and none must be wasted'.
- Lifebelts and wreckage with Greek lettering washed up on local beaches.

June

- The sorting van on the mail train from Aberystwyth to Shrewsbury was discontinued.
- Dr Ethe passed away in Bristol.
- Landlady of the Nags Head fined £1 for contravention of the Liquor Control Board Order – selling beer at 4.15 p.m.
- Captain Enos of Pinedene, North Road, Aberystwyth taken prisoner when his ship Cheltonian was sunk off Marseilles.

July

- A sign that things are getting tighter on the home front – a demonstration on fruit bottling held at the skating rink.
- A decree under the defence of the realm act cancelled all pleasure boat licences, including those connected with fishing for pleasure. No new licences will be issued to anyone under the age of sixty.
- Negotiations are under way to bring munitions workers to Aberystwyth for a week-long holiday.
- Commencement of Third Battle of Ypres, also known as Passchendale on 21st. Battle lasted until 6 November.
- Sir Robert Fossett's Circus visits Aberystwyth for the first time in sixteen years.
- Fresh Mackerel are being sold at 4*d* for a small one, 6*d* for a larger fish.
- Thomas Owen & Co. Ltd of Ely Mills, Cardiff offer 3/6*d* (18p) per hundredweight for waste paper.
- An inspector from the Ministry of Food visited Aberystwyth and has talked with the local authorities, bakers and confectioners. He expressed surprise that in the light of food rationing the Food Control Committee had not taken action with regard to lighter fancy pastries and that the making of these must cease.

August

- Due to a combination of hot weather and severe restrictions on the brewing of beer, many pubs in Aberystwyth ran dry.
- Negotiations to bring munitions workers for a holiday fell through.
- Robert Humphreys from Llanberis remanded for a week for wearing military decorations to which he was not entitled. He was subsequently sentenced to two months' hard labour.

- Celebrating the 31st anniversary of Holy Trinity Church, it was noted that on the Roll of Honour on the Church door, there were the names of 101 communicants who have joined the colours and ten who had been killed. A large number of the women and of the older men have gone into munition works and taken up other forms of national service, so that fully one-third of the congregation has left the town in consequence of the war.

September

- Fifty-one wounded soldiers arrived from Neath by train on 21st.
- Captain George Fossett Roberts promoted to Major.
- Flag Day in Aberystwyth in aid of St Dunstan's Home for visually impaired ex-servicemen.
- More pubs ran dry.
- Albert Davies, serving on HMS *Caesar* stationed in Bermuda, wins the quarter of a mile open swimming race.
- Complaints that the field planted with potatoes by the College Women was a disgrace, overgrown with weeds, and that there was no sign of potatoes, beans or anything else.
- Captain H. H. Payne, previously a lecturer in physics, awarded the Military Cross.

October

- John Arthur Hughes of Reliance House, Upper Great Darkgate Street, confirmed as being a prisoner of war in Limburg Camp.
- YMCA opened its doors in North Parade.
- The mayor gave notice of motion at a meeting of the County School Governors that the employment of language teacher Dr D. J. Davies, a conscientious objector, be terminated.
- The price of coal increased. The Town Council attempted to cap the price that can be charged. The local coal merchants refuse to sell at the price set. To overcome the deadlock, an assessor was brought in who points the finger of blame at the coal companies for charging the merchants high prices.

November

- Cardiganshire Battery involved in heavy fighting during the third Battle of Gaza.
- A meeting is held at the Town Hall to address the problem of food profiteering. Two days later, a demonstration is held in the town.
- At the instigation of ex-mayor C. M. Williams, governors of the County School vote by a majority of one to dismiss Dr Davies. One hundred and nineteen past and present pupils write in on his behalf.
- Children, mainly boys, from the County School excuse themselves from school and parade through the town chanting 'The Governors should be shot, shot, shot' and 'C. M. Williams should be shot, shot, shot'.

December

- The maximum retail price of butter raised from 1/10d to 2/2d a pound. Milk is now being sold at 5d a quart, a penny more than last year.
- An exhibition is held at Alexandra Hall to showcase articles by Belgian refugees now living at Uden in Holland. The exhibition, a sale of work by students and a sing-song raise over fourteen pounds for the War Victims Relief Committee.
- A motion was put forward at the monthly meeting of the County School Governors 'That the motion passed at the November meeting to terminate the engagement of Dr Davies

be rescinded'. The governors defered the matter in what the newspapers call a 'lame and impotent conclusion'.

- The District Agricultural Committee decided not to plough up the golf links, but strips of land adjoining the course were to be ploughed.
- Convalescents from Red Cross Hospital visit the cinema on Christmas Eve. On Christmas Day, a tree was erected in the hall of the Red Cross Hospital and presents distributed.
- The Rheidol United Choir performed 'The Messiah' at the Coliseum on Boxing Day.

1918
January
- Farewell performance by 'Monty and Carlo' – Drummer Wagner and Private Basson whose double act was immensely popular in the town.
- T. R. Fear outlined his plans for a Memorial Hall, the present arrangements for the YMCA being inadequate.
- Governors of County School decided to withdraw Dr Davies notice of dismissal after a heated three and a half hours of meeting. He returns to school to a tremendous ovation from his pupils.
- The Vegetable Committee announce that they have sent two and a half tons of carrots and a ton of swedes to the Royal Navy.
- The body of an unidentified sailor is washed up near Ffoslas, just to the south of Aberystwyth.
- Enquiries about the possibility of housing forty German prisoners of war at the workhouse were roundly condemned.

February
- Women got the vote.
- A gas explosion at a shop in Bridge Street caused damage, but there are no casualties.
- Professor Pope, professor of chemistry at Cambridge, addressed the College Scientific Society on the subject of colour hotography.

March
- An illustrated lecture by Mr S. G. Jones, MSc., on the cultivation of the potato is held in the Old College. Children aged under fourteen are not permitted to attend.
- Seed potatoes were distributed to allotment holders.
- Cllr Robert Doughton died aged seventy-nine.
- German prisoners of war pass through Aberystwyth on their way from Frongoch POW campto Lampeter. Some are allowed to stretch their legs on the railway station platform.

April
- Baron von Richtofen, 'The Red Baron', shot down and killed on 21st.
- Revision of military age up to fifty years.
- Ration cards for meat, butter and margarine were issued and came into force.
- Captain Boillet addressed a meeting in the Town Hall on Alsace-Lorraine.
- Baker Street Welsh Congregational Chapel Band of Hope raised £5 for the 'Starving Prisoners of War Fund'.

May

- The USS *Allen* and USS *Patterson* claimed to have sunk a German U-boat in Cardigan Bay.
- Progress was being made on the new allotments both at the side of the National Library and on the slope in front of the library, but the latter needed much weeding. Satisfactory progress had also been made on allotments at Cae Bach and at the side of St Michaels Church.
- A White Elephant and Garden Produce Sale was held at the Skating Rink, the proceeds going to the Comforts Sub-Committee of the Aberystwyth War Service Committee to provide comforts for the troops.
- The Speedwell, a fishing smack built in Aberystwyth, was purchased from owners in Liverpool and brought back to Aberystwyth by Henry Thomas of Rheidol Place.
- Timber felling was in progress in the Rheidol Valley and near Devil's Bridge. The timber was transported on the Vale of Rheidol Railway, thence to South Wales for use as pit props.
- Ellison's Entertainers opened their summer season.
- The mayor convened a meeting to make preparations for a War Weapons Week in July.

June

- Body of a sailor washed up on Llanrhystud beach. The only form of identification was the name 'Thompson' sewn into his jumper. He was buried in the YMCA grave space in Llanbadarn cemetery.
- First donations made towards a war ,emorial.
- Performance of 'Snow White and the Seven Dwarfs' at the Coliseum along with a presentation by the mayor on behalf of the Battery of a walking stick and £8 to RSM Fear. He pledges that the money will be put towards a new YMCA building.
- Preparations began to celebrate the French National Day on 17 July.

July

- War Weapons Week between 8th and 13th of the month. The total raised was way in excess of even the wildest imagination.
- French National Day celebrated with a concert at the Coliseum organised by Madam Barbier, wife of the professor of french. Items included Welsh and French folksongs, tableaux, dances and a short play.
- Russian Royal family murdered on 18th.
- Gunner R. J. Davies, RFA, wrote home stating that he is well and a prisoner at Langensalza, Germany. He was reported missing on 27 May when Berry-au-Bac Bridge was stormed by the Germans.

August

- A large number of visitors throng the town, many munition workers from South Wales and Birmingham. The amount of meat allocated to the town is insufficient. A meeting of the local Food Committee authorises butchers to obtain more sheep from local farms.
- The slaughter continues with the commencement of second Battle of the Somme.
- Mark Hambourg gives what is described as the best piano recital in the town in sixty years at the Pier Pavilion.
- Due to the influx of visitors, the Post Office is as busy as at Christmas and lodgings are hard to come by.

- Police moved people along for singing in the castle shelters as they were in breach of a 1906 bylaw preventing singing within 100 yards of a place of entertainment.
- A rowing boat containing ten sailors from a vessel torpedoed in Cardigan Bay reaches Aberystwyth Harbour. The crew were shown much kindness by townsfolk and visitors alike. A collection for them raises £52.

September

- Second Lieutenant Roderick A. W. Richardes, nineteen-year-old heir to the Penglais Estate, was wounded and taken prisoner of war by Bulgarian troops at the Battle of Grand Couronne, Macedonia. Last seen on a stretcher, but in good spirits, he is never seen or heard from again.
- Able-seaman Albert Davies demonstrated his swimming prowess again. In a competition open to both army and navy at Plymouth, he was first in the quarter mile, first in the 100 yards and first in the relay race. In races open to all the Allies, he was second in the 200-yards relay race and second in the 200 yards.
- Ministers urged to mention to their congregations the dire need to be economical with coal supplies.
- *Cambrian News* offered children a halfpenny per pound for waste paper and cardboard brought to their offices in Terrace Road.

October

- Thefts of parsnips, marrows and carrots from allotments at Cae Bach and the National Library.
- RSM Fear organised a brass band to be conducted by Mr J. H. Rowe to welcome back returning troops.
- An aeroplane made an emergency landing near the town, without serious damage or casualties.
- A rota was established to attend to the supply of flowers at the shrine to local heroes in the town library.
- First incidents of the virulent strain of influenza, so-called Spanish Flu, reach Aberystwyth.

November

- William Edward George Pryse Wynne Powell, a Lieutenant in the Welsh Guards and heir to the Nanteos Estate, killed on 6 November.
- Armistice signed on 11th.
- Cardiganshire Battery wait at Alexandria for embarkation home.
- A series of burglaries were carried out at local shops. A man believed to be a deserter from New Zealand and his accomplice, an older lady named Martin, were arrested at lodgings in Cambrian Street. It was rumoured that Mrs Martin is the wife of a gentleman well known in the highest circles whose name was not Martin. When the case came to court, Raymond Alan Watkin and Elsie May Hewitt are both found guilty of breaking into shops in Aberystwyth. Each was sentenced to one year in prison, Hewitt with hard labour. As Watkin had been gassed, enquiries were being made as to his suitability for hard labour. The proceedings reveal no hint of scandal in higher circles pertaining to the couple.
- Influenza outbreak still spreading, university and schools closed, talk of closing cinemas and Sunday Schools.
- Milk was now selling at 7d a quart. The Food Control Committee is chastised for not doing more to obtain supplies at a lower price.

Dedication of a memorial erected by tenants and employees of the Nanteos Estate in memory of Lt W. E. Powell, heir to the Nanteos Estate. His name also appears with seven others on a plaque in the Memorial Hall, Penparcau.

December
- Ardwyn County School, closed due to the influenza outbreak, was to reopen on 31 December.
- Free Church Council objected to the suggestion people should stay away from Sunday services due to the influenza epidemic.
- Wreckage marked 'Kristanis' washed up on Aberystwyth and other local beaches.
- Christmas celebrations at the Red Cross Hospital were muted this year as most of the patients have been sent home on leave.
- Shiloh Chapel adopted a proposal to support the formation of a League of Nations.

CHAPTER 11

THE UNIVERSITY

Aberystwyth's fine war memorial, inscribed with the names of 110 townsmen, is a notable landmark. The town contains another memorial with almost as many names on. This is a far more modest affair to be found in the Old College, with the names of 102 students and ex-students of the university who made the supreme sacrifice.

The university contributed to the war effort in many ways. Most obviously, many students and ex-students obtained commissions as officers, and by the end of the war, it is unlikely that many regiments had not seen an old Aberystwyth student in their ranks. Initially, women students joined the VAD and went on to other activities as the war progressed. In 1914, the Edward Davies laboratories were used for (unspecified) government work and were placed at the government's disposal afterwards. The Department of Agriculture was concerned with food production and in particular with attempts to revive the mussel industry.

Aberystwyth's fine war memorial inscribed with the names of 110 townsmen is a notable landmark not easily missed. It might surprise a lot of people to know that the town contains another memorial with almost as many names on. This is a far more modest affair to be found in the Old College and contains the names of 102 students and ex-students of the university who made the supreme sacrifice.

Student Numbers

At the start of the academic year 1914–15, numbers of male students had fallen to 223 from 261 previously and fell further the following year to 146. The number of female students rose over the same period from 168 to 180. Some short courses, notably in law, were suspended shortly after the outbreak of hostilities, as six members of staff had joined the forces. Their work was carried on where possible by unpaid service or at a minimum cost to the college. Besides undertaking additional teaching work, members of the staff also assisted in forms of voluntary war service, such as instruction given to the officers and men of the Welsh Reserve Division billeted in town during 1914 and 1915. Later, they assisted with the Red Cross Hospital. Numbers fell further in 1916 when there were only 248 students enrolled at the start of the academic year, but significantly 172 were female students. Of the seventy-six male students, most were classified as medically unfit for general service, and some had already been discharged from the services. Two more were

classified as advanced students of technology and science and not to be called up without reference to the War Office; eighteen had not yet been medically examined, and one was Japanese.

Officers Training Corps

Aberystwyth's Officer Training Corps was founded in 1908 to replace the College Volunteer Company of the 4th South Wales Borderers. Despite their being in the region of a hundred officer cadets and over 250 men who had passed through the OTC ranks by 1914, only six had gone on to further their army career, a fact commented on when the corps were inspected by General Sir William Robinson. In fact prior to the summer of 1914, the War Office had told the Aberystwyth OTC that they were to be put on probation and unless they produced more career officers the unit would be disbanded.

Members were required to devote much of their leisure time to military work. Three or four drills were held each week, and Saturday afternoons were devoted to route marches, manoeuvres and field work. In addition, weekly lectures were held on topics such as field tactics, musketry, map-reading and military topography. Signalling classes were also held under the auspices of Mr F. W. Durlacher of the zoology department.

By May 1915, of 332 students who had enrolled in the Officer Training Corps since inception, 103 held commissions, 16 served as privates, 3 were civilian prisoners of war, 12 were employed as chemists in explosive works and 50 or so were either medically unfit, or otherwise engaged in the ministry. Many were abroad and were to be found in South Africa, Jamaica, Canada, India and Japan. Other ex-students previously not in the OTC had also joined up. In addition, ten men who were not students were training with the OTC in the hope of gaining a commission. Six months later, 289 past and present students of the

UCW Aberystwyth Officer Training Corps marching along Pier Street, *c.* 1916. (By permission of Llyfrgell Genedlaethol Cymru/National Library of Wales)

college were known to be serving in the forces, eighty-five being present-day students. Six alumni had already lost their lives. In January 1916, the introduction of conscription led to membership of the corps being thrown open to anyone (male) under the age of nineteen who wanted to try for a commission. In addition, men who had enlisted but had not been called up could also attend for training.

One particularly unlucky graduate of Aberystwyth was Captain Tom Rees of the RWF. On 17 September 1917, he volunteered to act as an observer with the Royal Flying Corps. Their plane, an ungainly looking FE2b, was near Villers-Plouich when spotted by a flight of six German planes. One pilot in a superior aircraft latched onto the FE2b eventually killing the observer and fatally wounding the pilot with machine gun fire, his first 'kill'. Tom Rees had just become the first victim of a pilot who came to be known as the Red Baron.

In the same month Capt. H. H. Paine, previously demonstrator in physics, was awarded the Military Cross, his brother being wounded in the same battle. By April 1918, Paine was using his skills in the Sound Ranging Section and saw action at St Sylvestre Cappel. Sound ranging involved using an array of scattered microphones to determine the location of enemy artillery. He was discharged in January 1919 and returned to the university.[1]

By June 1917, the Roll of Honour extended to 537 names. Three DSOs and twenty-two military crosses had been awarded, and eleven men mentioned in despatches. A year

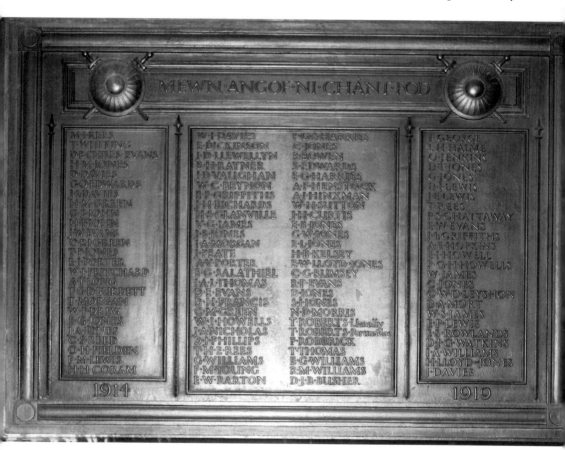

Oak Memorial Panel in the Old College.

later, a further seventy-three names had been added to the roll. At the end of hostilities, Aberystwyth staff and alumni had amassed an OBE, 3 DSOs, 31 Military Crosses and 16 men had been mentioned in despatches. In addition, a French Croix de France and Belgian Croix de Guerre had been awarded. The memorial in the Old College contains the names of men who served in forty different regiments or branches of the forces. Extrapolation from this source indicates that most OTC members joined Welsh regiments such as the Royal Welch Fusiliers (21%), the Welsh Regiment (14%) and the South Wales Borderers (8%).

Voluntary Aid Detachment

In September 1916, a Red Cross VAD was established at Alexandra Hall under the guidance of the Warden Miss Tremain. Their main function was to assist in the care of convalescent patients at the Red Cross Hospital. Enthusiasm for this aspect of work seems to have declined in inverse proportion to the eagerness to undertake agricultural work.

Aftermath

By 1917, UCW was accepting discharged soldiers to study for teaching qualifications. This was the vanguard of what was to come.

By 1918, student numbers had started to recover with 410 students, including 14 Serbian refugees studying. This compares with 429 students in 1913. But by 1919, the figure had more than doubled to 971 as returning students and discharged soldiers overwhelmed the university and the town. In 1919–20, over 90% of university admissions to Aberystwyth were ex-servicemen. This figure included forty American soldiers who arrived in March to study until the end of the summer term. After being entertained at the YMCA, one of their first priorities was to form baseball teams, later giving a well-attended exhibition game on the Vicarage Fields. The *Cambrian News* rather snootily reported that the game required about the same amount of exertion as cricket and that it was 'an improved edition of the game of rounders'. The game was part of a national tournament for American students studying at universities across Britain, culminating in a final in London on 4 July.

In a section of the thirty-fourth UCW Sports confined to American students, two of their number also set new records. Tierney (from Montana) threw the cricket ball 102 yards, 2 feet and 6 inches, while Devonport (a native of New Jersey) set a shot putt record of 31 yards, 8.5 inches. In the same sports, Dr T. H. Parry-Williams achieved third in the 100-yard staff race.

Not for the last time in its history, the university was temporarily faced with an accommodation crisis. As a result, Carpenter Hall was opened on the seafront. The total number of students admitted increased again in 1920 to 1,092. One of these students who arrived under these circumstances and went on to contribute to the life of Aberystwyth was George Rowlands. Joining the RWF in 1917, he had been wounded, gassed and temporarily blinded before he was twenty. Initially, he came to Aberystwyth in the hope of reading chemistry. However after a few weeks it became apparent that he reacted adversely to the

fumes released during practical experiments, a result of having been gassed. Instead, he chose to read English. After graduating, he went on to teach at Alexandra Road School, then to Ardwyn, eventually becoming Deputy Headmaster. During the Second World War, he was an instrumental figure in the Home Guard and, like RSM Fear before him, organised gifts and letters to local service personnel serving abroad. Also a councillor, he was elected mayor in 1955.

Accommodation was not the only crisis to engulf the university. Ex-servicemen were a new category of students unlike their predecessors – not only were many of them considerably older than the usual intake, but these were individuals who had risked their lives for their country. These men in particular had suffered intolerable conditions, been shot at, shelled, gassed and perhaps wounded and seen sights nobody should have to see. Treated as heroes by the outside world, they had learned to gamble, sing bawdy songs and lost their innocence in more ways than one. Why should they feel duty bound to the Victorian social conventions still adhered to by the university? For example, Regulation 1,

> When outside College, men students are not allowed to escort women students. Conversation between men and women students outside College is forbidden except at public meetings, at athletic matches, at tennis and at such social functions as are sanctioned by the warden of Alexandra Hall.

The army had given their soldiers regular tots of rum in the trenches and taught them how to kill, but now these men apparently had no right to enter a public house (previously prohibited), or more importantly dance and socialise with the opposite sex without being chaperoned. Consequently, new rules, still draconian by today's standards, were drawn up while others were no doubt flouted or ignored. Regulation 1 now allowed:

> That all men and women students be allowed to converse during the hours of daylight (i.e. to lighting up time) in the town within a line drawn between the College, the Athletic Ground and Alexandra Hall.

However, it was not just the rules and regulations that came under close scrutiny from the new intake of students. A few years of army life had honed their instinct for detecting bunkum. Professors who had sidestepped the war and were still churning out the same lectures as years before were decried as frauds and faced sharp criticism.

It was probably this new, more gung-ho attitude that caused a riot in the Coliseum in 1919. During a performance of the pantomime 'Robinson Crusoe', vegetables were thrown intermittently onto the stage by a group of students. A cabbage stem hit one performer in the head. This was the last straw for the performers, the curtain came down, and the performance ended prematurely. Many townspeople who had been enjoying the pantomime were now annoyed and turned on those responsible for spoiling the performance and a fracas ensued.

Such was the impertinence of this new intake that picnic groups were found invading the game preserves of the gentry, much to the wrath of local gamekeepers. Just because they had risked their lives for their country, did they think they now had the right to trespass on the grounds of the gentry? Come on! What were they thinking?

Although in the space of a few years the intake of ex-servicemen passed through the university to take their place in society, they left their mark on the institution through changing outdated regulations and social conventions, making for a more relaxed and open academic environment.

CHAPTER 12

AFTERMATH

On 19 January 1919, the first advertisement was published in a local newspaper announcing an intention to raise £10,000 to build a memorial to Aberystwyth's fallen. Other inhabitants believed the money should be spent on YMCA and YWCA buildings – both were subsequently purchased – or a memorial hall or an athletics field.

War Memorial

War memorials to the town's fallen heroes were erected in numerous chapels, churches and schools. The names of many of the fallen appear on more than one memorial. Particularly noteworthy was the first to be unveiled, that in Alexandra Road School, in June 1919. This was carved by Mr Saer, the headmaster, and is in the form of a Peithynen. The forty-eight names were carved on twelve revolving four-faceted bars. It still stands in the school buildings, in the Help The Aged office.

In a ceremony similar to thousands held across Great Britain, Llanbadarn Fawr War memorial was dedicated on a wet Saturday afternoon in January 1921. After singing 'Marchog Iesu yn llwyddianus', the curate, Reverend D. Davies and Reverend D. J. Evans of Capel Seion read from the scriptures. The Lord's Prayer followed in Welsh Lieutenant Colonel Lewis Pugh Evans VC, then unveiled the seventeen-foot-high granite cross. After a brief silence, Albert Burbeck played the Last Post. This was followed by 'When I survey the wondrous cross'. A dedication by Revd Jones, vicar of Llanbadarn, followed. Reverend J. Bodfan Anwyl then addressed the crowd in Welsh. His address was followed by 'O Fryniau Caersalem' and a blessing by Reverend Jones. After another hymn, 'Dan dy Fendith wrth ymadael' the two national anthems were sung, and the ceremony complete.

Two of the leading citizens in the campaign for a memorial in Aberystwyth were Captain Edward Llewellin, landlord of the Central Hotel and Captain B. Taylor-Lloyd. In 1915, Edward Llewellin had obtained a commission in the Royal Regiment of Artillery despite being over fifty years of age. He was promoted to Captain by December 1916 and came through the war unscathed having been mentioned in despatches. Captain Taylor-Lloyd, Royal Field Artillery, had been mentioned twice in despatches, wounded in the right foot and awarded the Military Cross for bravery in the field.

At a meeting in June 1919, the following resolution was passed:

That the Aberystwyth Town War Memorial shall consist of a Statue or Monument to be erected on some prominent site, and an Institute or Building to provide for the social life

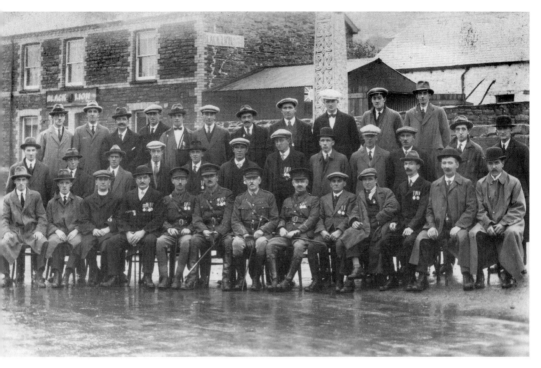

Llanbadarn Fawr Veterans shortly after dedication of the memorial.

of the young men and women of the town, and to be vested in Trustees or body of persons in trust for the sole use of the Y.M.C.A. and Y.W.C.A. and to permit the same to be solely occupied and controlled by the Y.M.C.A. and Y.W.C.A.; and that there shall be one united appeal for subscriptions, and that no subscription shall be earmarked for either of the said projects.

Professor Mario Rutelli, a renowned Italian sculptor, had already been chosen to design the memorial for Tabernacl Chapel.[1] When the first set of designs, submitted by another sculptor, were rejected, Professor Rutelli was approached. Allowed to choose the location himself the result is the magnificent memorial, we see near Castle Point today. The column is sixty-five feet high and has two sculpted figures. On the top is Winged Victory standing on a globe, while at the base of the column is a nude figure emerging from foliage – Humanity Emerging from the Effects of War. The historian Gwyn Alf Williams famously said of this figure that it is 'the finest backside in Cardiganshire'.

Work on building the memorial commenced on Armistice Day 1921 with priority given to hiring unemployed, married ex-servicemen for the construction. In June 1922, a list of names to be included on the memorial was published in local newspapers, accompanied by a request to submit omissions or amendments.[2] In October, the bronze statues arrived by ship from the sculptor's studio in Italy.

The official and emotional unveiling took place on 24 September 1923 by the mayor Captain Edward Llewellin. Every organisation in the town was represented in a procession that made its way from the Town Hall to Castle Point. The local clergy and dignitaries spoke, but the overriding memory for many came at the end as loved ones laid flowers on the base of the memorial. Hand in hand went a brother and sister, the little boy wearing his

father's medals. Laying down their flowers, he then stood erect and saluted the name of the father he had barely known.

Aberystwyth War Memorial Trust

The trust fund is still in existence. It donates to causes for the general benefit of young inhabitants (defined as up to the age of twenty-one) of the area, for which provision is not made out of rates, taxes or other public funds. The town of Aberystwyth is deemed to include Penparcau, Llanbadarn Fawr and Waunfawr.

NOTES

Chapter 1

1. Guy Harries, by now a captain in the Royal Welsh Fusiliers, was killed a little over a year later in Gallipoli, on 17 August 1915. He is buried in East Mudros Military Cemetery, Limnos, Greece.
2. Marie Marvingt (1875–1963), athlete, mountaineer, aviator and journalist, became the first woman to fly combat missions as a bomber pilot in the French Air Force, was a qualified surgical nurse, excelled at numerous sports and at the age of 86 rode her bicycle from Nancy to Paris. At some point in her career, she earned the nickname 'The fiancée of danger.' In 2004, she was commemorated on a French Airmail stamp.

Chapter 3

1. Equivalent to £5.15*p* in 2015.

Chapter 5

1. John Rea, also known as Jack, was a native of Aberystwyth. His parents kept the White Horse Hotel as he did in later life. A talented sportsman, he had played soccer for Aberystwyth, Wales (winning 9 caps) and West Bromwich Albion. He was very popular with his men and an able officer. He and Dr Abraham Thomas were close friends.
2. Recruits were to be between 19 and 35 years old, five feet four inches tall to be a driver, five feet seven inches to be a gunner.
3. The port of embarkation may have been Southampton as J H Chamberlain was discharged after having been injured at Southampton.
4. The Battery received monthly parcels from the Comforts for fighters Fund until its closure in February 1919. In total, £227 15*s* 6*d* was spent on parcels sent to the Battery.

Chapter 7

1. George Stapledon (1882–1960) came to Aberystwyth in as a head of the newly created Department of Botany in 1912. He went on to become the first director of the Welsh Plant Breeding Station (now IBERS) from 1919 to 1942.

Chapter 8

1. Horace Blair was killed on 25 August 1918, leaving behind a widow and a son he had never seen.

Chapter 9

1. Qingdao today. The TsingTao Brewery Co. Ltd, China's second biggest brewery, is a legacy of the German influence in the area.
2. Service personnel who had been honourably discharged due to wounds, illness or old age were entitled to wear a silver badge. When worn on civilian clothes, it identified the wearer as an ex-serviceman who had served during the war.
3. Q-ships were so named after their home port of Queenstown (Cobh) in Ireland.

Chapter 10

1. Professor Fleure was Head of Zoology at UCW Aberystwyth.
2. The name Spanish flu was derived from the greater press coverage given to the outbreak in Spain. In Germany and the Allied countries, press censorship sought to play down the severity of the outbreak, giving the impression that the outbreak was far worse in Spain than elsewhere. Globally, it is estimated that between 3 per cent and 6 per cent of the world population died from the outbreak.
3. Thomas Melini Morgan moved back to Trefeurig and is still fondly recalled as a large, jovial, white-haired man with a small English-speaking wife. He helped run a local Sunday school.

Chapter 11

1. He was later a professor of physics at the University of Witwatersrand in Johannesburg.

Chapter 12

1. Now in Amgueddfa Ceredigion Museum.

APPENDIX 1

LIST OF NAVAL RESERVISTS IN THE COUNTY OF CARDIGAN (ABERYSTWYTH DISTRICT), AUGUST, 1914.

(Aberystwyth unless otherwise stated)

John James Bracegirdle, 2, Picton Terrace, Borth.
Thomas Brodigan, 15, Spring Gardens.
John Edward Brodigan, 2, Penyranchor.
Richard Brodigan, 2, Penyranchor.
Wm. Gregg Brown, 10, Fountain Court.
John Daniel, 16, Skinner Street.
Evan Daniel, 24, Portland Road.
Albert Edward Davies, 6, Vulcan Street.
Evan. James. Davies, 6, Vulcan Street.
David Davies, 4, Bryn Place.
Wm. James Davies, 7, Cambrian Square.
William S. Davies, 6, Vulcan Street.
Ernest Davies, Pembroke House, Queen's Road.
John James Davies, Wesleyan Place, Borth.
John Wm. Davies, Wesleyan Place, Borth.
Daniel Edwards, 24, High Street.
James Thomas Edwards, 1, Beehive Terrace.
David James Evans, 3, Bryn Place.
David Thomas Evans, 18, Rock Terrace, New, Quay, Cards.
Frank Evans, 3, Thespian Street.
Lawrence O. Gurney, 4, High Street.
Morgan Hopton, 1, Vulcan Street.
David Hughes, 4, Chalybeate Cottages.
Morris Davies Hughes, 9, Rheidol Terrace.
Wm. David James, 38, Portland Road.
W. Richard Jenkins, 2, Crynfryn Buildings.
David Theophilus Jenkins, 7, Crynfryn Row.
Richard A. Jones. 24, South Road.
Richard Jones, Pretoria, South Road.

Thomas Owen Jones, 8, Glanrafon Terrace.
Edward David Lewis, 9, Rheidol Place.
Richard Parry, 1, St David's Place.
David Rees Parry, 7, Greenfield Street.
Stanley Parry, 7, Greenfield Street.
James Pugh, 40, Portland Road.
James Lewis Pugh, 5, Glanrafon Terrace.
William John Roberts, L.C. and M. Bank.
William George Shewring, Aubrey House, Queen's Road.
John James Silcock, 12, Spring Gardens.
John Warrington, 22, Portland Road.
Benjamin White, 15, Thespian Street.
Edwin White, 6, Pound Place.
Llew Williams, 20. High Street.
William Wright, 22, Prospect Street.

APPENDIX 2

EMBODIED AND EFFECTIVE SOLDIERS OF THE CARDIGANSHIRE BATTERY, 2ND WELSH BRIGADE, RFA, 1 AUGUST 1914.

(Aberystwyth unless otherwise stated)

Major J. C. Rea, Ellerslie, Boverton Road, Roath Park, Cardiff.
Captain George Fossett Roberts, Laura Place.
Lieut. Cookson, Plaspadarn, Llanbadarn.
Lieutenant Evans, 6 Laura Place.
Lieut. E. Tudor Jones, Frongog, Llanbadarn Fawr.
Lieut. Gilbert Morgan, Pontrhydfendigaid.
Surgeon Dr Abraham Thomas.
Albert Ager, 4 Penglais Terrace.
W. Astley, St Johns Buildings.
RSM A. C. Acteson, 6 St George's Tce.
J. W. Blair, 9 Bryn Place.
Frank Bennison, Lisburne Arms.
D. Bitchell, Avondale, Trefechan.
J. Bitchell, Avondale, Trefechan.
J. E. Burbeck, 25 Bridge St.
T. Cartwright, 12 Mill St.
J. H. Chamberlain, Trefechan.
E. S. Clements, 12 Eastgate.
J. D. Coombe, 14 Corporation St.
R. Corfield, Glandale, North Road.
A. Davies, Comins Coch.
A. Ll. Davies, 70 Mountain Ash Rd, Abercynon.
D. Davies, Post Office, Bow Street.
D. E. Davies, 22 July St, Manchester.
D. J. Davies, 9 Queen St.
D. T. Davies, 6 Baker St.
QMS F. E. H. Davies, Ladysmith, Rhydyfelin.
E. J. Davies, 26 Queen St.
E. L. Davies, 11 Corporation St.

Joseph Davies, 8 High St,
J. W. Davies, 45 Portland Rd.
R. W. Davies, 11 South Rd.
W. R. Davies, 4 Castle Tce.
J. Edwards, 1 Bridgend Tce.
R. Edwards, 34 Greenfield St.
W. J. Edwards, 14 Rheidol Tce.
Ellis, G., Padarn View, Llanbadarn Fawr.
A. R. Evans, Waunfawr.
D. Evans, Bryndolau, Llanbadarn.
D. M. Evans, 4 Castle Street.
E. E. Evans, Fairview, Comins Coch.
E. A. Evans, 50 Cambrian St.
E .R. Evans, 68 Cambrian St.
G. C. Evans, Whiting Road, Chirbury.
H. Evans, 1 Fountain Court, Trefechan.
J. D. Evans, 1 Fountain Court, Trefechan.
O. T. Evans, 4 Glanyrafon Tce.
T. E. Evans, Fountain Court, Trefechan.
W. E. Evans, Myrtle Hill, Llanbadarn.
W. L. Evans, Bryndewi, Aberarth.
H. Freer, 9 Bryn Place.
J. D. Good, Waterloo Hotel.
G. Gornall, 3 Penyranchor.
P. R. Gornall, Trefechan
C. Griffiths, 18 Thespian St.
T. H. Griffiths, 43 Portland St.
H. R. Griffiths, Ty Clyd, Llanbadarn.
H. Gurney, 29 Northgate Street
P. Harker, Cwm Road, Talybont.
H. Hope, 4 Vulcan Street
J. H. Hopkins, 24 South Road.
D. Hopkins, Brynawel Cottage, Clydach.
W. R. Howells, Primrose Hill, Llanbadarn
H. H. Hammond, 7 Thespian Street.
E. J. Humphreys, 17 Mill Street.
D. C. Humphreys, 6 Padarn Tce, Llanbadarn.
T. Hughes, Dyffryn, Merioneth.
D. Hughes, 4 Portland Rd.
J. R. Hughes, Railway View, Bow Street.
J. M. Hughes, Troedybryn, Trefechan.
R. D. Hughes, Brynonen Cottage, Borth.
E. J. Hughes, 4 Cambrian Place.
Sgt J. L. James, 13 Cambrian Place.
E. L. James, Dolrodyn, Llanbadarn.
W. R. James, Old Ropewalk.
D. James, Pencae, Taliesin.
G. J. Jenkins, 81 Cardiff Rd, Abercynon.

E. J. Jenkins, 34 Bartlett Street, Caerphilly.
W. E. Jenkins, Tycrwn, Llanbadarn Fawr.
E. Jenkins, Back Street, Penparcau.
J. E. Jenkins, 81 Cardiff Rd, Abercynon.
W. T. Jenkins, 11 Poplar Row.
T. D. Jenkins, Bryncarnedd.
P. H. Jones, Homelea, Dinas Tce.
J. Ellis Jones, 57 Cardiff Rd, Abercynon.
A. S. Jones, Rhydlas, Cambrian St.
D. T. Jones, 62, Cambrian St.
F. H. Jones, Tymawr, Llanbadarn.
J. E. Jones, Tycoch, Bow Street.
J. E. Jones, 39 Cambrian St.
R. Jones, 50 Cambrian Street.
T. M. Jones, Prospect Tce, Llanbadarn.
E. W. Jones, 30 Mill St.
D. Jones, 3 Penmaesglas Rd.
D. J. Jones, Meifryn, Penparcau.
Sgt Evan Jones, Padarn Tce, Llanbadarn.
J. Jones, Tymawr, Llanbadarn
J. O. Jones, 13 Park St, Senghenydd.
J. L. Jones, Penybank, Southgate.
R. E. Jones, Gogerddan Cottage, Penrhyncoch.
W. H. Jones, Pant Cottage, Trefechan.
E. J. Joseph, Comins Coch.
A. Lee, 52 Cambrian St.
F. Lee, 75 York St, Oswestry.
Joseph Lee, 3 Bryn Place.
A. J. Lewis, 5 Union St.
T. Lewis, Taigwinion, Llandre.
W. G. Lewis, 12 High St.
W. J. Lince, 34 Hill Street, Ogmore Vale.
F. T. Lloyd, 11 Thespian St.
W. A. Lloyd, 1 Vulcan St.
Sgt-major A. A. Mace, Gloucester.
W. J. Martin, Post Office.
T. J. Meredith, 41 Portland Rd.
Richard Messer, New Row, Ponterwyd.
Llew Morris, Penparcau.
Sgt E. D. Morris, Penparcau.
QMS J. Morris, Penparcau.
T. H. Morgan, Pantyrallt.
W. J. Morgan, Alma, Edgehill Rd.
A. L. Morgan, Padarn Tce, Llanbadarn.
R. W. Millman, 3, Lime Lane, Trefechan.
A. D. McPherson, Clyde House, Queens Rd.
C.W. Myring, Milton House, Llanbadarn.
A. Owen, 46 Terrace Rd.

W. Owen, 4 Penyranchor.
E. M. Owen, 11 Glanrafon Tce.
W. Owen, 43 Cambrian St.
D. Parry, Three Tuns, Trefechan.
J. P. Povey, Coniston House, Alexandra Rd.
J. Price, 28 Portland Rd.
R. Punyer, 15 Cornwallis Ave, Edmonton.
G. L. Putt, 24 Portland Rd.
J. R. Putt, 24 Portland Rd.
R. T. Putt, 24 Portland Rd.
A. Rees, 6 Powell St.
D. Roberts, 25 Cambrian St.
J. W. Rowlands, 9 Corporation St.
D. L. Samuel, Dolau, Capel Bangor.
E. J. Samuel, 58 Cambrian St.
D.C. Sandford. Rose Cottage, Llanbadarn. J. L. Schwartz, 10 Smithfield Rd.
C. E. Stephenson, Craiglais.
A. W. Summers, Central Hotel
J. R. Tanner, Castle St, Montgomery.
J. H. Thomas, Ivy Cottage, Comins Coch.
A. Thorpe, 4 Skinner St.
H. E. Todd, 28 Beecham Rd, Southport.
E. L. Warrington, 3 Cambrian Court.
M. Warrington, 3 St David's Place.
Sgt-major David Wells, Castle Hotel.
J. G. P. B. Wemyss, Llanbadarn.
W.E. White, 6 Pound Place.
J. T. Williams, Oswestry.
W. D. Williams, Cefnllan, Llanbadarn.
J. Williams, Cefnllan, Llanbadarn.
J. Ll. Williams, 12 Tabernacle St, Aberaeron.

Aberystwyth War Memorial. The top set of panels below the column record the dead of the First World War, the bottom panels those of the Second World War.